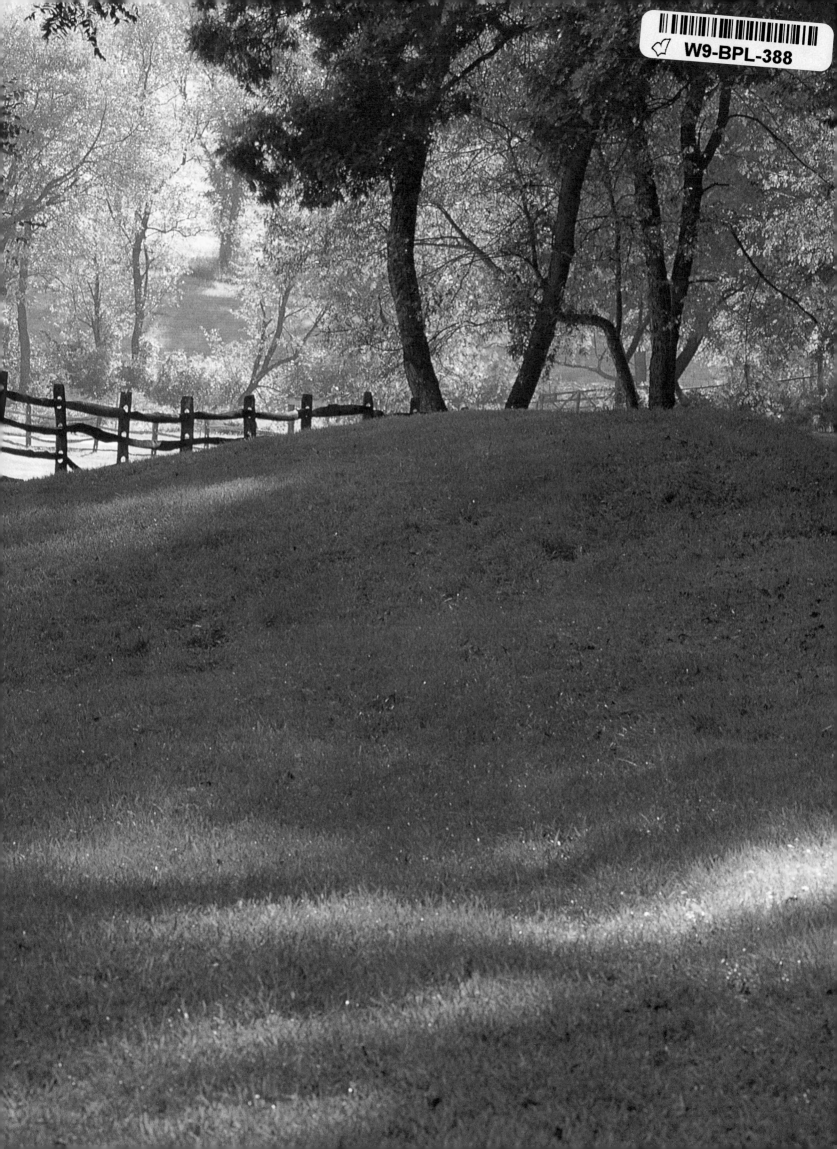

Christmas 1995

Dear Mom and Dad —

Enjoy this!

Always with all my love,
Adrienne

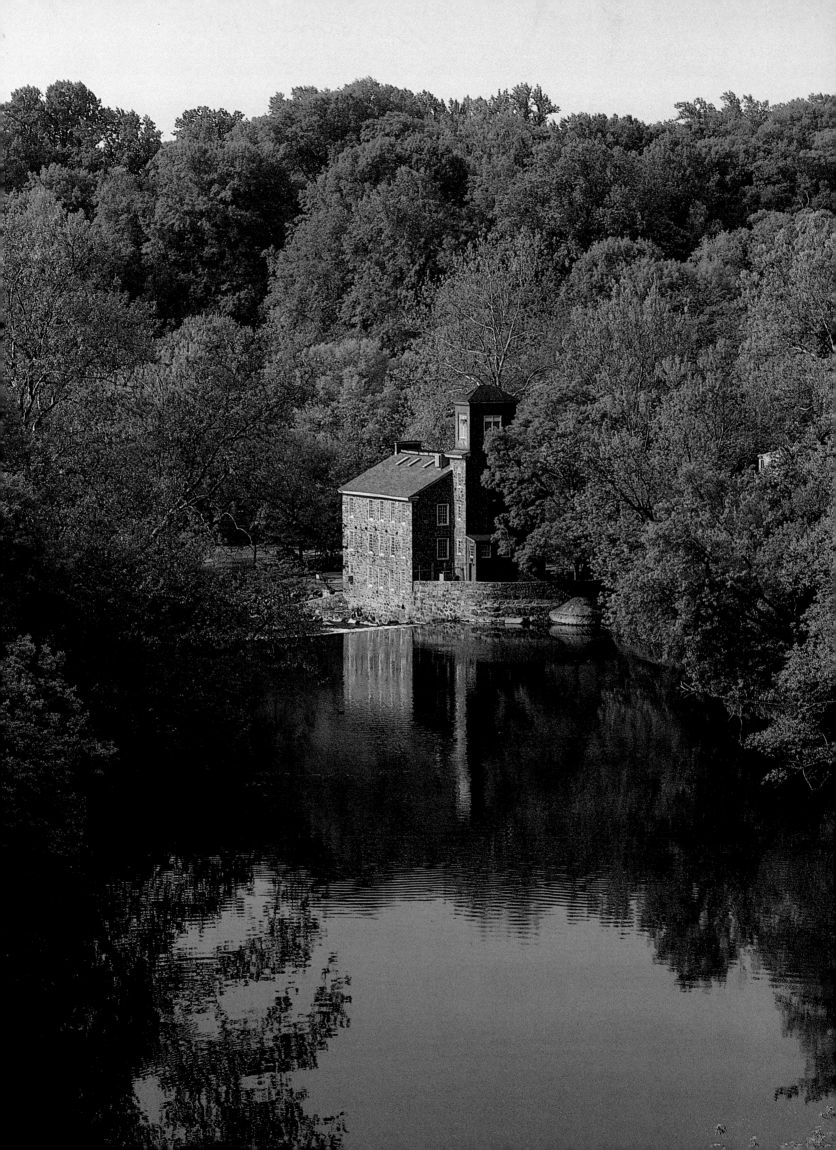

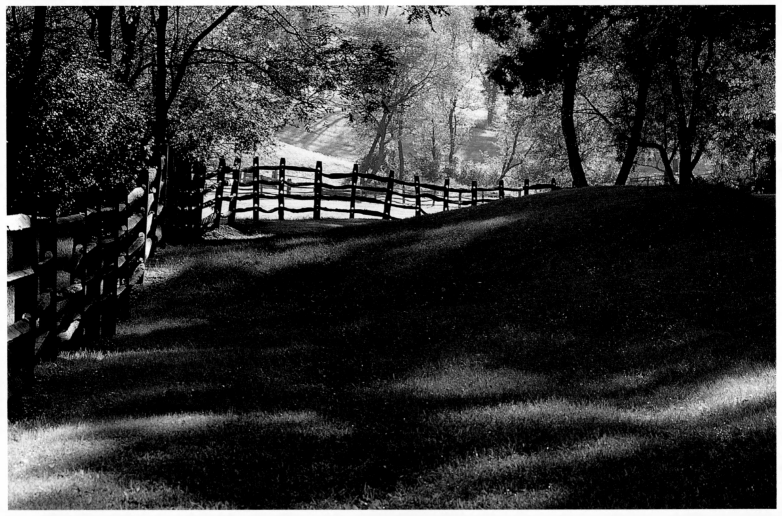

Brandywine

A Legacy of Tradition in du Pont-Wyeth Country

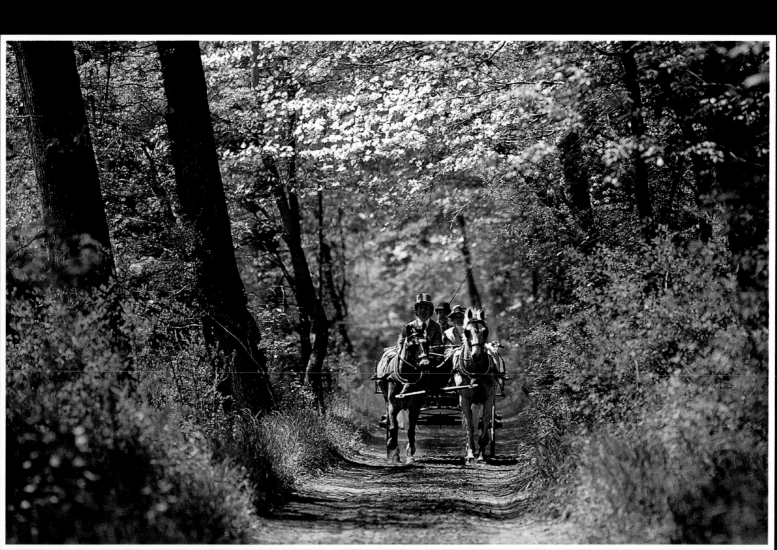

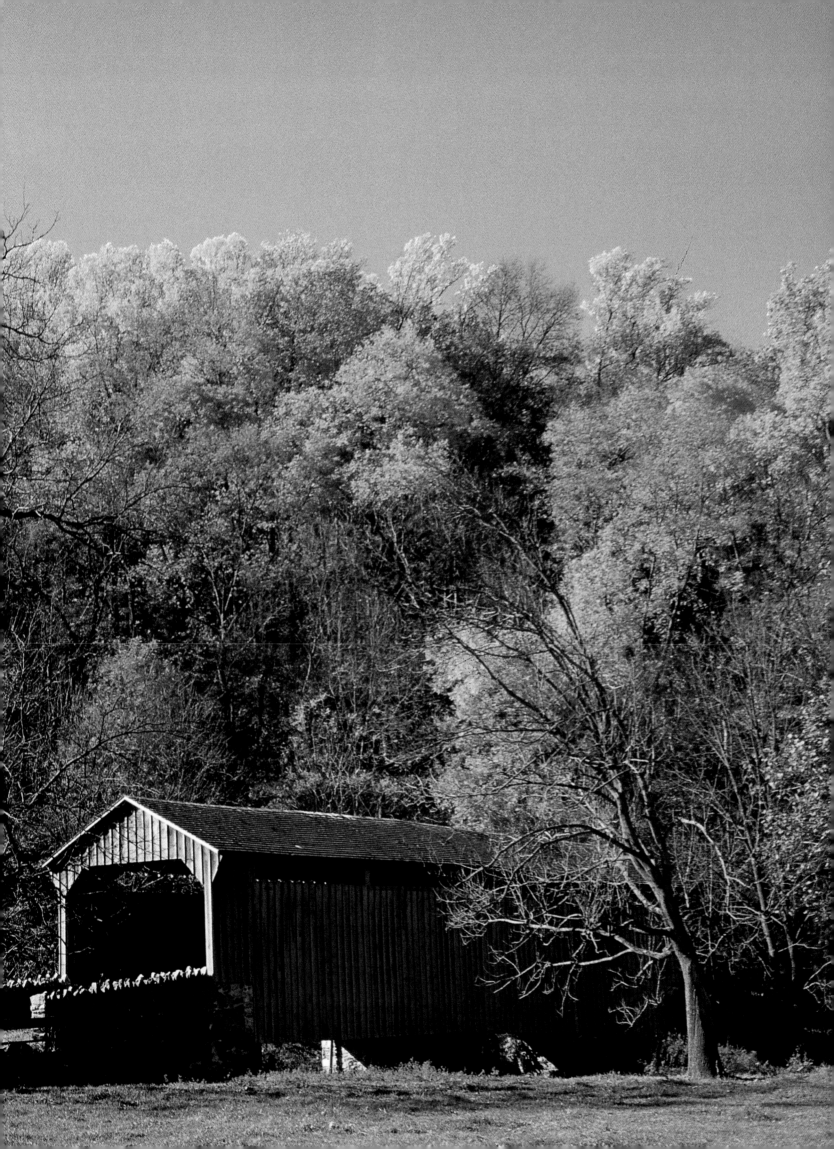

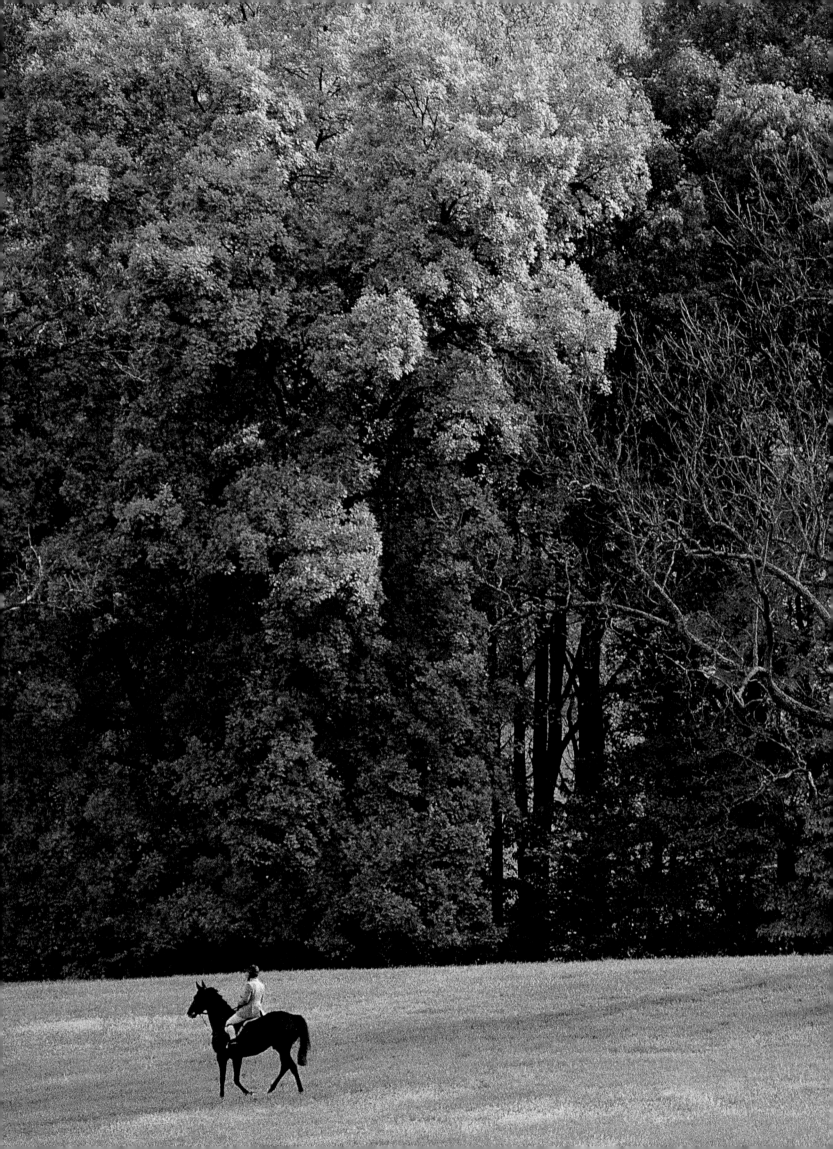

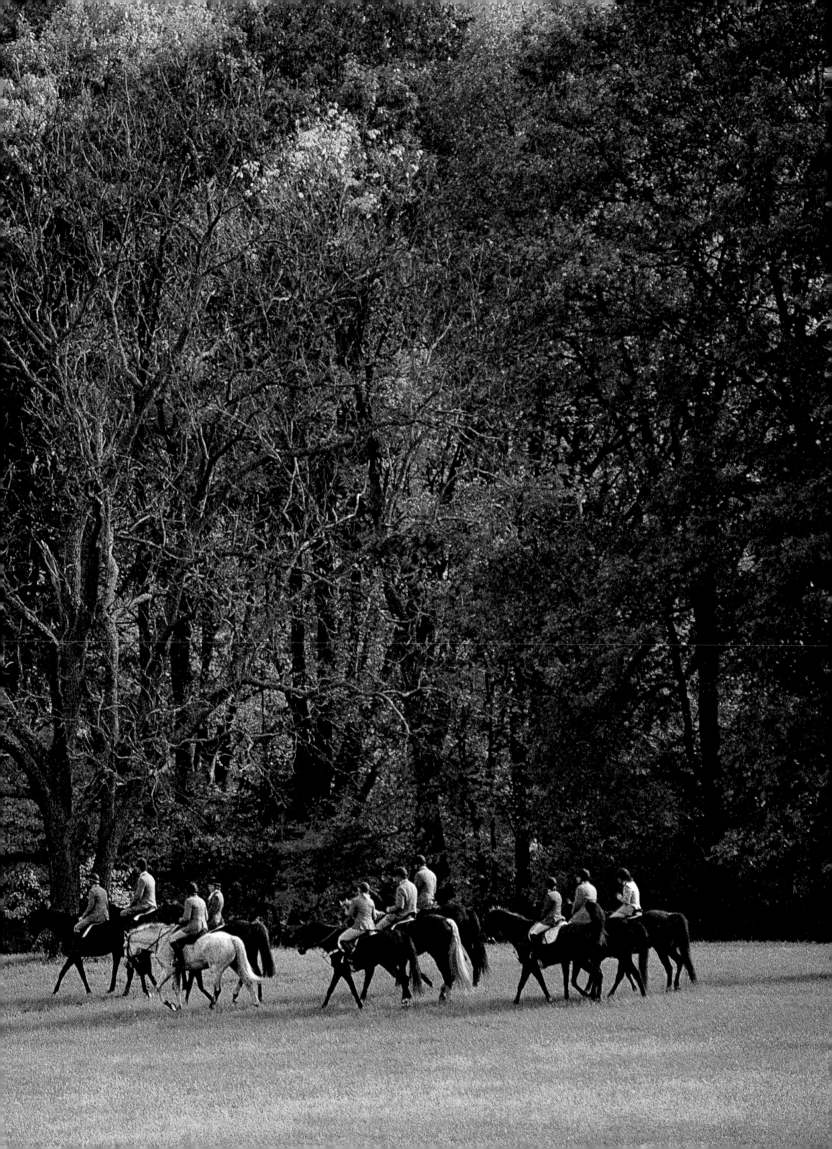

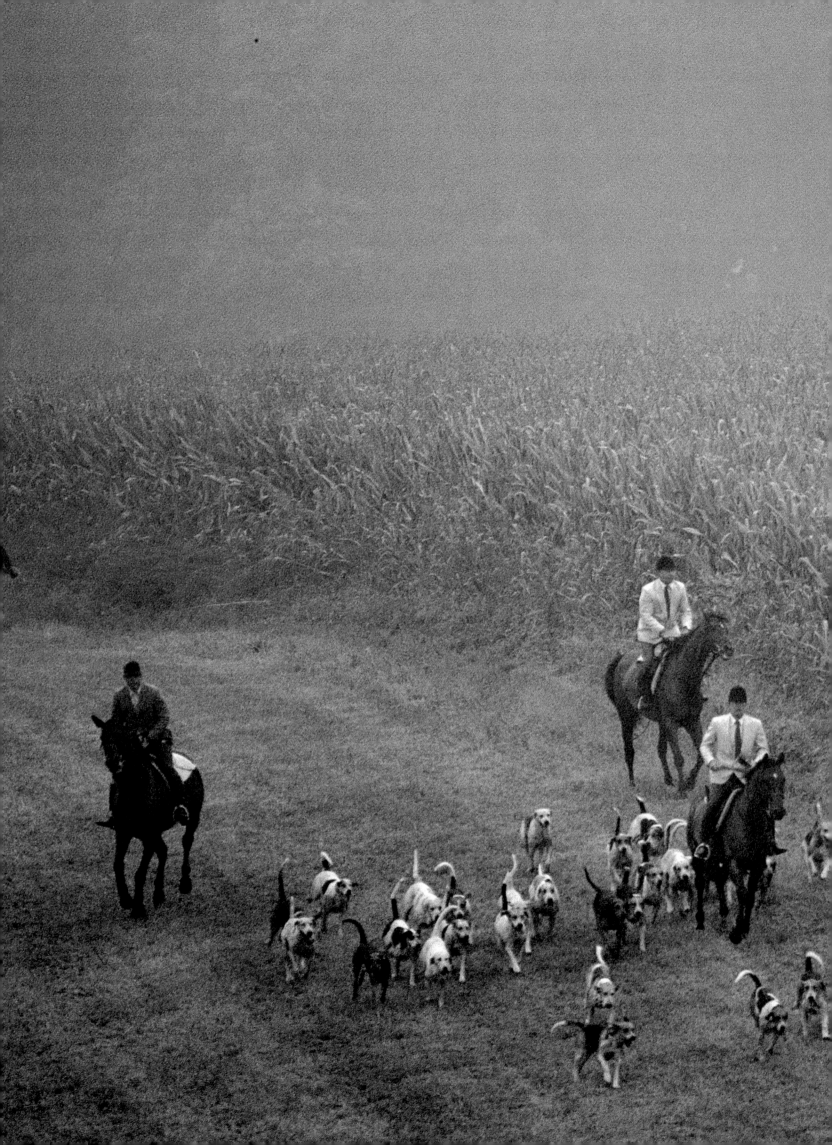

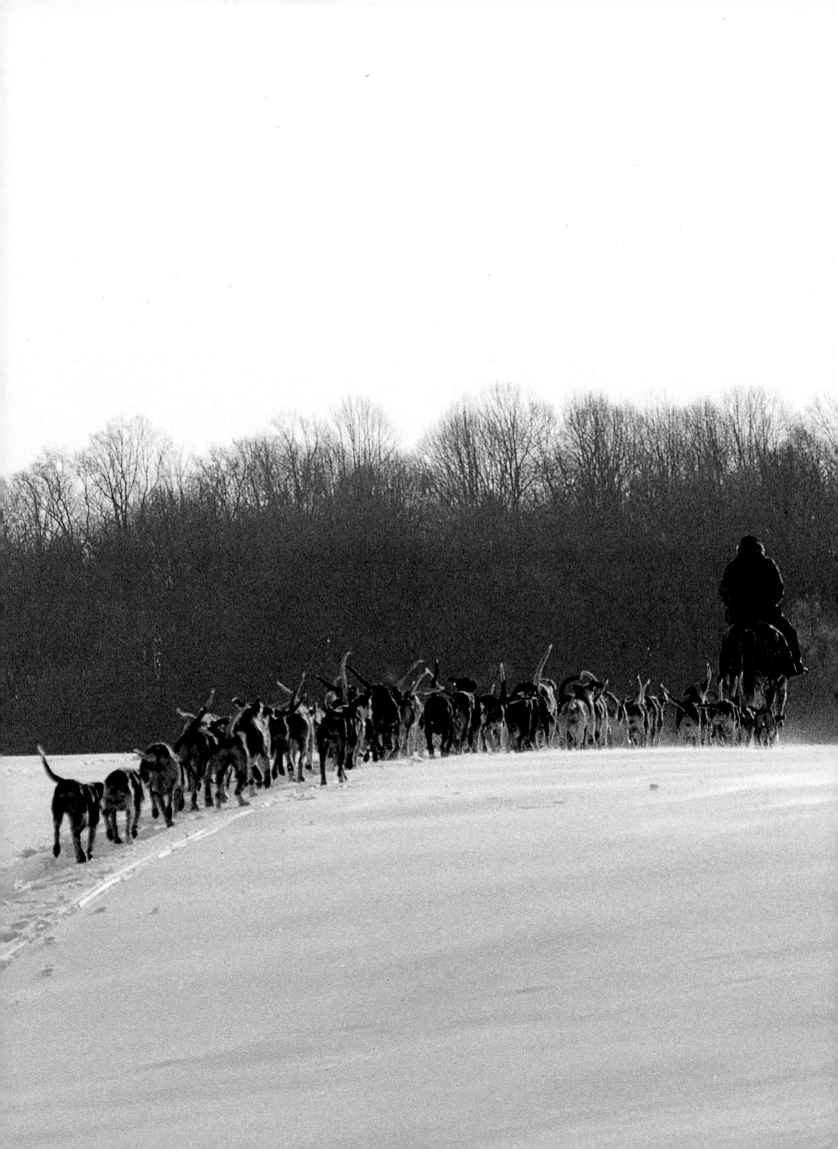

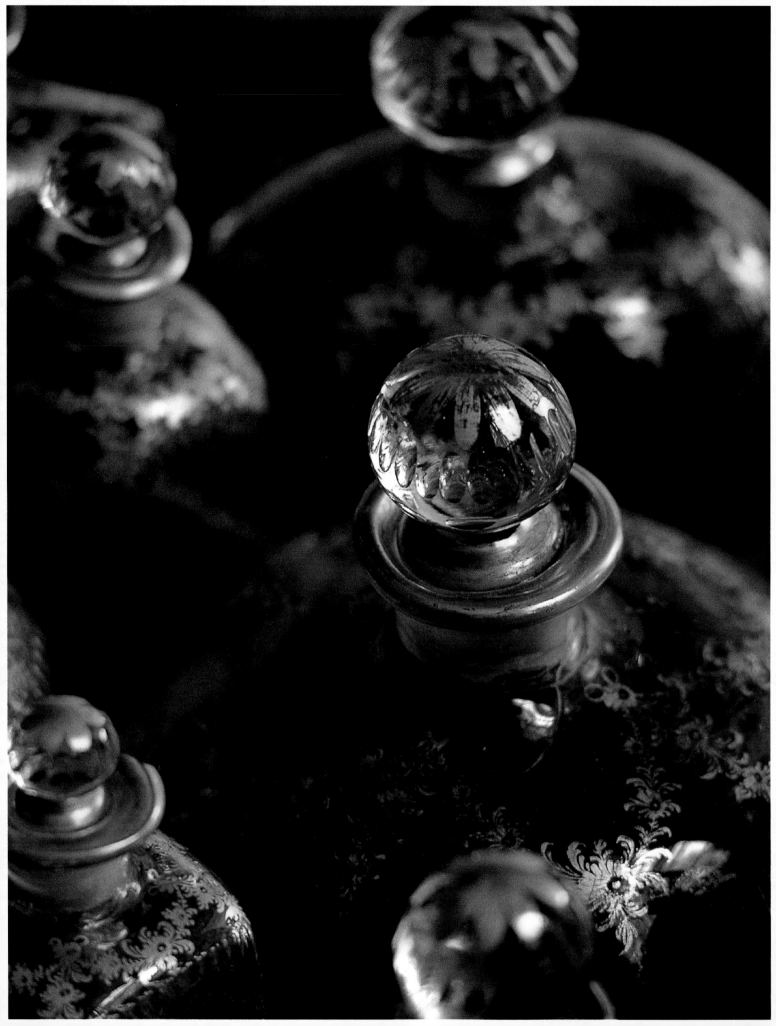

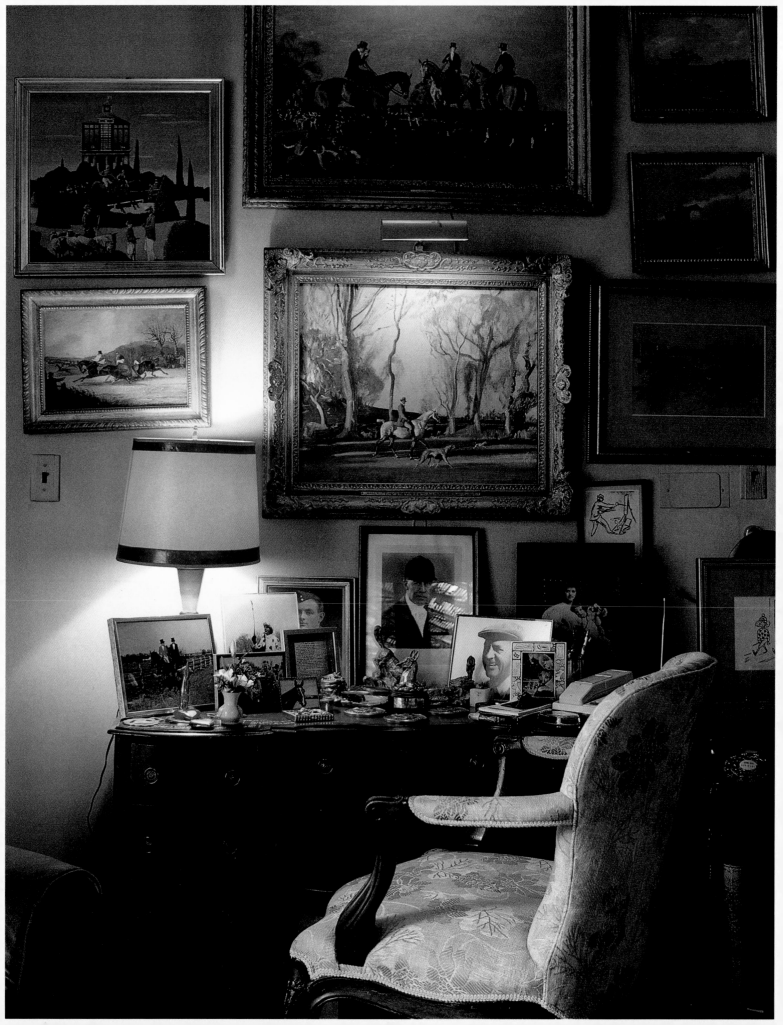

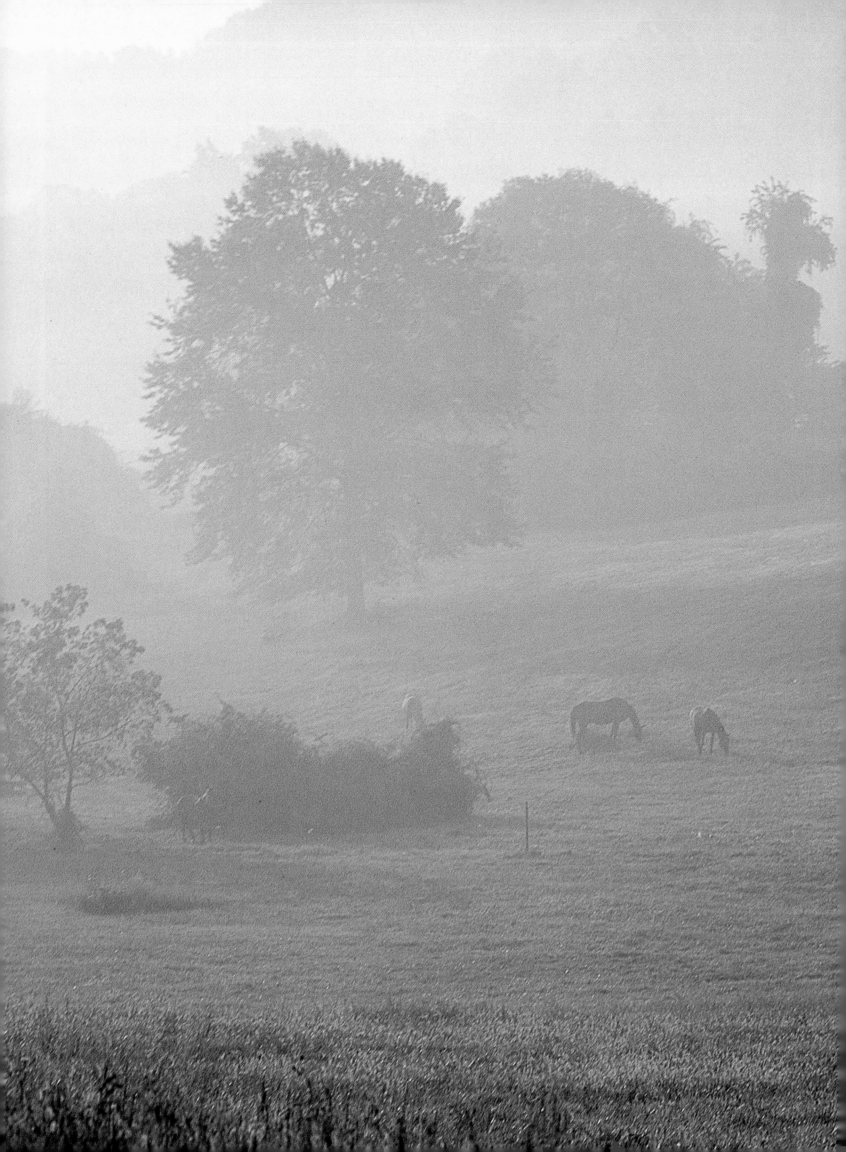

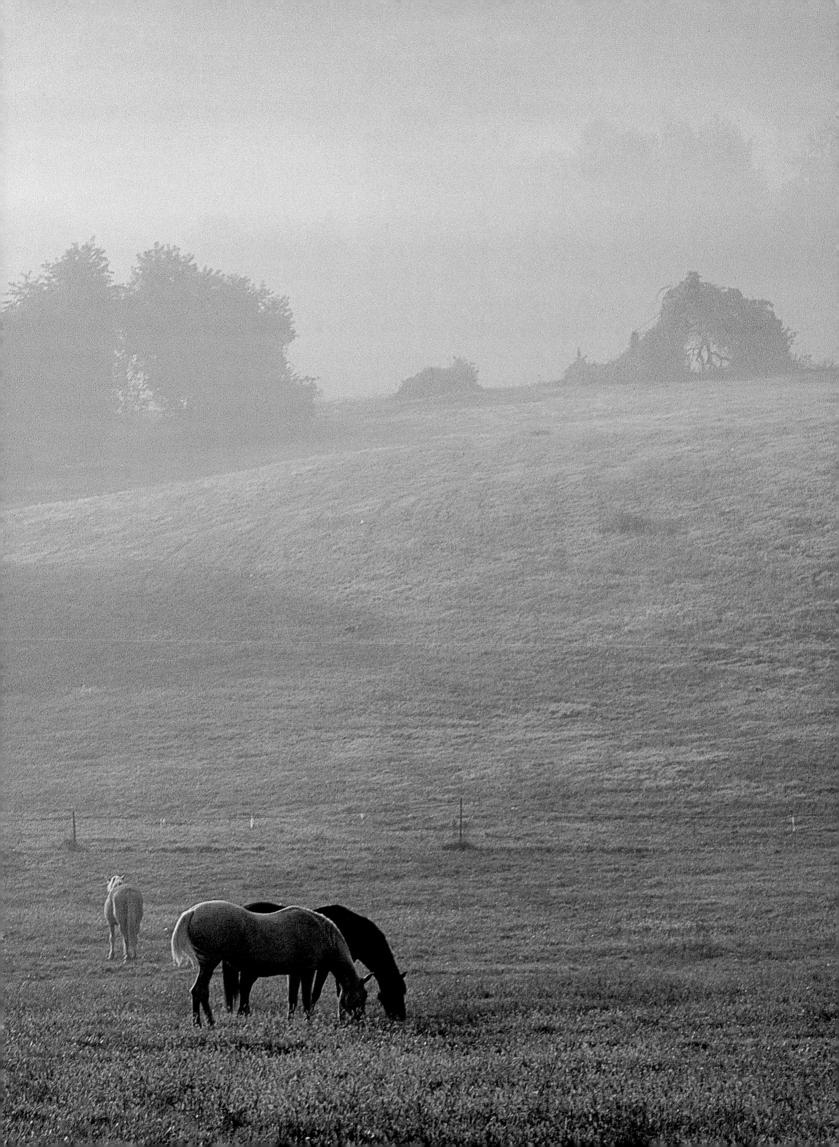

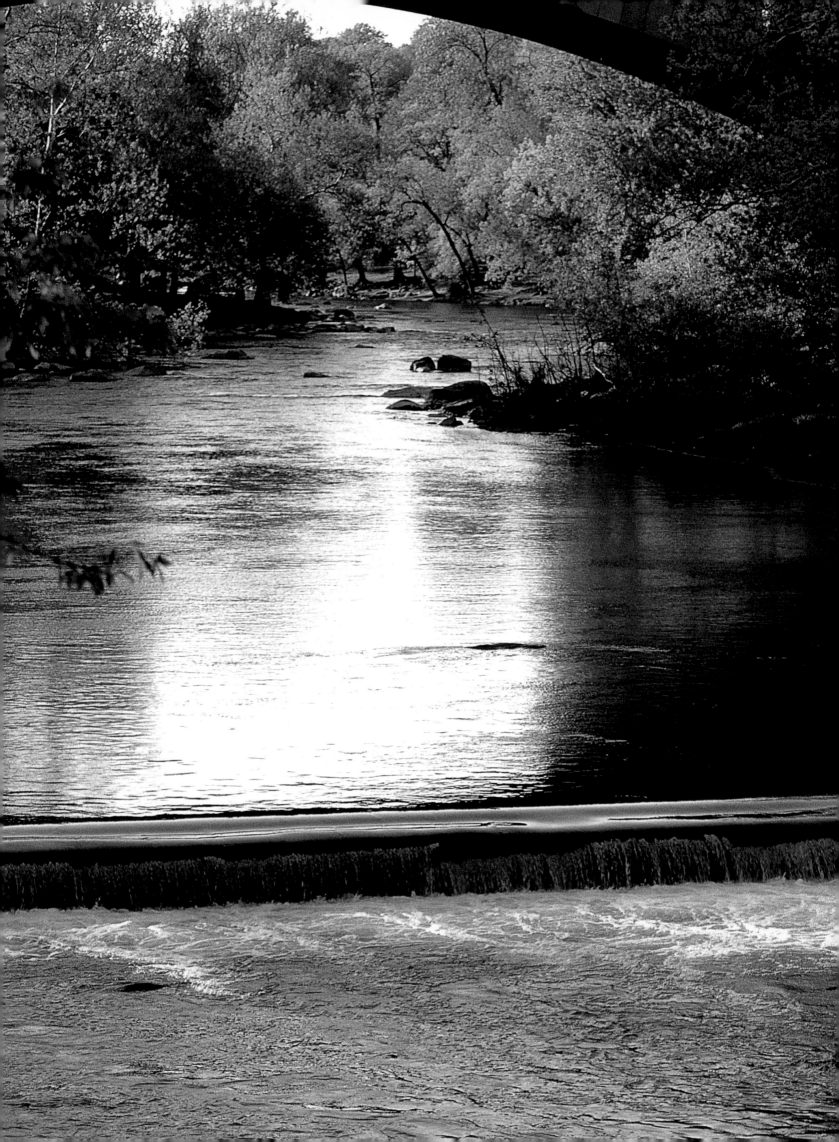

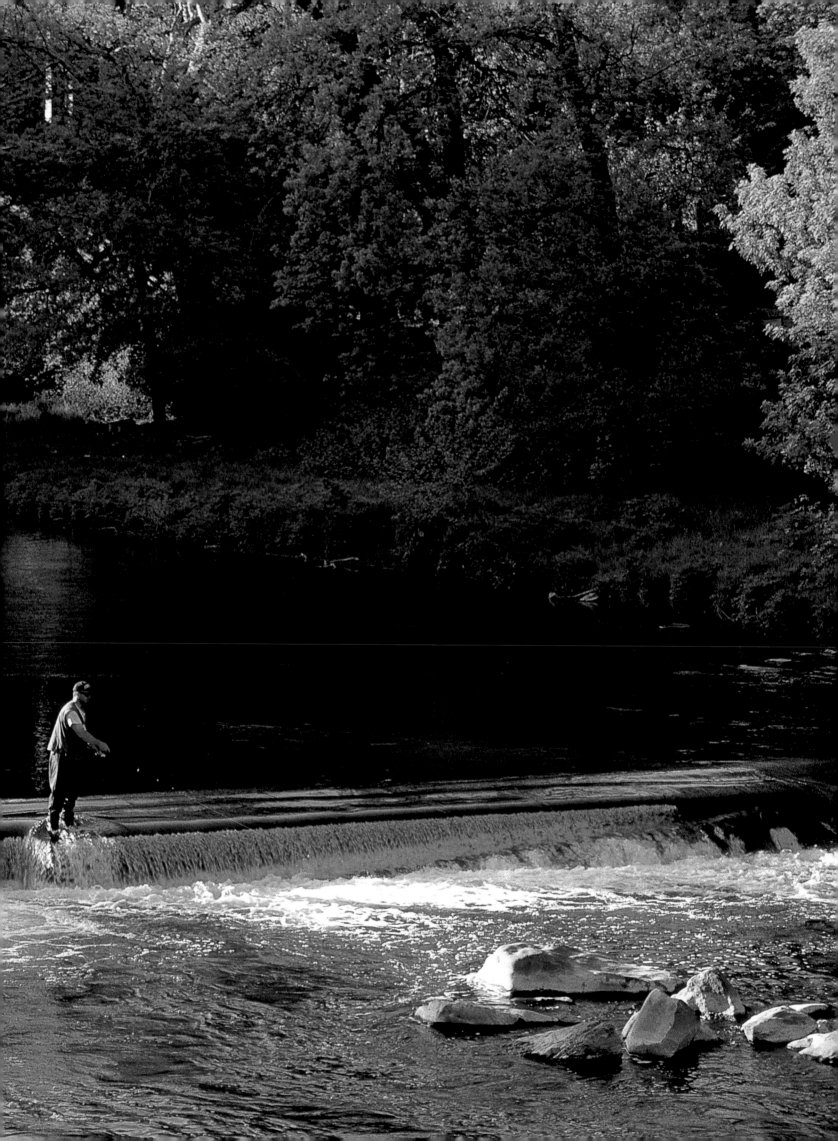

Pages 1-19:

Scenes from the Brandywine Valley, including Breck's Mill, downstream from the Hagley Museum (1); the "creek" as it flows toward Wilmington (2); a hunt-country estate near Unionville, Pennsylvania (4); artist Jamie Wyeth and his wife, Phyllis, coaching under an allée of dogwoods the day before the Winterthur Point-to-Point races (5); one of two covered bridges in The Laurels, a 771-acre nature preserve near the headwaters of the Brandywine (6); the "field" for Mr. Stewart's Cheshire Fox Hounds waiting for a fox to be drawn near an ancient stand of trees outside of Unionville (8); early-season fox hunters "cubbing" by a stand of corn (10); exercising a pack of foxhounds in sub-zero temperatures (12); a rare antique travelling case fitted with crystal bottles at Winterthur (14); the accoutrements in a prominent horsewoman's house, including family photographs, racing trophies, and the obligatory horse scenes by Sir Alfred Munnings (15); a pastoral landscape south of Chadds Ford (16); and fishing the pristine waters of the Brandywine in downtown Wilmington (18).

This page:

A "naturalistic" pondside setting at Mt. Cuba, Mrs. Lammot du Pont Copeland's private, 240-acre estate and gardens outside of Wilmington, Delaware.

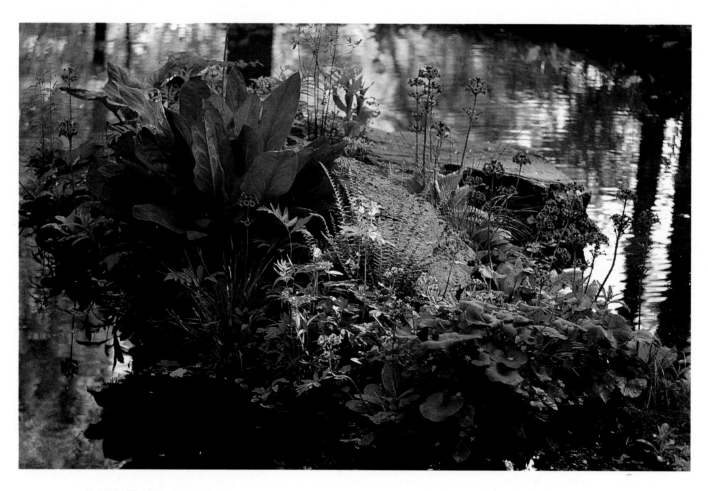

Published by Thomasson-Grant
Copyright © 1995 Thomasson-Grant
Text © 1995 Lisa Zeidner
Photographs © 1995 Anthony Edgeworth
Captions © 1995 J. Spencer Beck
Project Editor: J. Spencer Beck
Designer: Samuel N. Antupit

Printed in Singapore

Any inquiries should be directed to:
Thomasson-Grant, Inc.,
One Morton Drive, Suite 500,
Charlottesville, Virginia 22903-6806 (804) 977-1780

01 00 99 98 97 96 95 5 4 3 2 1

Library of Congress Cataloging-in-Publication Data

Zeidner, Lisa
 Brandywine : a legacy and tradition in du Pont-Wyeth country / text by Lisa Zeidner ; photographs by Anthony Edgeworth.
 p. cm.
 ISBN 1-56566-080-3
 1. Brandywine Creek Region (Pa. and Del.)--Pictorial works. 2. Brandywine Creek Region (Pa. and Del.)-- Description and travel.
 I. Edgeworth, Anthony. II. Title.
F172.B78Z45 1995
975.1'1--dc20 94-43914
 CIP

Contents

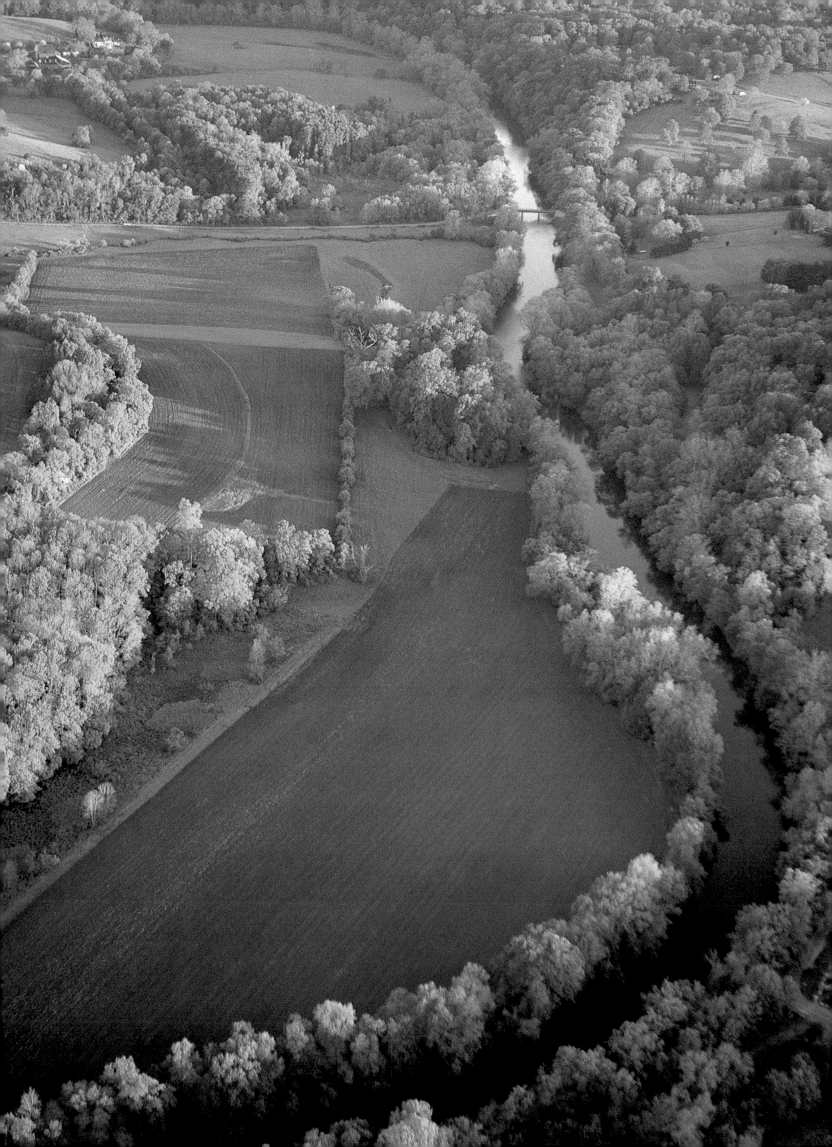

BRANDYWINE VALLEY
The Past and Progress

Depending on whom you ask, the Brandywine River is not even a river. It's a creek. Or *crick*, as they say around these parts. This is no mighty Mississippi, where you can stand on one bank and barely spy a steamboat in the distance. At its widest points, the Brandywine River is a mere hundred feet across.

But the very intimacy of the Brandywine is part of its allure. If you sit on the river's banks in spring, you might get a curious, "new in the neighborhood?" look from a deer sampling sprigs nearby. You can cross a covered bridge while geese swirl beneath you, their tailfeathers glinting crisply against the water. The leaves, too, seem drawn in lusciously sharp relief, as if every dewdrop had been hand-painted by some painstaking miniaturist wearing a jeweler's glass.

Despite the intoxicating beauty of the landscape, the Brandywine has nothing to do with brandy or wine. The river is probably named for Andren Brainwinde, a Dutch settler who claimed two hundred acres of farmland here in 1670. It's not difficult to imagine how thrilled he was to come upon this land and carve his name in a tree to stake out his territory.

He was not the first, nor the last. The Lenni-Lenape Indians had already made a home here; Swedes would follow, and then the British and Welsh and Scottish and Germans, and the Quakers, Mennonites and Amish.

Ignoring state boundaries as rivers are wont to do, two small branches start in southeastern Pennsylvania, meet in Chester County, Pennsylvania, and flow for twenty miles through a valley before emptying into Wilmington, Delaware's Christina River, which in turn empties into the Delaware River. Every inch of the Brandywine River has been lovingly explored.

But it was not the Brandywine's beauty that attracted these early settlers. It was the river's power.

The river's flow made farming possible. Its fast, hard fall — almost three hundred feet from beginning to end — made it ideally suited for the technology of early industry: dams, sluice gates, and gargantuan water wheels. The Brandywine powered grist and lumber mills, and later the gunpowder mills that made the fortune of the du Ponts, the Brandywine River Valley's most dominant family — a family so large and complex, so full of triumphs, intrigues, and narrow escapes, that no lavishly-costumed miniseries could do it justice.

Few landscapes offer this combination of peace and power, delicacy and durability. No doubt the foliage in spring and summer is spectacular, but winter may be the best time to see the Brandywine. In winter the trees don't obscure your view of the vistas, and you can feel the stillness of the place, its sense of rich austerity. Andrew Wyeth, famous for painting the land he knows so well, is particularly drawn to naked trees and the lush white of snow-covered hills. Against the frozen quiet, the river echoes, and you can finally feel its strength.

Most of the industry along the river is gone now, the mills boarded-up and decaying rustically. (Even the manufacturing buildings, made from a native limestone in subtle hues of gold and beige, are so pretty against the river and foliage, an interior designer could have picked the palette.) The water looks pure enough to cup in your hands and drink, thanks to the efforts of a dedicated, well-organized conservation movement. As you watch people fish, canoe or raft here, you'd never guess that this river spent a good

Opposite page:
Flowing from the westernmost environs of Philadelphia south to Wilmington, Delaware, the Brandywine meanders through countryside evocative of the great horse country of Leicestershire, England. Crossing beneath Smith Bridge Road at the Pennsylvania - Delaware border, it skirts by "Granogue," one of the grandest of the du Pont family estates.

couple of decades seriously polluted — so filthy that, according to local legend, you could tell what color dye they were using upriver at the paper factory by whether the water flowed blue, black or red.

The environmental activists here were ahead of their time in trying to preserve the landscape. But then preservation comes naturally to the Brandywine River Valley. This has always been a place that holds fast to what it has, that values tradition: antique furniture, antique cars, gardens to rival those of the French estates that the founding du Ponts left in 1799. Not only the rich here value land conservation. When a thousand acres in Honey Brook, Pennsylvania, went up for sale in 1977, along the west branch of the Brandywine, ten Amish farmers banded together for the purchase.

The region's emphasis on tradition may be summed up best by this oddity: while Californians plaster their Mercedes and Porsches with vanity license plates, the status plate in Delaware is an old, old, old one. The older, the lower the number, the better. The governor's plate number is 1; two- and three-digit numbers are handed down from generation to generation; four-digit plates can be bought on the black market for as much as $100,000. To drive an old car, or at least own an original black-and-white plate, proves that you belong, that you've belonged since the beginning.

The license plates may seem a bit silly, but the stress on tradition is not. People *hold on* here, not only to property but to valued crafts and skills. The Brandywine's citizens value fine work, recognize "good honest labor." Workers and employees are unusually loyal to each other. It's a place where you can still carve out a life devoting yourself to work you love — horses, or horticulture, or sculpture. Cherished skills stay in families for generations.

If the whole of Delaware is a small state, and proud of it — the state's motto, after all, is "Small Wonder" — the pocket of the Brandywine River Valley that concerns us here is even tinier. In the valley, your morning jog might take you past your governor, who will greet you by name. "I know everyone," says Thomas Baldwin, who runs Baldwin's Book Barn as did his father before him. "I go into town to shop at merchants I went to school with. I've travelled around the world, but I always love to come home, to the beauties of my own area. Everyone knows me, what I stand for and don't stand for."

Notes one recent arrival to the Brandywine, whose husband was born here and couldn't stay away, "I socialize with people who have known each other since they were born, whose parents have known each other since *they* were born. It's amazing how the place holds people."

But it's not hard to see why. On top of the region's astonishing natural beauty, the area is, in the words of Brandywine River Museum Publicity Director Lucinda Laird, "big enough to have resources, but small enough not to be overwhelming."

Furthermore, tucked away in this one lush valley is a collection of museums and gardens of world-class scope and quality. Longwood Gardens is discussed in the same breath as London's Kew Gardens; the Winterthur Museum displays the largest collection of American antiques and decorative arts in the world; Hagley is one of only a handful of museums devoted to interpreting industrial history. Along with The Brandywine River Museum, the Delaware Museum of Art, The Historical Society of Delaware, The Delaware Museum of Natural History, Rockwood, and Nemours, these institutions comprise a confederacy nicknamed "The Brandywine Nine," all close enough to each other that you can stay in an historic Colonial inn where George Washington himself might have slept and visit them all. (The Brandywine Battlefield, where Washington lost to the British in 1777, is right down the road.)

That's a lot of history and culture to take in before dinner. For a less weighty break, rest assured that the region is also home to the unrivaled Mushroom Museum in Kennett

Square, Pennsylvania, and to one of the largest collections of perfectly-restored antique horse-drawn carriages in the world, not to mention some of the nation's top-winning horse trainers and jockeys.

At other repositories of great historical treasures like Williamsburg, Virginia, actors stroll around in costume to give you a sense of the period. Such role-playing is called "living history." Area Revolutionary War buffs do reenact the Battle of the Brandywine each June, donning full military regalia to fire authentic muskets. Generally, however, the Brandywine Valley has no need for such play-acting. Here you find *real* living history, because many of the forces who created this region and helped to preserve it are still very much alive. They are having cocktails at the estates, driving the horse-drawn carriages, fertilizing the lavish gardens — joyfully, adamantly carrying forth customs of yore.

Thus on New Year's Day, several hundred du Pont family members continue an old French tradition called New Year's Calling, as they have done since New Year's Day, 1800, when the family first arrived on these shores. The male members of each family will visit ten or fifteen relatives' houses. They start first thing in the morning, bearing small gifts for the women of the households. By the time all of the uncles and aunts and grandchildren are assembled, there could be a hundred festive relatives in a single house, all calling each other Cousin — so many relatives that nametags are essential.

Thus, too, once a month — always on Thursdays, always during the full moon — The Philadelphia Farmers' Club meets for dinner. Since Benjamin Franklin's day in 1786, membership to this most exclusive club has been limited to twelve, and membership is for life. The powers-that-be are no longer solely agrarian, so politicians and artists belong to the exclusive group now as well as farmers, and many still choose to arrive in their carriages.

Another longstanding tradition, which takes place three days a week from November through March, is the fox hunt. The hunters' red coats gleam against the snowy hills as the whipper-in sounds an ancient horn to announce the hunt's commencement. When they are finished, the hunters tip their hats in the twinkling afternoon sun and bid each other "Good Night," just as hunters have done for centuries.

When they leave the hunt, the riders can be heard chatting on horseback or getting into Jeep Cherokees, comparing real estate notes. Delaware's wealth now depends more on credit cards than gunpowder, and McDonald's erects its golden arches here the same as everywhere. But the people who make the Brandywine Valley their home have struck their own balance between the past and progress. Fiercely retaining their history, they refuse to be merely *quaint*.

This book will introduce you to some of these people, their lives and legacies. We have restricted ourselves to the verdant valley, sidestepping the downriver bustle of Wilmington, as well as the many farmers and craftsmen who make their home upriver as their families have for generations. But given the Brandywine's enormous wealth — both in dollars and talent — it's impossible to be comprehensive even about our tiny slice of the river. Instead, we aim to give a sense of the remarkable communion of past and present that makes the Brandywine Valley one of the most dynamic — if unusual — regions in the country.

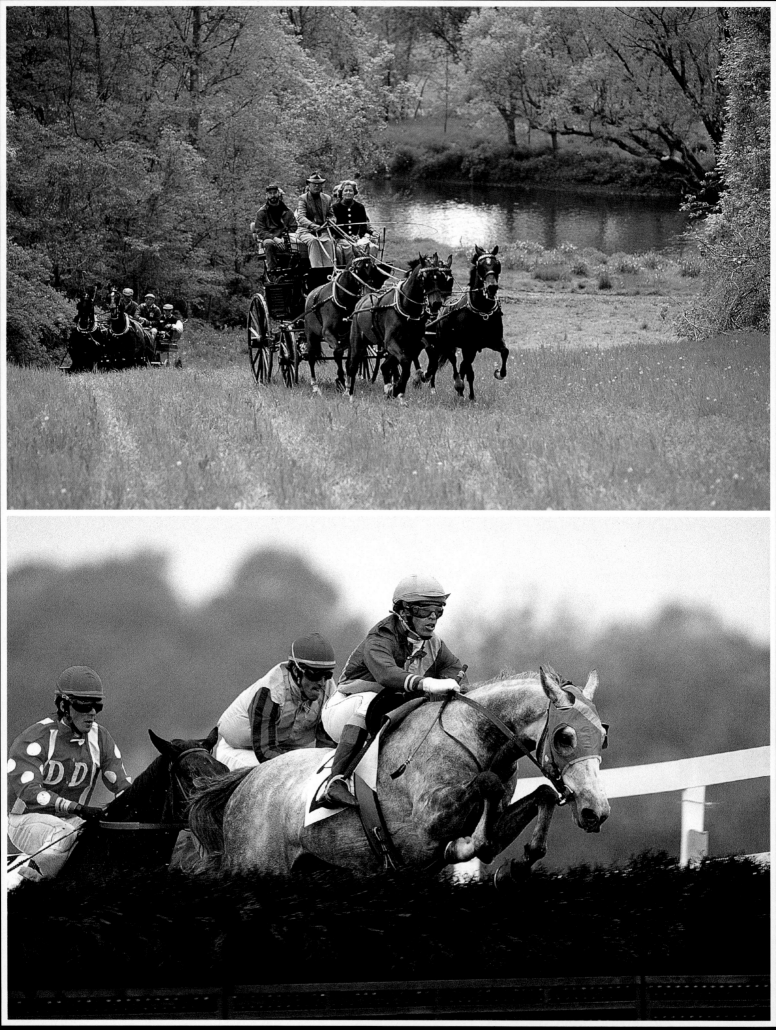

Top: *Traditions (and pockets) run deep in Brandywine Valley horse country. Here, Brandywine Conservancy Chairman George A. "Frolic" Weymouth takes the reins to retrace the now-famous carriage ride around his property that helped convince his friends to found the Conservancy in 1966.* Bottom: *Steeplechase racing has put quiet Unionville, Pennsylvania — "one of the horsiest areas of the country" — on the horse-world map.*

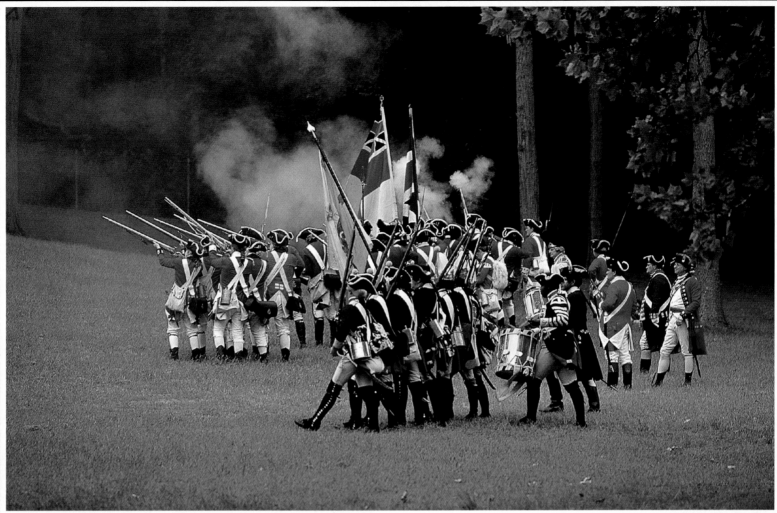

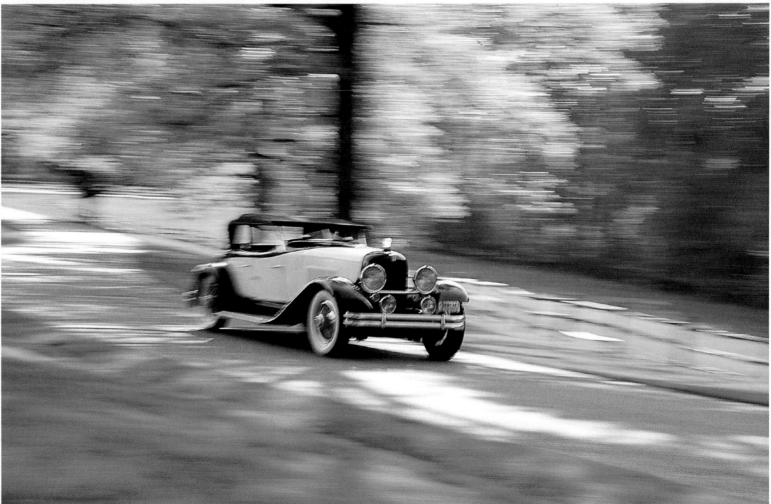

Top: *Twenty-five years before Eleuthère Irénée du Pont settled along the Brandywine in 1802, his fellow countryman the Marquis de Lafayette fought in the famous Battle of the Brandywine, re-enacted each June near Chadds Ford, Pennsylvania. Bottom: Ignoring his family's enormous stake in General Motors, E. Paul du Pont in 1919 produced his own Du Pont roadsters, a rare collection of which is now owned by Richard E. Riegel of Montchanin, Delaware.*

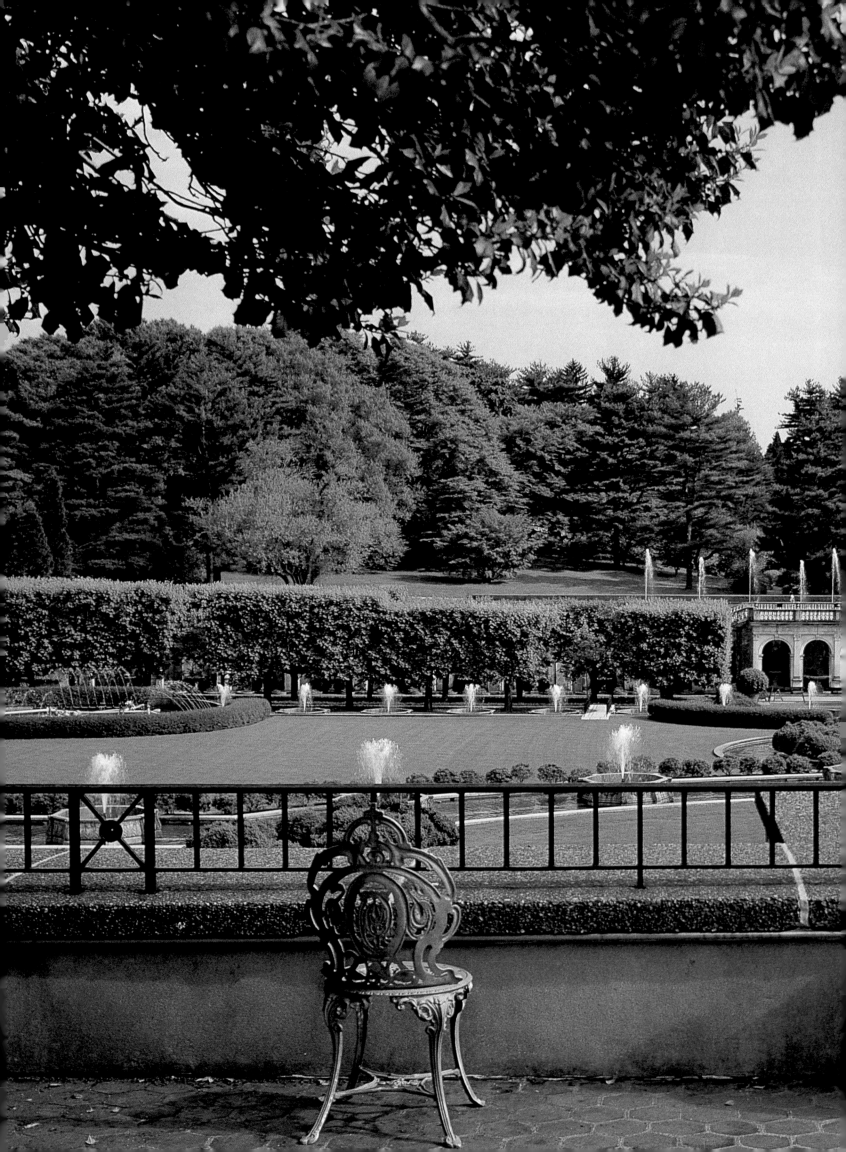

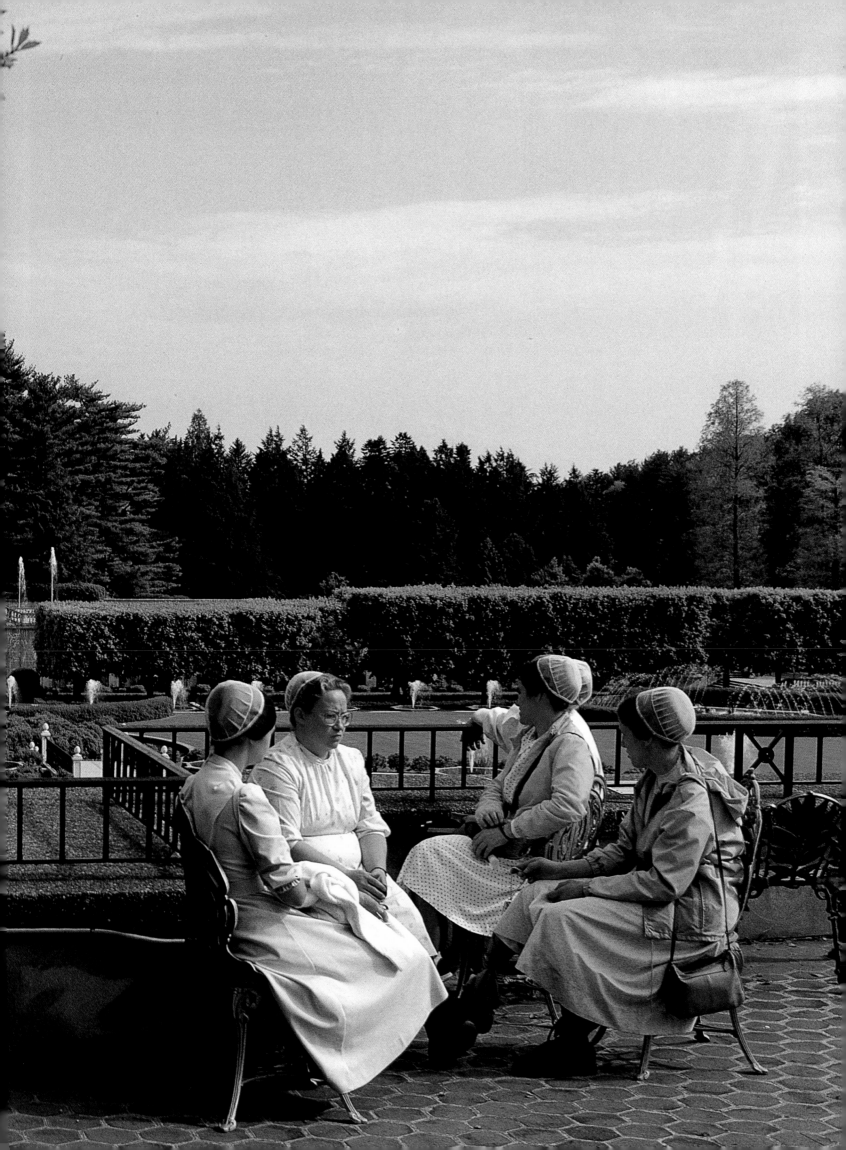

Pages 30-31: *Only the locals, such as these Old Order Mennonite women, seem unimpressed with the world-class splendors of Longwood Gardens, the region's most celebrated attraction.*

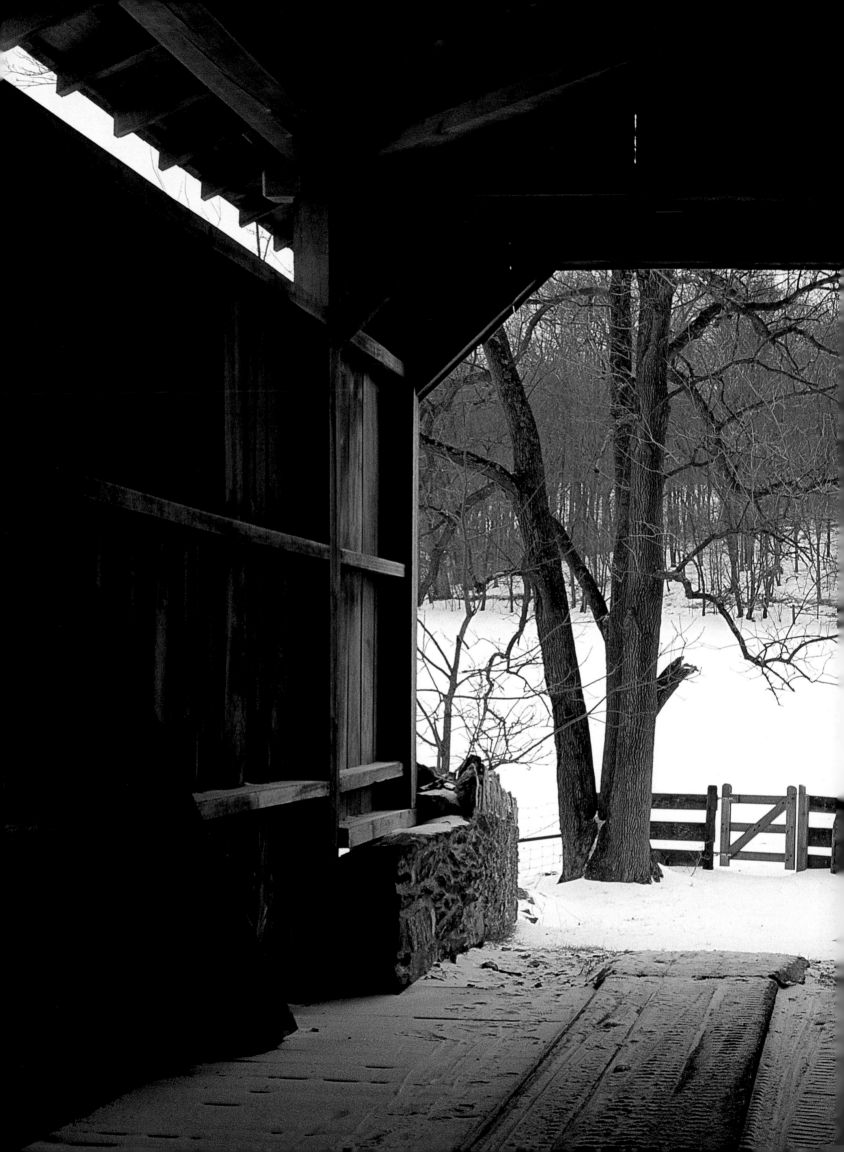

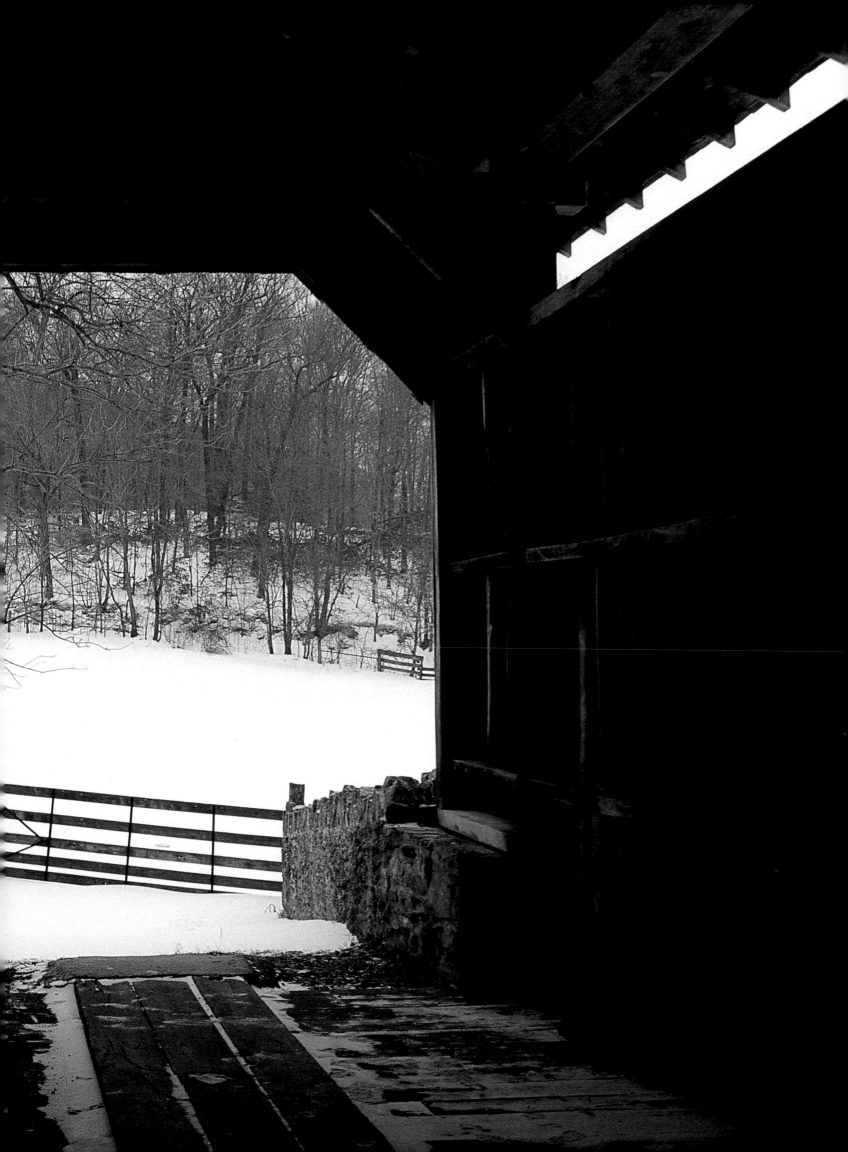

Pages 34-35: *Crossing the Brandywine near its headwaters, this covered bridge will see little traffic in the future. Protected in perpetuity by the Brandywine Conservancy, it sits amid The Laurels, a 771-acre private nature preserve closed to motor vehicles.*

The rustic simplicity of a barn door near Chadds Ford epitomizes the region's unspoiled charm.

The view from one of two covered bridges in The Laurels encompasses a frozen wintertime landscape near Unionville, Pennsylvania.

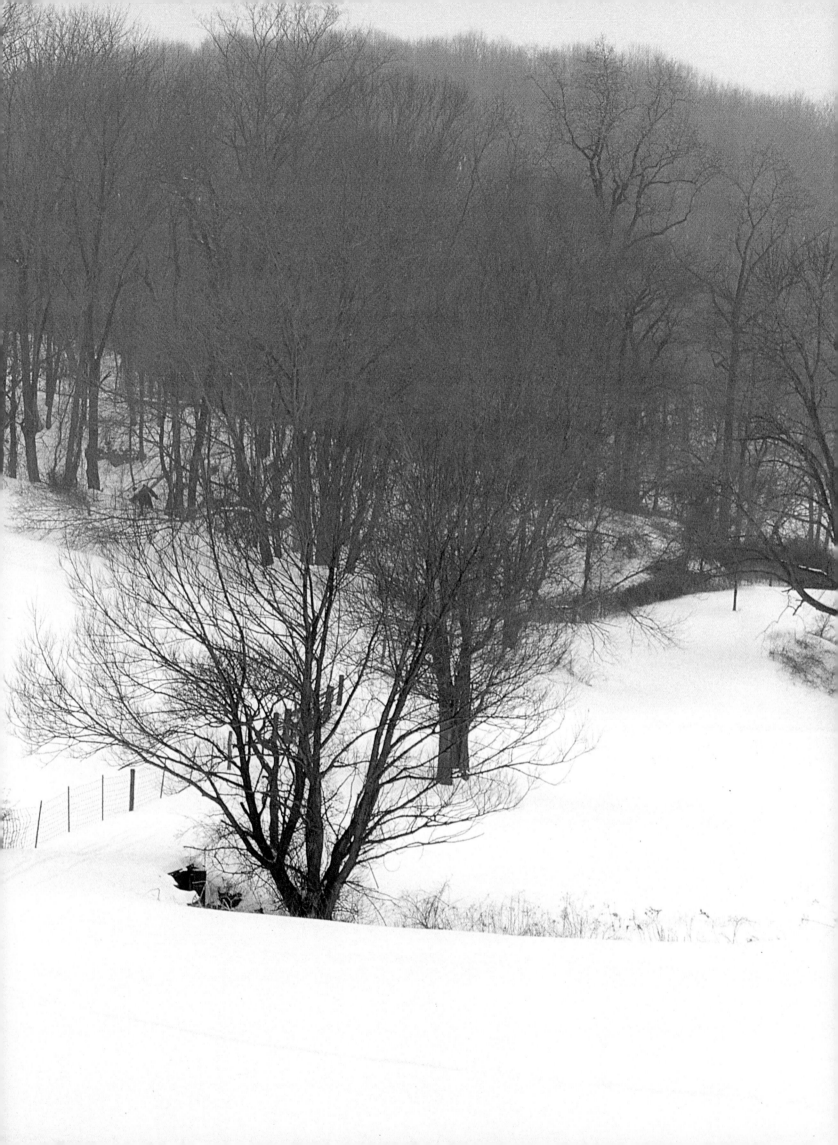

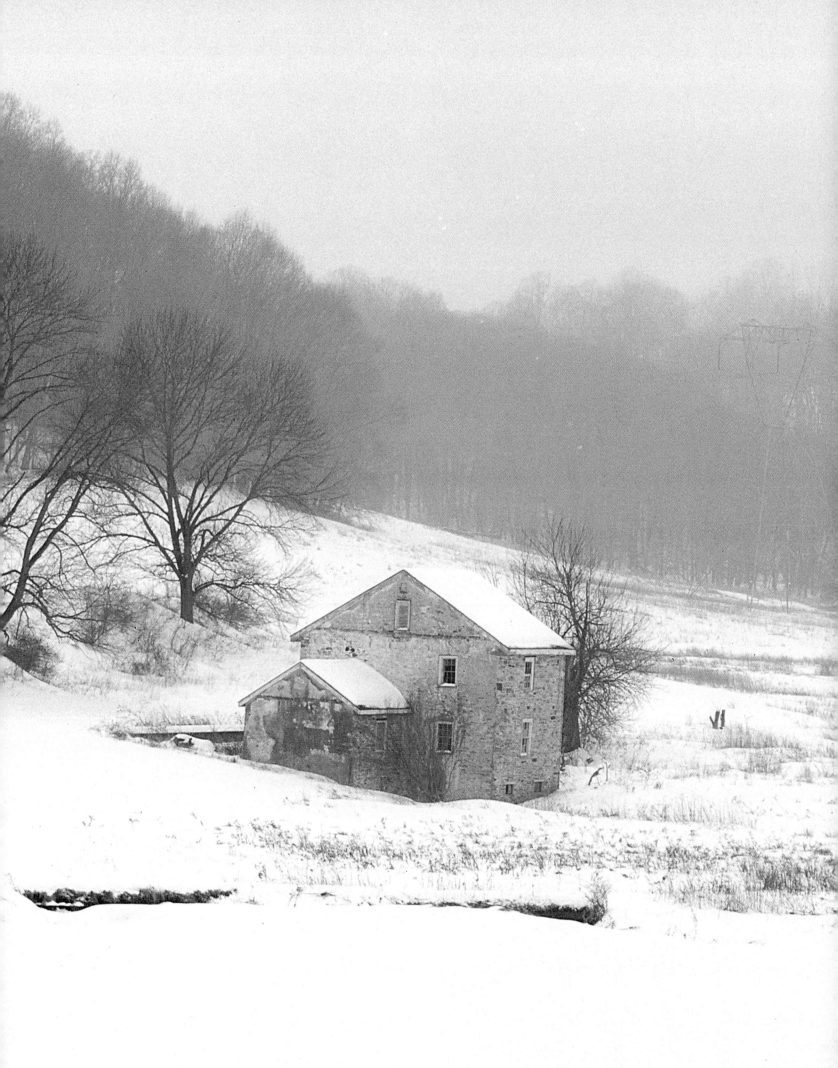

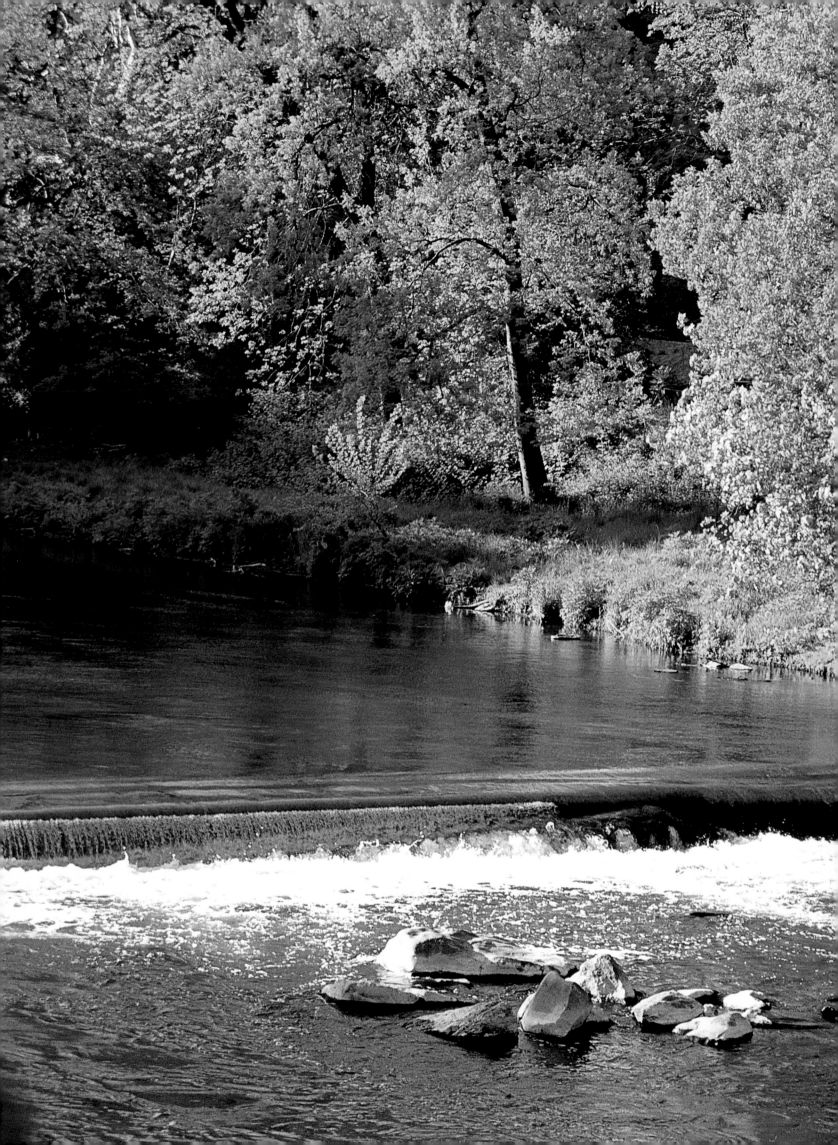

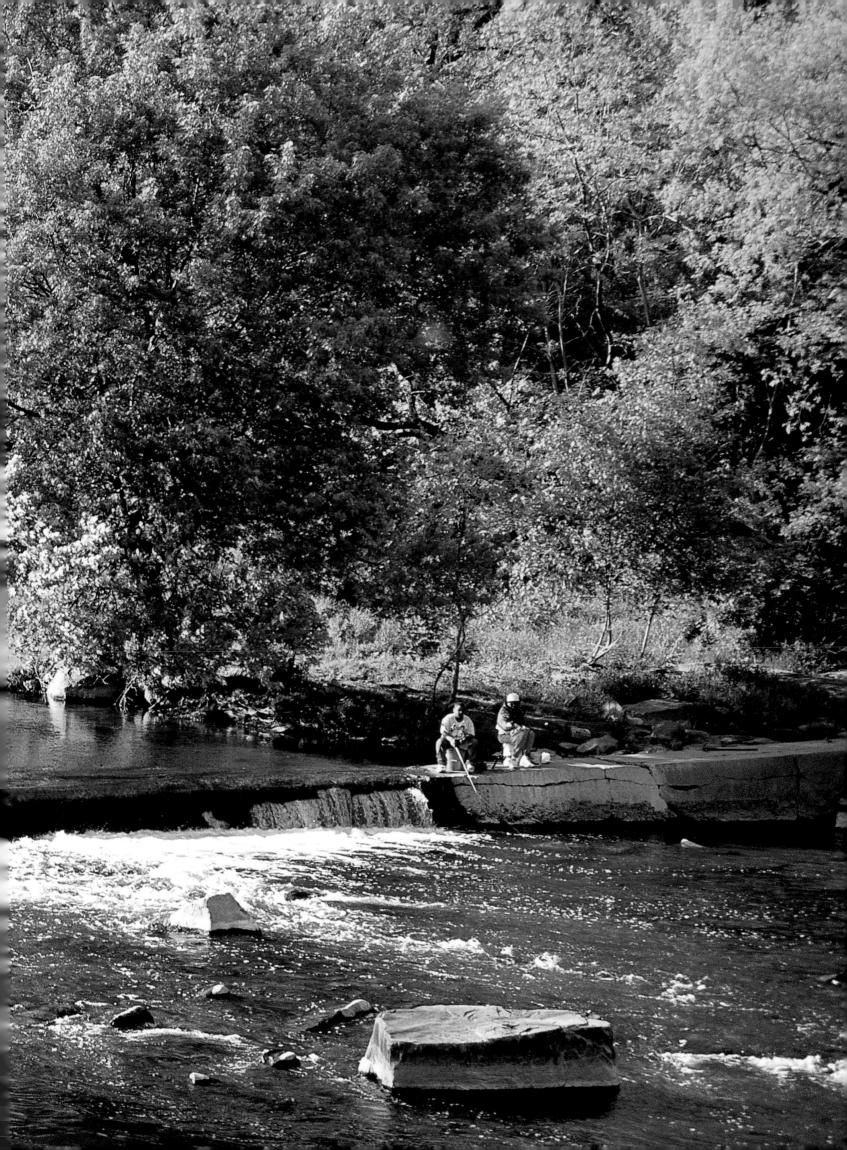

Above and opposite page: *Its main doors may be of a more recent vintage, but this typical*

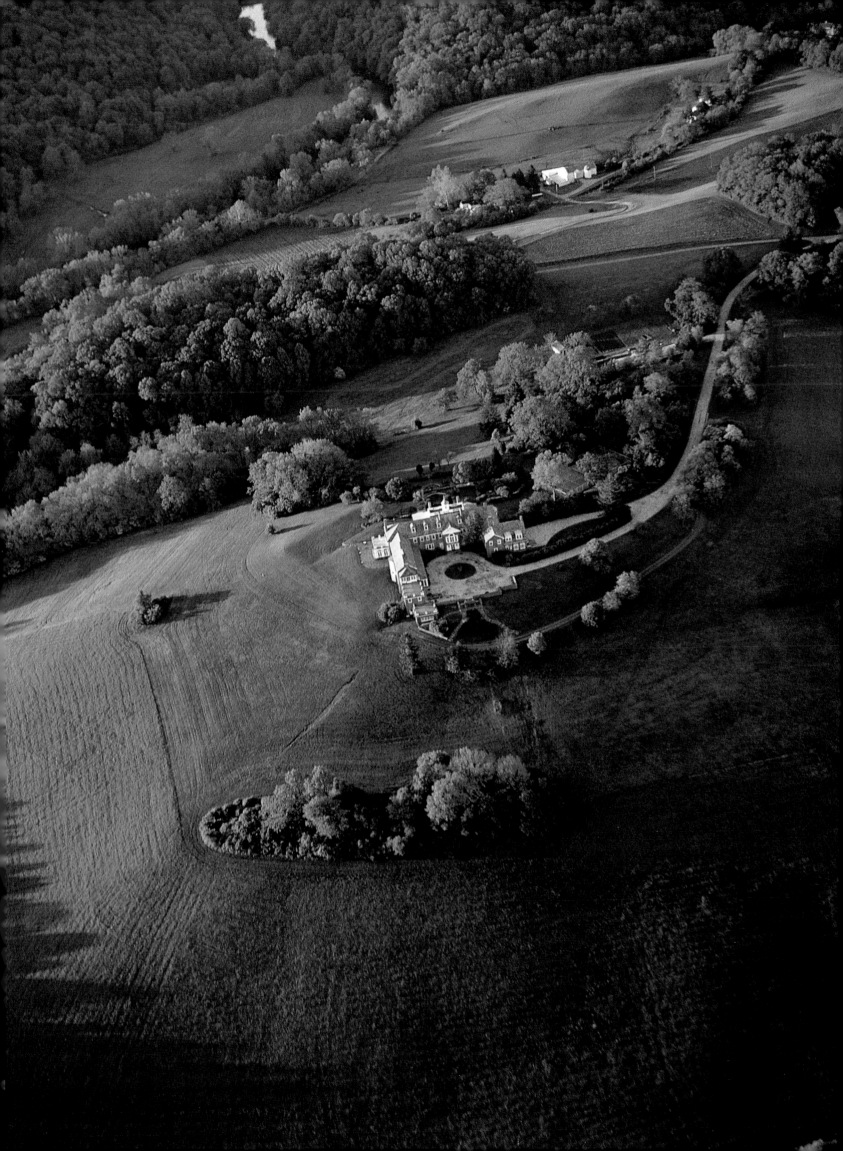

DELAWARE DYNASTY
A Land Flowing With Milk and Honey

In 1654, an engineer named Peter Lindestrom visited New Sweden on the Delaware River, and wrote home to gush about the fish, the trees, the richness of the soil. "It is such fertile country," he said, "that the pen is too weak to describe, praise and extol it; on account of its fertility it may well be called a land flowing with milk and honey."

But the early colonists did not come all this way to farm. Henry Hudson was the first European to enter the Delaware Bay. On the same trip, in 1609, this British captain of a Dutch ship also "discovered" the Hudson River. Neither river, alas, led to China as he had hoped. But the trip did reveal abundant sources for fur. By 1610, the Dutch West India Company was in full swing along what they called "The South River" (the Hudson was "The North River").

Early relations between the Dutch colonists and the Lenni-Lenape Indians were cordial. The Indians were quite happy to serve as trappers in exchange for pots, guns, and liquor. The Indians' lives on the Delaware and Brandywine were relatively easy; beavers were so abundant that even the smallest streams were dammed.

As a result of this collaboration, the beaver — so plentiful and easy to trap — were depleted, which not only changed the river's ecology, but robbed the Lenni-Lenape Indians of their livelihood as the Dutch West India Company moved farther west to acquire its pelts. Thus trade and agriculture saw their first of many collisions here as elsewhere in the expanding nation. As students of history now know, American Indians did not feel that they owned the land, which is why they surrendered their claim to it so easily. The vastly different European and native philosophies of land ownership might best be summed up by this simple contrast: Very roughly translated, Lenni-Lenape means "Common People." The state of Delaware, on the other hand, is named for an aristocratic early governor of Virginia, Sir Thomas West, Lord De La Warr.

The New Sweden Company got into the trading act in 1638, when the first Swedish colonists arrived. For much of the seventeen years of New Sweden's existence on the Delaware, the colonists were a straggling lot, undermanned and in need of supplies. Johann Printz, appointed as Governor of New Sweden in 1648, wrote back to assure the Swedish government about the colony's wealth of possibilities. "The country is very well suited for all sorts of cultivation; also for whale fishery and wine, if some one was here who understood the business. Mines of silver and gold may possibly be discovered, but nobody here has any knowledge about such things."

Despite Printz's enthusiasm, the backers lost interest in supporting the project. From 1648 to 1654 not one ship came from Sweden with reinforcements or supplies. The remaining colonists felt themselves squeezed not only by limited resources, but by competition from the better-supported Dutch settlers.

Although they hadn't come to farm, the Swedes proved themselves well-matched to the landscape. For starters, they were used to the cold. They were also much more accustomed to building with wood than the English who followed. Since farming was the main activity in Delaware in the eighteenth century, the Swedes prospered. Then again, the English had the technology for the evolving grain and textile mills that would be so important to the area's prosperity in the late eighteenth and early nineteenth centuries.

Anyone who assumes such mills weren't welcome can look at pictures of how flour was milled *before* the Industrial Revolution. The new technology freed people from

Opposite page:
The feudal grandeur of "Granogue," the last of the great du Pont estates still privately owned, is a fitting testimony to that family's 200-year hegemony in the Brandywine region. The home of Irénée du Pont, Jr., the rambling fieldstone manor house was built by the current owner's father in 1923.

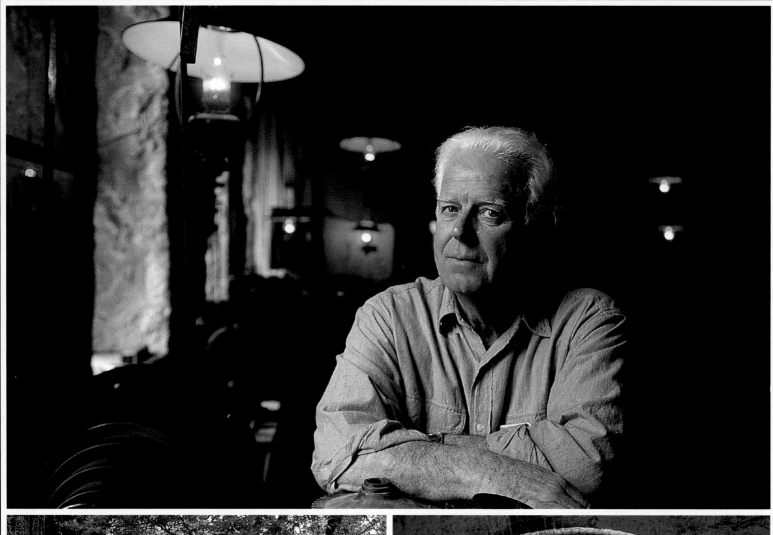

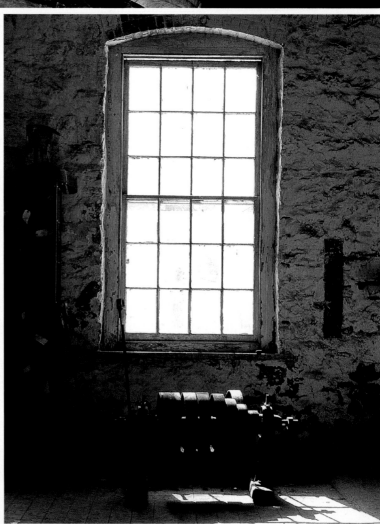

some of the more punishing, backbreaking aspects of manual labor, and also opened new opportunities: ships delivering flour could return with sugar, spices, and other non-native goods.

By the time the du Ponts arrived in 1800, the Brandywine River was home to a thriving, vibrant array of industries — mills for paper, cotton, and flour — as well as an ethnic and religious mix that could be matched only by Pennsylvania to the north.

Eleuthère Irénée ("E. I.") du Pont had not planned to add another mill to the roster. On his passport, the political refugee listed his occupation as *"botaniste."* He hadn't even planned to settle here — it was Bergen County, New Jersey, where he first landed, with plans to buy land on the Potomac. The du Pont family knew Thomas Jefferson, and had high hopes for land ownership. But only naturalized citizens could buy land, and the land was already too expensive in the areas they'd pinpointed. So with the help of a French friend, E. I., who had studied chemistry under the legendary Antoine Lavoisier before emigrating, walked the valley to find the river power needed for industry. He bought 65 acres on the Brandywine, and a burned-out cotton mill, with the idea of bringing superior French gunpowder manufacturing techniques to this country.

The land cost $6,740. As we all now know, the investment paid off handsomely.

When people in Delaware talk about "The Family," or "The Company," there's no question whom they mean. No discussion of the region can begin without a consideration of the dominant clan whose name appears on schools, hospitals, and roads all over the state, and whose history, from the Industrial Revolution through today, so closely mirrors the nation's changes.

And there's no better place to begin that discussion than at the Hagley Museum, home of the first du Pont gunpowder mill.

From Gunpowder to General Motors: *"Requiring Work for a Living"*

*F*ew families have seen their fates as well-documented as the du Ponts'. Since their arrival, family historians have kept everything: diaries, sketches of flowers, account ledgers, grocery and gardening receipts and, of course, bundles and bundles of letters. Long before car phones and fax machines, members of this close-knit tribe wrote to each other daily. They discussed politics and business, exchanged gossip, and inquired about each others' health. Their letters are now housed in The Hagley Library, one of the largest international depositories for records of industrial and social history.

At Hagley Museum, incorporated in 1951 with 230 acres of land donated by the Du Pont Company and du Pont heirs, visitors can inspect the original gunpowder mills, the estate of founder Eleuthère Irénée du Pont, and the houses on Blacksmith Hill, where the mill workers lived. In the Machine Shop, still redolent of oil and leather, the old lathes and drills are operable and manned by volunteers — some of whom are descendants of the original powder-mill workers.

As you walk around Hagley now, the river rustles. The place feels peaceful, shady, and inviting. So you need to strain to imagine how noisy and filthy the site would have been in its heyday. Making gunpowder meant soot from charcoal, the stench of sulfur, and the relentless pounding of waterwheels. On top of gunpowder manufacturing, many other activities on the site abounded, none of them squeaky-clean or whisper-quiet. The buildings were made from native stone, quarried on the property. The kegs to ship the powder were made in the cooper shop. Even the clothes were made from imported Merino sheep raised on the surrounding hills.

Opposite page:
Incorporating 230 acres along the banks of the Brandywine outside of Wilmington, the Hagley Museum features the du Ponts' first black-powder works (below left), the foundation upon which a chemical empire was built. Inside the restored Machine Shop, volunteers still man centuries-old lathes and drills (top), while unused rooms house a veritable treasure trove of the state-of-the-art mechanisms of Early Industry (below right).

The du Ponts themselves lived on the top of the largest hill, their home relatively modest by contemporary standards if palatial compared to the workers' tiny dwellings. "Eleutherian Mills," the family home, was literally shouting distance from the action — Irénée could address the workers with a trumpet from his back porch. The family was so accustomed to living right in the thick of things that when one of the du Pont daughters visited Charleston, she complained it was too quiet to sleep.

In their day, the workers were called "Powder Monkeys." It was considered a gesture of good faith for E. I. du Pont himself to live and labor on the grounds, his own family sharing the same dangers as his crew, many of whom had fled the Irish famine of the mid-nineteenth century. Two hundred fifty-one men, including the du Pont family members working alongside them, died at the mills in 120 years of operation — 60 percent of them in ten horrific explosions. Given the danger inherent in the workplace, this was actually an excellent safety record, borne of vigilance. Shovels were wooden rather than metal. Men could wear no metal buttons or buckles, and carrying matches was grounds for dismissal. In part because of the renowned risk of the site (and in part because of the du Ponts' own ethics), wages and benefits were good: high pay all year round rather than seasonally as in many other industries, school for the workers' children on Sundays, free housing, pensions for widows whose husbands died in the explosions, and free medical care.

Sadly, "medical care" could sometimes mean the du Ponts' personal physician cutting off a boy's finger on a porch, without ether, after an accident. The workers' lives may seem to have been brutal from a contemporary perspective — but that perspective can be misleading. "It was a great life compared to what they left," reminds Joseph Toomey, whose great-grandfathers on both sides were recruited from County Cork, Ireland, to work at the mills, and whose grandfathers on both sides worked there as well; one grandfather died in an explosion in 1915.

Toomey is a parishioner at St. Joseph's on the Brandywine, the Roman Catholic church built by the workers with materials supplied by the du Ponts. The church just celebrated its 150th birthday with a year of special events for its 800 parishioners, many of whom travel good distances to worship at their forefathers' church. Tooney helps people trace genealogies with the church's very old, very complete records of baptisms, marriages and burials. "The Irish don't talk too much," he admits, "so it's not too easy to get information on families." But he says that the descendants of those original workers feel a great deal of pride in their ancestors.

Hagley is a fascinating reminder of how difficult it is to view history objectively. Our politics are our lenses, coloring our interpretations of the past. Unsurprisingly, since Hagley sits on du Pont land, the official view of the industry's growth is fairly rose-colored. The guides like to point out, for instance, that the uses of gunpowder were not solely military; gunpowder was used for the more benign purposes of mining and building canals and roads to the West. But there's no denying that the du Ponts provided 50 percent of the gunpowder for the North during the Civil War. A less sympathetic treatment — like Gerard Colby Zilg's book *Du Pont: Behind the Nylon Curtain*, which accuses the du Ponts of "one of the most determined and ruthless campaigns of empire-building ever recorded" — takes a much harsher view of the du Ponts' involvement with casualties of the country's bloodiest war.

One of Hagley's strengths is that it allows visitors to grasp early industry in all of its complexity. Like other early industries, The Du Pont Company was run as a total "company town," with the family providing education, housing, and food for its workers. It is important to imagine what such paternalism meant at the time, rather than transposing it to a modern setting. Sure, the company controlled the workers' salaries and paid their bills. But then E. I. du Pont himself channelled most of his profits back into the

company. For those who worked here in the early 1800's, it was neither a pastoral paradise, nor a laborer's hell.

"People tend to make two mistakes when they think about the past," says Glenn Porter, an economic historian and the Hagley's director. "They tend to either romanticize the past — make it a simpler, easier, more appealing time than the present — or they concentrate on the technological differences, and make the past seem dour and difficult. The effect of either set of assumptions is to distance people from the past. And that's misleading, because people then had the same kinds of aspirations and fears as we do."

Amid the impressively tall, humidity-controlled shelving of the Hagley Library, scholars from Japan, Italy, Sweden, France and elsewhere comb the records for the truth of the workers' lives. For social historians, truth is in the details: what people ate, how much they earned, how they spent their money and their leisure time. Scholars in women's studies pay particular attention to the du Pont wives' diaries and letters. Notes Marjorie McNinch, a reference archivist in the Manuscript Department, many people come simply to seek information about their families. And the records here are as complete for the workers as they are for the du Ponts themselves.

"We have everything," McNinch says. "We have census reports and newspapers. We have the Du Pont Company's letter books documenting employees' comings and goings, ship passenger lists from 1820-1870, and the complete archives of the Brandywine Manufacturers' Sunday School — not only who attended classes there, but what their grades were."

At Hagley, rather than applaud or pity early industry, we learn to see it as an evolution, with both successes and failures. The difference between success and failure was often a fluke, a matter of timing. E. Paul du Pont's effort to manufacture luxury cars didn't work out — he was hoping to sell his cars for $4,000, at the very moment that Henry Ford began to churn out Model T's for $250 each. But other ventures, most obviously the du Ponts' later interest in General Motors, proved prescient.

In the office, built in 1837 and used for fifty years, we can see how this gargantuan company dealt with its orders before computers, toll-free numbers, and data bases. Orders were sorted by state, in wooden cubbyholes, then hauled out in Conestoga wagons. And we can see a primitive ancestor of the Xerox Machine, a big iron behemoth that, with a certain kind of ink, could produce one copy. We might laugh now, but it was a lot more expedient than using a quill pen. For one moment, it was state-of-the-art — like gunpowder itself.

The gunpowder mills were closed in 1921. By then, the Du Pont Company had diversified by purchasing into other industries, most notably textiles. Du Pont chemists invented the first synthetic fiber, Nylon; textiles are now the company's biggest business. At one point, the Du Pont Company was the major stockholder in General Motors, but was forced to divest after being embroiled in close to half a century of anti-trust suits by the Department of Justice.

Despite all the controversy, the family members who led the company felt pride in the ancestors who established the mill. As Pierre S. du Pont wrote to a nephew in 1922, extolling founder E. I. and the men who followed him:

"It is not an exaggeration to say that nearly all were in a position 'requiring work for a living.' This condition had its problems, its advantages and its disadvantages. The sum total of the effort has been successful financially and at the same time with due regard for the duties owed society in general. The du Pont family is entitled to a just pride in their name."

The du Ponts and the Company Today

*I*rénée du Pont, Jr. — or "Brip," as the family calls him — retired in 1978. He still keeps an office in the Du Pont Building in downtown Wilmington, a small room on the second floor with furniture dating from the '50s.

Home for Irénée Jr. is Granogue, the mansion that his father, nicknamed "Buss," built in 1923. He has been cautious about showing the estate, or allowing it to be photographed, since the turbulent early '70s, when anti-war activists threatened his family. But at the office, where this businessman in a plain dark suit still wears a Du Pont Company badge on a chain around his neck, he is direct and engaging. He speaks quietly about how he worked himself up through the ranks of the company as an employee.

"My first assignment with the company was to improve the simple process of winding fish reels on little spools," he recalls. "We did it on a crude winding machine. It was still strictly a mechanical problem. But golly, they built a new plant a couple of years later." For seven years he held supervisory jobs at plants in New Jersey and West Virginia before moving back to the "home office" in Wilmington.

"Obviously, I didn't have to work," he admits. "I could have had plenty of autos and sailboats without going to work. I think my brother-in-law Ernie May said it best — that people would hear the Brandywine gurgle and realize that somebody had to look after things. I was the only one who stayed on. I went on into management when I realized I wasn't entitled to more than two weeks of vacation a year."

Fewer and fewer family members have heeded that call to duty over the years. Irénée du Pont, Jr., is one of the last members of the du Pont family to work himself up through the company.

Irénée Jr.'s name — as well as his nickname — reveal a great deal of the family's vastness and closeness. He and his seven sisters are children of Irénée and Irene, distant cousins who are descendants of the original Eleuthère Irénée. Especially in the family's early days in isolated Delaware, marriages between cousins were not only permitted, but encouraged. As Pierre Samuel du Pont de Nemours — father of the founding Irénée — once wrote, "The marriages that I should prefer for our colony would be between cousins. In that way, we should be sure of honesty of soul and purity of blood."

Later, of course, such marriages were frowned upon, producing legends about unrequited loves between first cousins. But the repetition of the family names continued. The family tree is covered with Colemans and Lammots and Alfreds, each descendant proudly representing a long-standing lineage. Laughs Irénée Jr., "[Uncle] Pierre used to joke that most people give names to identify people, but the du Ponts give their names to confuse." Not surprisingly, there are many nicknames as an antidote. "In some of the old letters, it's pretty hard to know who they're talking about — they loved to call each other 'Pigface' and so forth." Brip himself can still remember when his nickname was promoted to Brother, and since his mother didn't want him to be called Brud, "Brip" was invented.

That contrast — between grand given names and simple nicknames — sums up one of the paradoxes of the du Ponts. They have amassed astounding collections of antiques (Henry at Winterthur) and cultivated some of the largest private gardens in the world (Pierre at Longwood), as well as run a company of enormous size and complexity for generations. But there is an emphasis on retaining the involved family feeling of the original settlers.

By 1993 figures, the Du Pont Company now has revenues of $37.1 billion and a net income of $566 million. With 90 worldwide laboratories and 114,000 employees, 34 percent of them outside of the United States, the company has metamorphosed into a

goliath quite unlike the original company, where any salesman buying Du Pont gunpowder would spend the night and socialize with the owners.

Not until the twelfth Chairman of the Board did a non-family member hold that position, when Walter Carpenter took over the post in 1940 (his brother, however, was married to a du Pont). The next non-family member was Irving Shapiro, in 1974. Not only was Shapiro not a du Pont, even by marriage, but he was a Jewish Democrat whose Lithuanian father ran a dry-cleaning shop in Minneapolis. Yet everyone agreed he was a superb manager — and there was simply no one in the family who could do the job as well, no one who knew the business as intimately.

Today, the du Ponts no longer control the Du Pont Company. In fact, the family owns less than 10 percent of the stock, with the lion's share — 25 percent — belonging to the Bronfman family, owners of the Canadian firm Seagram's. There are three du Pont family members on the board at present, and three Bronfman family members. It is fitting that the Du Pont Company, a family operation for so long, would wind up largely in the hands of another family operation, albeit one with a very different style and history.

To modern eyes, the whole idea of a "family business" ruling a region may seem dangerous and conspiratorial, straight out of *Citizen Kane*. But, in fact, many people here discuss the demise of du Pont power ruefully, in much the same terms that some mourn the passing of the old Bell Telephone monopoly. For example, while the family owned the local newspaper, *The News Journal*, until the mid-seventies, "you really could do just about anything you wanted to do," one reporter recalls, "say whatever you needed to say. A lot of old-timers will tell you it was a hell of a lot better then than it is now," referring to the current owner, one of the large, bottom-line-driven conglomerates that now dominates the newspaper business.

"If you think about it," another Wilmingtonian reminds, "Henry Francis du Pont and the Bancrofts [the other great Brandywine mill family] saved the Valley. If it weren't for them protecting all this land, preserving all this history, this place would look like New Jersey."

AVERELL DU PONT: *"Hardworking Fun"*

*B*efore Averell Ross of the Main Line of Philadelphia married Edmond du Pont in 1932, she scoffed at Wilmington. "Wilmington was just somewhere you passed on the train." But she has lived in the area with great pleasure ever since, remaining fascinated not only with the geography of her adopted home but with her adopted family. She found herself delighted to be immersed in the complex history and enmeshed relationships of the du Pont clan, serving as the Executive Secretary of the du Pont Genealogical Committee from 1975 to 1990.

Gracious and lively, with an amazing memory for dates and facts, she has witnessed many changes in the area. Her memories always circle back to the region's most dominant feature: the Brandywine River itself.

"In my day," she recalls, "the river was used so happily. There were canoe picnics and engagement parties — the river bound people together quite a lot. You can imagine how much fun the boys had growing up when it was so unspoiled. My husband was in that river as much as he was out of it. He'd fish there naked — there were no people to see. They'd take an old-fashioned fire screen to collect the fish."

Nature had its darker side, too. In the '30s and '40s, she says, "the mud on the river was terrible. The Coatsville plants used to dump everything in there." She also remembers the terrible floods in the early '40s, before her husband — who helped found the

Although not born into the Brandywine Valley's most fabled clan, Averell Ross du Pont knows more about du Pont history than most of those that were. Married for over 60 years to Edmond du Pont, she served as Executive Secretary of the du Pont Genealogical Committee from 1975 to 1990 and describes her years spent amidst her adopted family as "just like living in a novel."

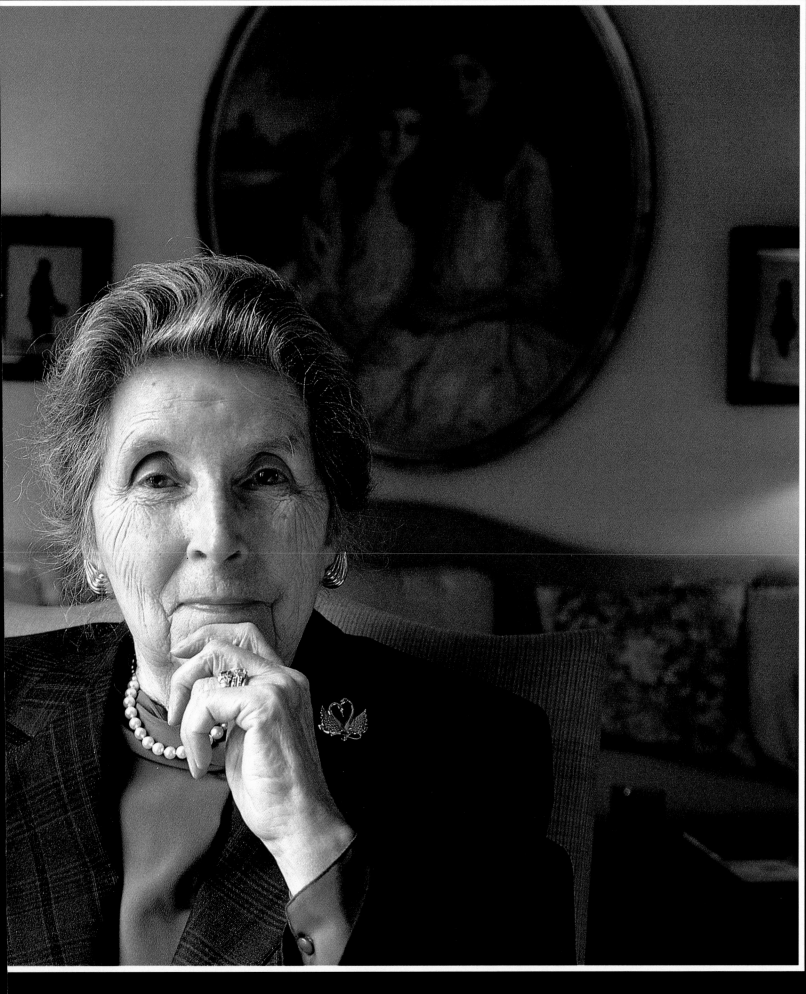

AVERELL DU PONT

Brandywine Valley Association — worked to introduce strip plowing and dams to the river. "We canoed in one flood, foolishly. I'll never forget the snakes rushing by in the water, and the skunks floating past us with their babies on their backs — the snakes and skunks just tangled together on this mass of leaves and twigs, not fighting, just trying to survive — and later, the bodies of horses and cows."

What she most admires about the early du Ponts was their elegant simplicity. "They were very cultivated people. The sisters sewed all the time, the most wonderful things — also layettes for the powder workers' babies. At night they read aloud in French and English. They even read Gibbons's *The Decline and Fall of the Roman Empire*. It took them two years, but they did it. It was hardworking fun."

What many people fail to recognize about the du Ponts, she believes, is that "despite all the money that has come in since, the original du Ponts were very modest people." When she was first engaged to her husband, "Cousin Victorine was still alive, all dressed in black. She lived just like ladies used to live, in a Victorian house with palm trees and the blinds drawn. She made the communion bread each week for Christ Church. There was nothing grand about it. On New Year's Day [during New Year's Calling], you talked to Cousin Victorine through an earphone."

She remembers, too, the lavish garden parties at Longwood in June in the early '30s, dancing in the ballroom with all of the fountains glinting out the windows, and the parties on Alfred du Pont's yacht. "After dinner, Alfred would take everyone down to the engine room. He was so proud of it. There the ladies would be in long, white organza dresses. But the floors of that engine room were so clean, their gowns wouldn't even get dirty."

Such parties were lavish, but that style of entertaining, Averell reminds, was hardly limited to the du Ponts at the time, and reports often falsely inflate the fanciness. Surely Irénée's mansion, Granogue, was immense, but "that was a home for ten children — they lost two, which was eight — and an absolute center for foreign cousins, who would come and stay; and remember," she laughs, "with all of those *girl* children, there were almost always coming-out parties and engagement parties and suitors."

For the Genealogy Committee, Averell du Pont was responsible for keeping accurate records about past du Ponts as well as over 2,000 living family members. That Committee also found and preserved many of the du Pont family letters now housed in the Hagley Library. "You just didn't get around very much," she says. "They wrote to each other daily even though they lived across the crick. They were always talking about their health — 'How is your back today?'" One batch of letters wound up being rescued from a storehouse near the docks.

Lest the concern with family trees seem like nostalgic ancient history, Averell's experience has been that it is the *youngest* members of the family most set on honoring its history and traditions. "Some young man called me up from Arizona to say 'It's come! The baby's come!' He wanted to make sure I got it in the records right away."

Another family committee maintains records about the du Pont cemetery, and she has been involved with that work as well. "People might think it's snooty, but it's not. It's just what you did then, take people into the field and plant them. Once the fence broke, and all the family members chipped in and put up a stone fence. When the cemetery got too small, Cousin Louise left the land to enlarge it. Now it's enough for quite a long time."

Averell and Edmond du Pont live in a retirement community near Longwood Gardens, where a 1916 portrait of Averell and her sister, Mary Ross Brown, dominates their small, sunny living room. She still has a hand in the Genealogy Committee — "They call me because there are always little details I can help with." With two sons, eight grandchildren, and, she jokes, "seven and two-thirds great-grandchildren," she is still deeply involved in family, both her own and that of the larger du Pont circle.

"It's a very strong-gened family," she muses. "If you look at the early portraits, they all look like each other — my sons are so du Pontish-looking, you wouldn't know I had anything to do with them.

"It has been just like living in a novel," she continues. "You get to see some of the forces that shape people through the generations, and what they make of those influences. I feel very grateful, and very lucky."

GEORGE A. WEYMOUTH: *"Use It or Lose It"*

It's hard to imagine how many times in his life George A. "Frolic" Weymouth must have been asked to explain his nickname. For the record, Frolic was the name of a cherished family dog who died shortly before the arrival of Deo du Pont Weymouth's second baby boy. An odd namesake — but artist, carriage driver, socialite, and Brandywine Conservancy Chairman Frolic Weymouth bears the name gracefully. In fact, given his flamboyance and insouciant humor, it even suits him.

Weymouth loves the Brandywine. In some senses, he is the region's most vibrant spokesperson, and certainly the most outspoken, visible member of the du Pont family — a group known for fierce reticence. While many du Ponts refuse to be photographed themselves, or speak to reporters, Weymouth flings open his doors.

"I've only lived in two houses in my whole life," he explains, "and wouldn't even consider living anywhere else." One of his well-known paintings, *The Way Back*, shows him holding a horse's reins as he steers a carriage toward his simple house framed by bare winter trees. As well as painting the land he knows so intimately with a crisp and affectionate realism, he has dedicated himself to its protection.

Where else but the Brandywine could he drive one of his sixteen carriages every day, as he has for thirty-five years? "Use It or Lose It" is his motto about everything — carriages, cars, china, even rare furniture. Guests are encouraged to flop down in his museum-quality Windsor chairs; one of his four dogs might be seen sniffing around what he likes to call his "Bad Taste Room." He figures that he has put in over 35,000 miles on his "everyday" carriage.

In the now-famous carriage ride that began the Conservancy in 1966, Weymouth, concerned about plans to convert some farmland into an oil facility, took six friends with deep pocketbooks out for a picnic. "You *feel* the land that way," he says. "In a carriage, when you go into a valley, you feel the warmth, and the rush of cool air when you come back up. You can't give people the same feeling in a Jeep. You can't smell the land — the mud, the honeysuckle, the horse manure."

After the picnic, the friends wrote checks, and the Conservancy was born, with plans to convert the mill on the property in question into The Brandywine Museum. The rest of the needed funds came quickly, largely due to Weymouth's social abilities to charm a large group of friends and acquaintances — a circle that includes Michael Jackson, Luciano Pavarotti, Walter Annenberg, and Nancy Reagan.

On the day before the Winterthur Museum's annual Point-to-Point races, as many as fifty of those friends meet at his house with their own carriages (some of which he gave to them, so they could take part in this ritual) and retrace the original picnic ride to Point Lookout, on the property of neighbor Jamie Wyeth, the artist, with their dogs — Dalmatians, terriers — napping scenically in the rear. Their route includes a ride through Weymouth's famous carriage maze. He's the only person who knows the way out — because he mows the maze's grass himself, in the dark, to protect the secret. Whether this is a fact, or just another of the amusing rumors about this ebullient eccentric, is not quite clear.

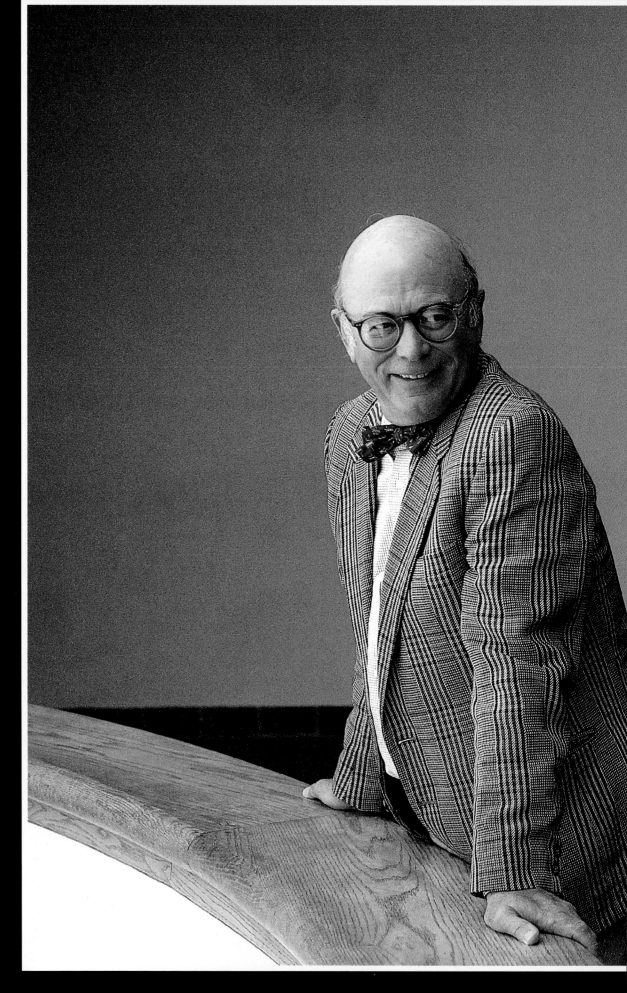

Artist, carriage driver, indefatigable fundraiser, and man-about-town, Brandywine Conservancy Chairman George A. "Frolic" Weymouth poses in front of one of his own canvases in The Brandywine River Museum, which he founded in 1971. A du Pont on his mother's side and formerly married to N. C. Wyeth's grand-daughter, Weymouth was a natural to lead the fight to preserve the region's rich natural and cultural heritage.

GEORGE A. WEYMOUTH

Despite the photo in his office of himself taking Nancy Reagan and Prince Philip, the Duke of Edinburgh, for a spring carriage jaunt, Weymouth is modest about his connections. "I've been very lucky to know the people I have. We have something to sell here that's right. Our methodology works. It's sound. It has a grass-roots approach and it's a great combination — private land publicly used."

Weymouth does understand that you can't control *all* growth. He has watched the area surrounding the du Pont family cemetery being taken over by residential housing developments of the type he calls "See-my-g'rage." "Here are million-dollar houses with Palladian windows, but there's nowhere to pull up — you go right into the garage. That's why I call 'em 'See-my-g'rage.' What's wrong with walking? Every little old lady in New York City manages to get into the house with her groceries!"

Weymouth himself began driving carriages in 1960, when he bought his 226-acre estate, The Big Bend, and didn't want an ugly car ruining the approach to his beautiful house. His driveway is two miles long and unpaved, which keeps strangers out and makes for a better carriage ride. The first carriage he acquired had belonged to artist Mary Cassatt's family and before that had served as Abraham Lincoln's inaugural coach. Early on, carriages were given to him, since they were then considered worthless curiosities. At one point, Weymouth owned about a hundred.

He renovated the 1640 house with his now ex-wife, Ann McCoy, artist N. C. Wyeth's granddaughter. "When we bought the house it hadn't been lived in since 1925. There were cows wandering in and out of the bottom room."

"I'm sure the house is haunted," he adds. "A friend once brought a clairvoyant here, and he had visions in my living room. He said a body was buried under the floor there, and it was — I know. We put the new floor in."

The turtle is the Indian sign for the property, part of which was deeded by William Penn back to the Indians in 1683, the first act of its kind ("though I'm sure they gave back only a tiny part of it," Weymouth adds). He has giddily surrounded himself with hundreds of versions of the icon. He has turtles on his monogram and his harness. "I like to sneak turtles into my paintings. If you look closely at one of the medals on the chest of Prince Michael of Kent, you can see the turtle."

When Weymouth started painting at Yale University, the chairman of the art department hated him. Realism was definitely *not* the rage. "The only way for me to learn anatomy was to go to the medical school and draw the corpses. They thought I was crazy. There were only two or three of us realists in those days. It was very lonely — you were considered an old-fashioned jerk."

His artistic life was made less isolated by his longstanding friendship with the Wyeths, who amaze him in evincing "no jealousy. They're so helpful to each other and other artists. Unfortunately, many people come here and miss the point of realism. They think you just try to paint every hair. The trouble with being a realist is that you realize how much you're *not* getting. Andy Wyeth painted Helga over and over, as if to finally get it all. And there has to be a reason for a picture; you've got to have something to say."

With all of his high-profile entertaining and fundraising — all the society columns trumpeting the guest rosters at his illustrious parties and recounting the menus at his glorious Point-to-Point picnics — Weymouth rues that his life as a painter sometimes gets a bit lost in the shuffle. But he still manages to paint every day. When he remembers to sign his paintings at all, he is sure to sign in pencil — "So the signature will disappear sometime and people will have to judge the work on its own merits."

After completing the de rigueur ride through George Weymouth's famous carriage maze, Jamie Wyeth, along with dozens of other friends of the Brandywine Conservancy, repairs to a picnic repast at Pt. Lookout, part of the artist's property, the day before the Winterthur Point-to-Point races in early May.

Above and opposite page: *Of the decided opinion that antiques mustn't necessarily look old, the proud owner of this meticulously refurbished carriage has made sure that every brass and leather appointment fairly gleams.*

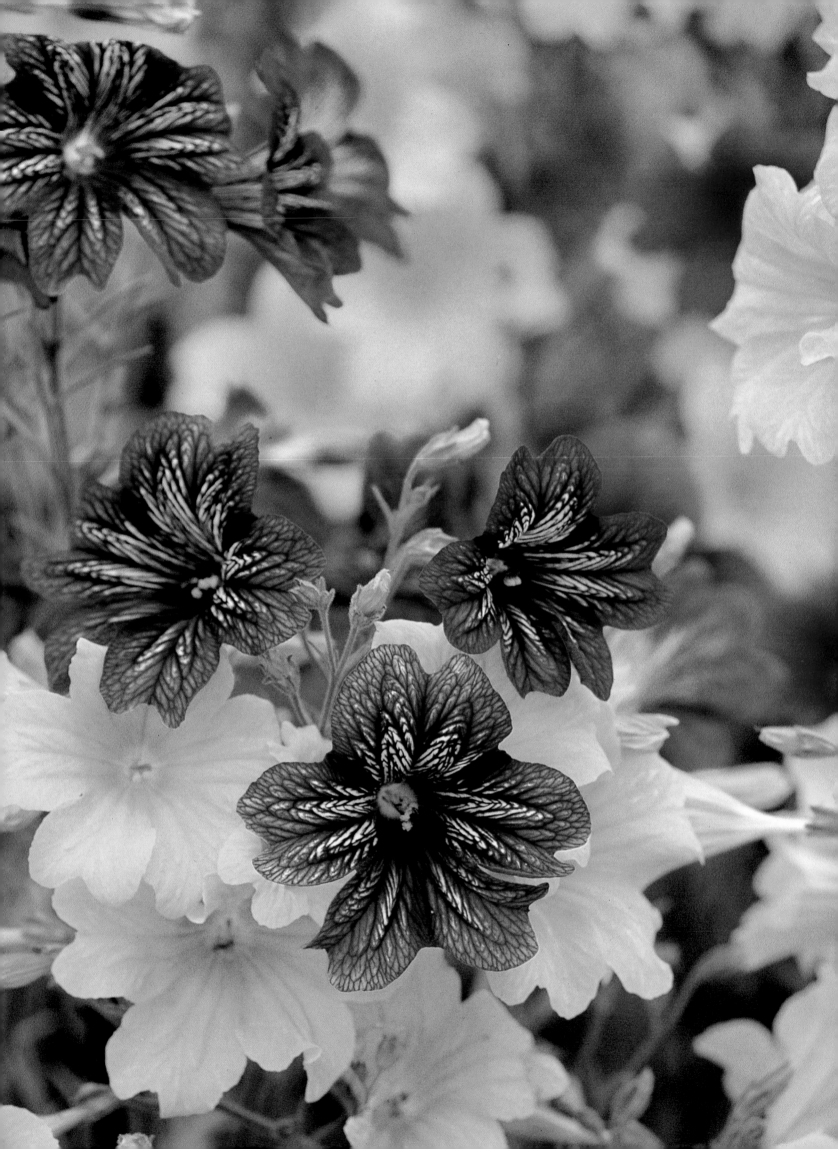

GARDENS AND HOUSES
Cultivating Beauty

*I*never was much of a nature boy," confesses Irénée du Pont, Jr. "I didn't catch the family gardening bug. I preferred gasoline and smoke and speed, all those teenage boy things. I still do."

It's not surprising that Irénée Jr. should take after his father. Those intimate with the du Pont dynasty know that family members tended to fall into two camps: the Victor side, lovers of art and nature; and the E. I. side, lovers of science and technology. That's a broad generalization, of course: tastes often overlap, and in-laws bring their own ingredients to the brew. But the clarity and intensity of those two branches define both family and region.

At first it may seem odd that an area whose reputation was built on gunpowder should also boast such spectacular gardens, that the love of nature should exist so strongly alongside a love of machines. But the contrast between the natural and the manmade is less harsh than it might at first appear. Here a perfectly-polished car is recognized as a thing of beauty, as breathtaking as a dewy flower. Besides, everyone who lives near the river understands that gorgeous flowers don't just appear willy-nilly, at least not in the modern world. Any garden — even one that looks casual, the flowers wildly tumbling — requires scientific coordination and timing, as precise and technical as the work in any car factory.

No one in the Brandywine Valley forgets how closely the world *culture* is linked to *cultivation*. The root of both words means *to till*. Factories, paintings, sculptures, antiques, cars, trees, flowers — all require time, attention, the careful application of the best available techniques. Obviously, any garden on the scale of Winterthur or Nemours can't be run by Sunday putterers. At Winterthur, it takes 23 people to maintain the hundreds of acres of gardens. And gardening skills seem to run in families: about twenty families have had either multiple members working the gardens at the same time, or subsequent generations taking their places — including the Felicianis, who have held key posts in the Winterthur gardens for four generations.

But the most famous of Brandywine's gardens, Longwood, is far too huge to be kept as a family operation. In fact, gardeners come from places as far-flung as Japan, South Africa and Estonia for the privilege of helping to run what is arguably one of the finest horticultural showplaces in the world.

The Glories of Longwood

If Pierre S. du Pont, E. I. du Pont's great-grandson, had not bought the 202 acres of Peirce Park in 1906, the historic arboretum — dating back to 1684 — would have been destroyed. Saving the trees was only part of his motivation for acquiring the site. He also claimed to have some modest social goals for his new country home.

"I have recently experienced what I would formerly have diagnosed as an attack of insanity," Pierre wrote to a friend, "that is, I have purchased a small farm about ten miles from here. I expect to have a great deal of enjoyment in restoring its former condition and making it a place where I can entertain my friends."

A passionate gardener, Pierre had been fascinated with fountains since visiting the 1893 World Columbian Exposition in Chicago. Disgruntled with the landscape archi-

Opposite page:
More than 11,000 different types of plants and flowers thrive amid hundreds of acres of outdoor gardens and woodlands, indoor conservatories, and illuminated fountains at Longwood Gardens in Kennett Square, Pennsylvania. Considered one of the finest horticultural showplaces in the world, the former estate of Pierre S. du Pont is also the Brandywine region's greatest tourist attraction.

Pages 68-69:
An arbor covered with a dreamy profusion of old-fashioned wisteria provides a perfect late-summer-afternoon idyll at Longwood Gardens.

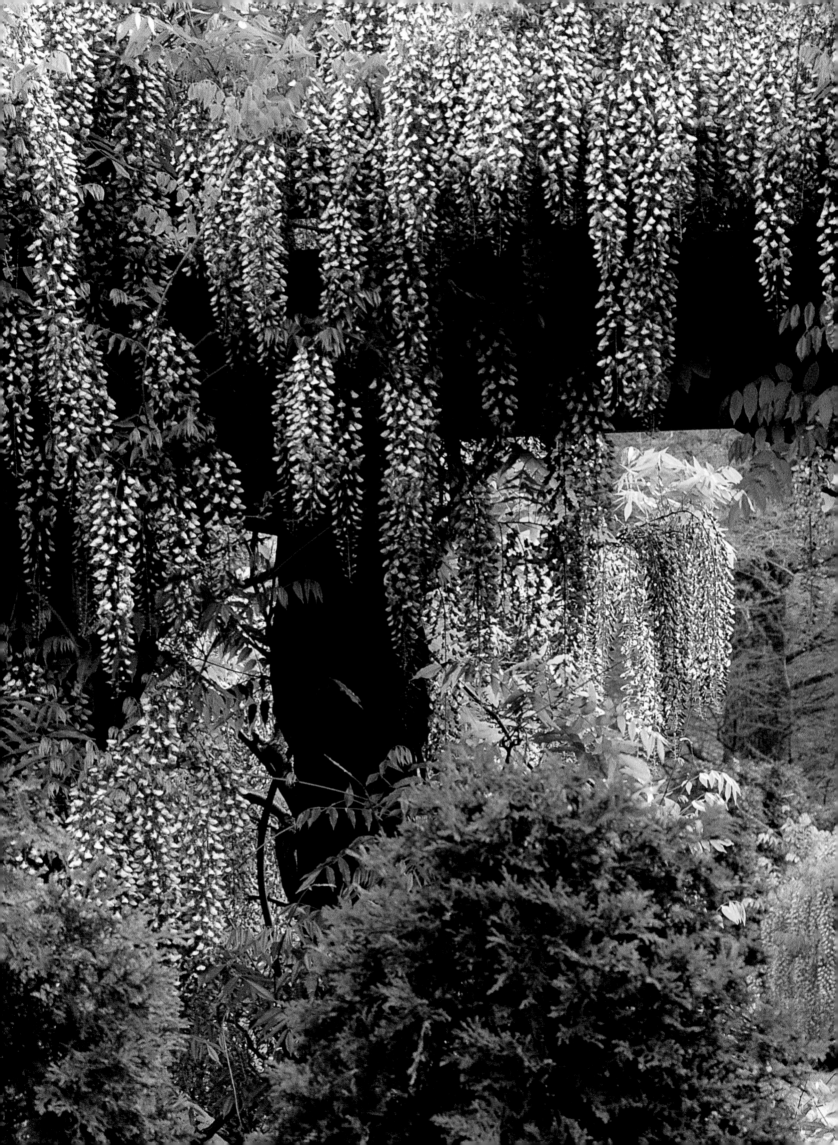

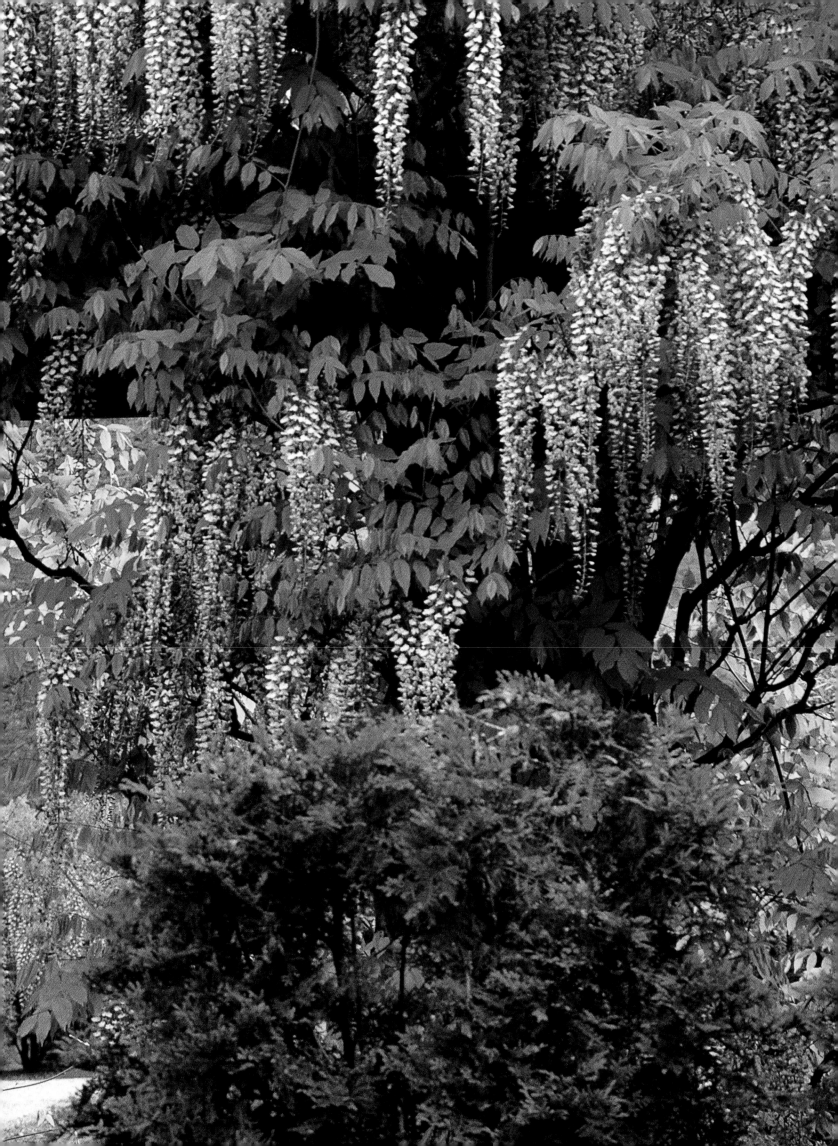

tects he had hired on past projects, he did all of the designs for Longwood himself. When he hosted the first of his renowned June garden parties in 1909, Longwood was still a comparatively small-scale affair, with a 600-foot-long flower garden and one grand fountain boasting a single, powerful jet.

Each year Pierre added to the extravaganza's surprises: fireworks, more fountains, and an open-air theater where imaginatively-lit harlequins danced between the guests, strewing roses and confetti until they vanished into the trees.

By the time he married his cousin, Alice Belin, in 1914, Pierre had even grander designs for Longwood, including the 10,010-pipe organ and even more spectacular fountains with thousands of wildly-shooting colored sprays.

Pierre died in 1954. Since he and Alice had no children, Longwood was not bequeathed to his heirs as other du Pont estates had been. Instead, he had begun planning in the '30s for an endowment to make the gardens public.

Now over 800,000 people a year visit Longwood's hundreds of acres of gardens, meadows and woodlands and four acres of greenhouses. The sheer numbers involved in gardens this scale are staggering: not only the annual supply of 160,000 spring bulbs and 6,500 orchids (each one with at least three blossoms per stem) but the 20,000 books in the horticulture library, the 200,000 outdoor lights, and the 300,000 gallons of fuel needed to power the greenhouse boilers.

As you walk down Tulip Lane in spring, past home gardeners exchanging tips ("You've got to watch out for too much nitrogen in the fertilizer"), scents waft at you in intruigingly orchestrated waves. Birds trill in the high, lush trees nearby, so perfectly in tune with a perfect afternoon that you may suspect even the birds are hired.

On a busy day in the Conservatory, you can barely see the orchids through the visitors crouching with their cameras: hundreds of happy snappers testing out their telephoto lenses. But even in the throngs, the sights and scents transport you. And on even the busiest days, you can still turn a corner, meander down an unexpected path, and find yourself alone in a thicket of fragrant foliage.

Keeping this operation smooth is the responsibility of 172 full-time and 132 part-time workers, plus 100 volunteers and 30 international students.

The day at Longwood starts at 7 AM, when gardeners are grafting, budding, and using the automatic seeders on the flats. "We are the finest professionals around, well-trained and proud of being here," says Helen BeVeir, Flower Garden Foreman, who is in charge of outdoor display and production as well as the nursery, where Longwood grows its own annuals, 8,000 mums for fall display, and a good part of its herbaceous plants. "Before our gardeners leave for the day, they make sure the area where they were working is nicely mulched. On Fridays, nobody goes until everything looks perfect for the weekend."

The gardeners here are like directors, actors and stagehands rushing to prepare for opening night — except that their theater is prey to the elements. BeVeir says that the entire staff puts in a great deal of tense overtime in March and April. "After the winter of 1994, we had so much sand here we could have put in our own beach. This winter I lost 125 roses and a lot of perennials. We try to anticipate and jump in on problems before they become eyesores — as soon as one flower pops out dead we want something to put in its place."

Under the leadership of Fred Roberts, Longwood is now able to meet about half of its roughly $20 million annual operating budget through revenue. Much of that expense is in rebuilding. "Time is the great destroyer of physical plant — and plants," says Colvin Randall, who, like many at Longwood, wears multiple hats: the public relations director is also the historian for the fountains, programs the annual fireworks, and even plays the organ for the firework display.

"We lose a couple of big trees every year," Randall explains. "The Main Fountain

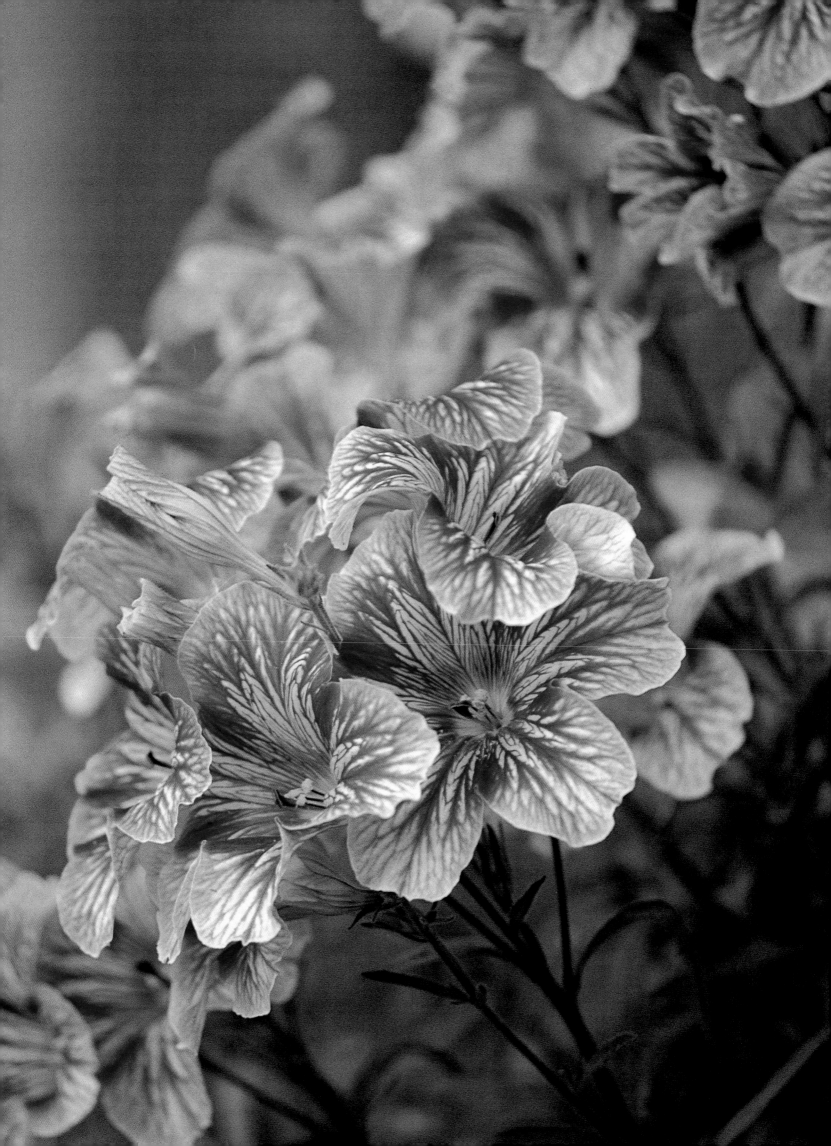

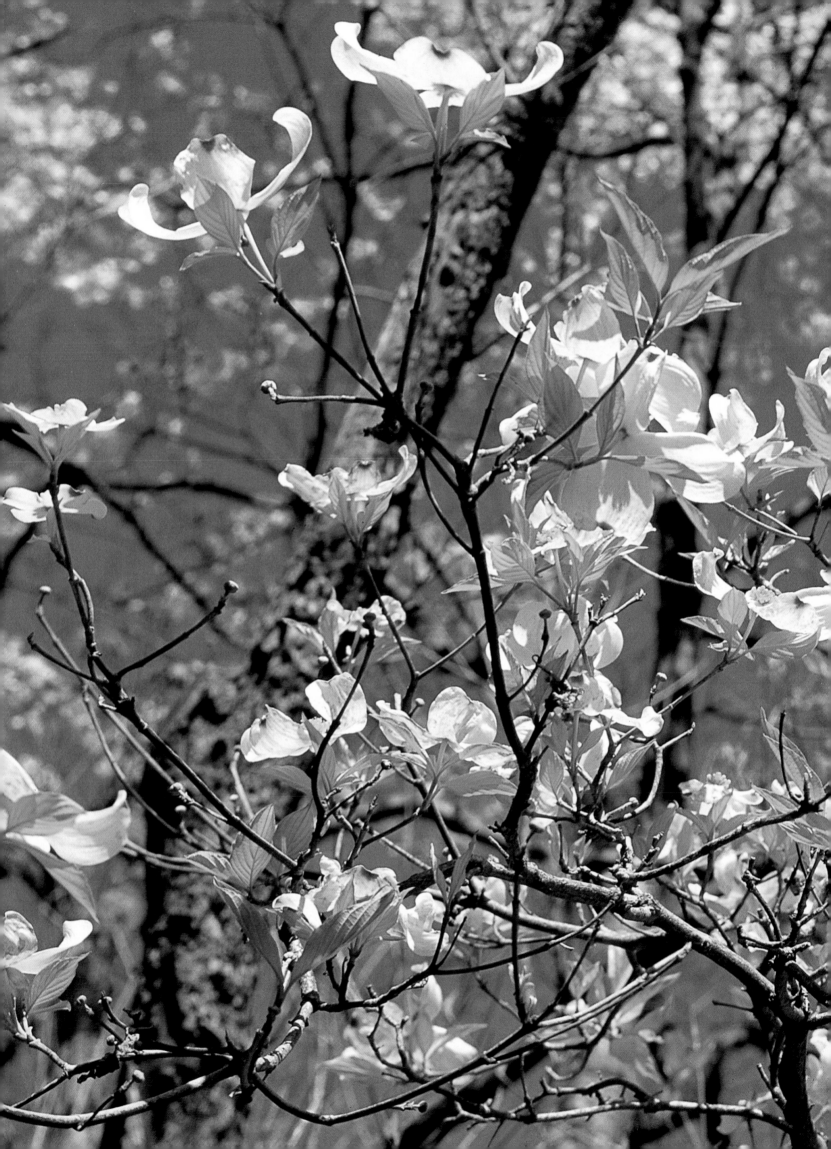

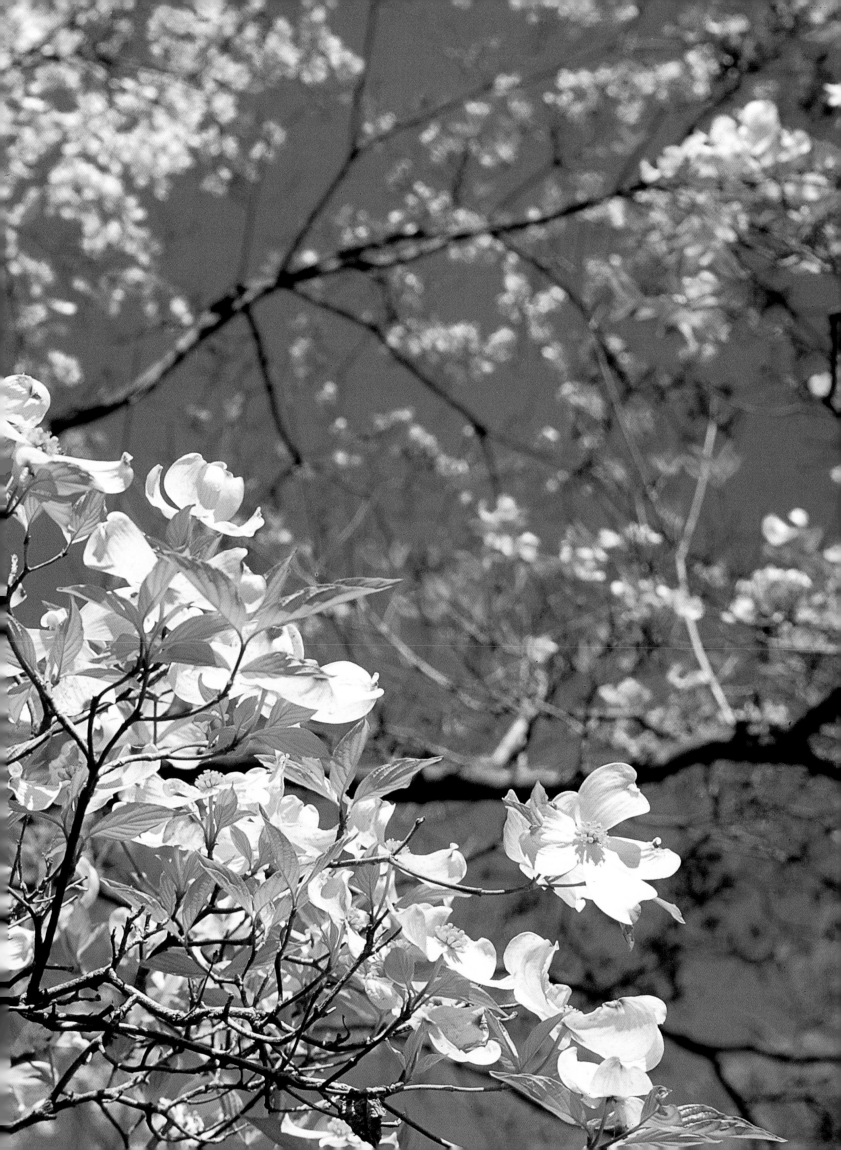

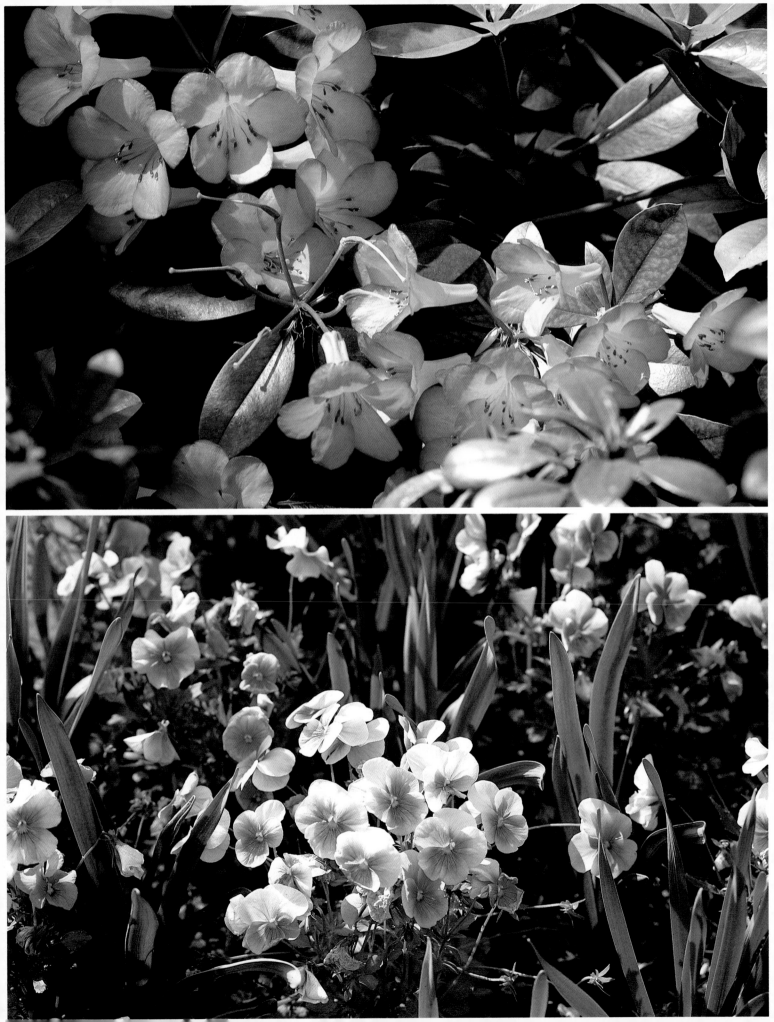

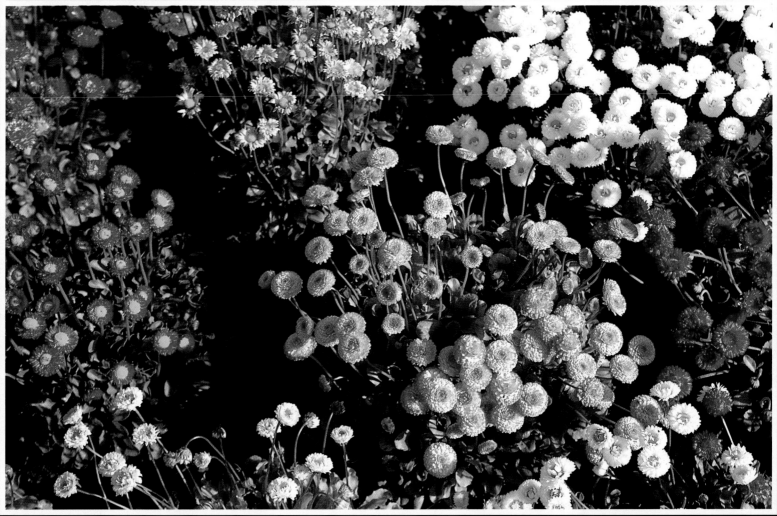

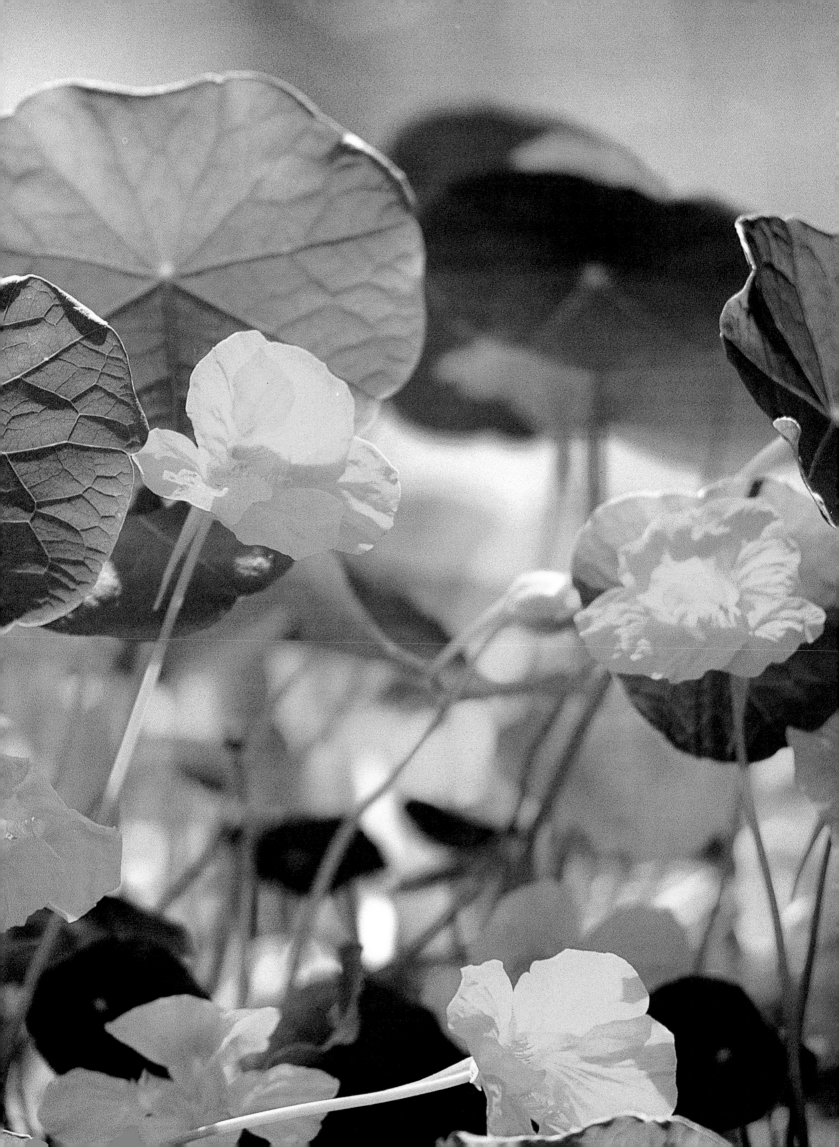

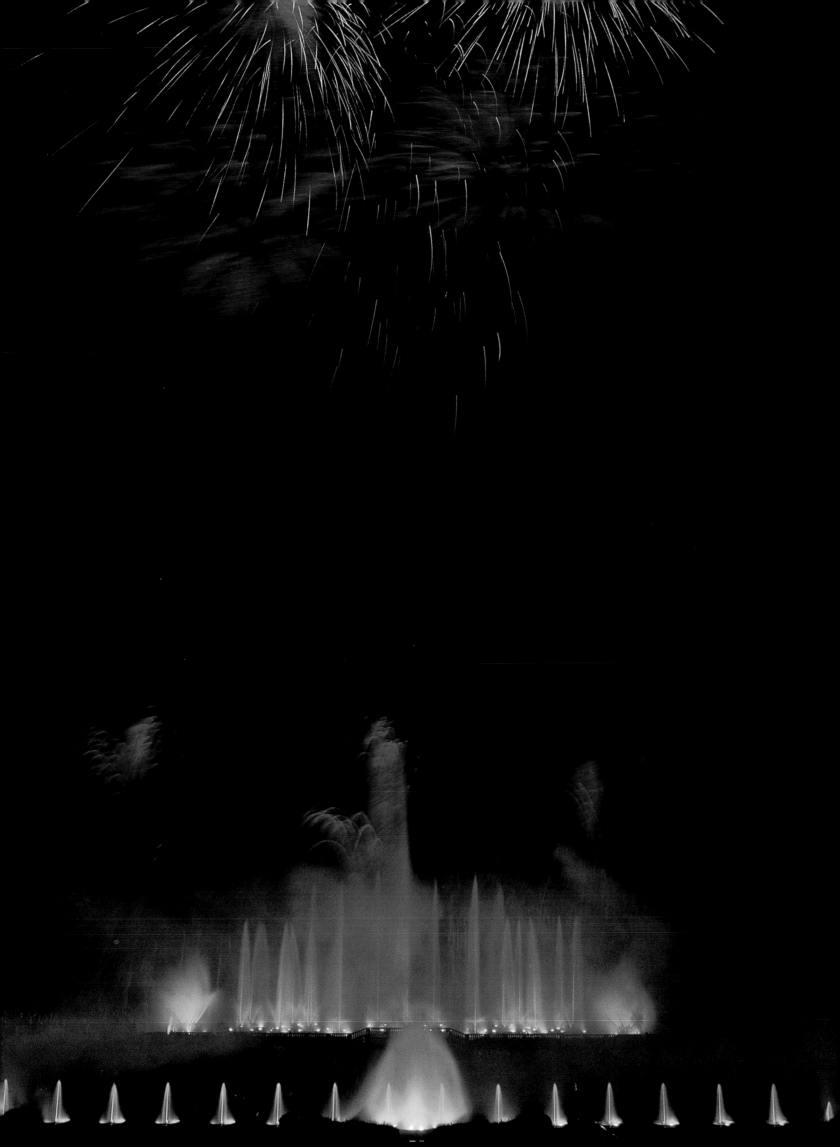

Garden basically hasn't been touched since 1931." Forty-five million dollars will need to be spent by the end of the decade just to restore the Italian Water Garden and Conservatory. Also slated is a new, state-of-the-art production facility with computerized climate control, where gardeners will be able to change the photoperiodism (day length) in order to grow out of season.

Much of the construction of that facility will be done by Longwood's own staff of metal workers, carpenters, plumbers and masons, many of whom took over their forebears' jobs. Gone, however, are the class distinctions and strict hierarchy of Longwood's earlier days. Director Roberts stresses a more democratic approach, where all employees are involved in problem-solving.

Always, problems are solved "before visitation," as Longwood employees say, so the visitors see nothing but the glorious fountains and foliage.

One thing that the staff never wants the public to see is the flowers being pulled. At night, most of the flowers are mercilessly yanked when their time is up, often in perfect condition, and composted in Longwood's own compost bin. "It'd be nice to ship them to a hospital, but the logistics are just too hard," says Randall. "Everything here gets reused as compost or mulch, though, which in its own way is nice too."

PATRICK NUTT: *"Setting a Standard"*

*P*atrick Nutt, in charge of the greenhouses, came to Longwood in 1957 to start the tropical and water-lily displays after training in England at the Royal Botanical Gardens at Kew. Nearly four decades later, his exuberance for Longwood has not waned.

"Coming here from Britain," he says, "where I listened to crusty old gardeners bragging about the estates they'd worked, Longwood seemed better than any of them. It reminded me of an old Edwardian garden. Of all the places where I've worked, this place sets a standard. We don't have much pilfering, for example. Keen gardeners love to take slips — they keep a little knife handy in their pockets and sneak it out, like so." He demonstrates with a sly smile. "Well, we don't have much patience with that."

Horticulture, Nutt says, is very precise work, especially now that environmental concerns limit and change the gardener's methods. "We don't want fertilizers and pesticides getting into the water table. We're not *wholly* organic, but our Integrated Pest Management program uses methods other than pesticides to control pest populations. We use parasites, predators, and timing" — like moving in lace wings to eat the aphid larvae. For controlling white-fly populations, the greenhouses use a parasitic wasp that is presently being bred and sold by the millions, although Nutt isn't sure the technique is yet available to home gardeners.

During the day, the fast-talking, cheerful Nutt can be seen motoring around in a golf cart, listening for his beeper, consulting with gardeners on his walkie-talkie. "Much as I like to cover a lot of ground on foot, it's better this way, to save those vital minutes. We had a blackout once with almost 5,000 people here on a tough Christmas weekend. Hothouses are a little eerie in high winds to the uninitiated."

Nutt lives three miles from Longwood — "closer as the crow flies," since he can walk by cutting across the Kennett Square Country Club's golf course. "That's sort of a boast, since I've only done it twice in 37 years." Both times were during blizzards, when Longwood was snowed-in, its roads impassable; he was thrilled to be able to see his workplace in that most pristine condition.

When he leaves Longwood, Nutt often goes straight home to tend his own 2.4 acres of garden — which he jokingly calls "Shortwood." He grows all of his own vegetables

Native and ornamental dogwoods of all varieties grace the formal allées and woodlands of Longwood from early spring until mid July.

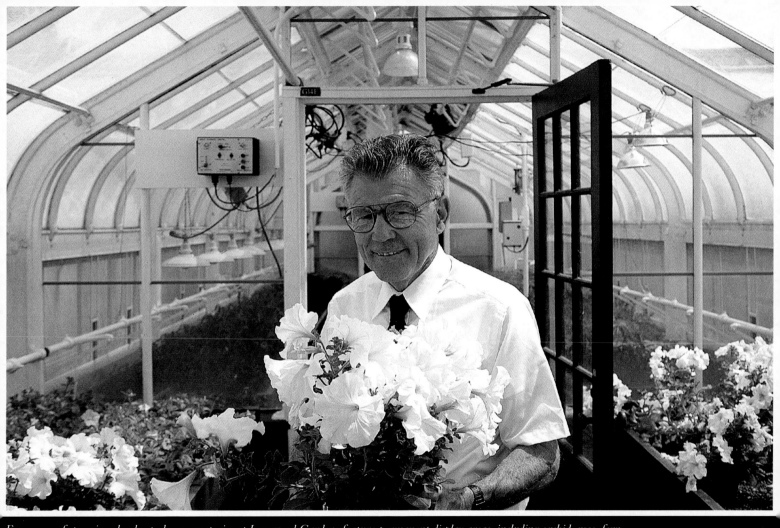

Four acres of stunning, landscaped conservatories at Longwood Gardens feature permanent display areas, including orchid, rose, fern, tropical-plant, desert, and rain-forest rooms. Patrick Nutt, whose own property, which he has modestly nicknamed "Shortwood," is near the gardens, apprenticed at England's Royal Botanical Gardens and is now in charge of Longwood's dozens of state-of-the-art greenhouses.

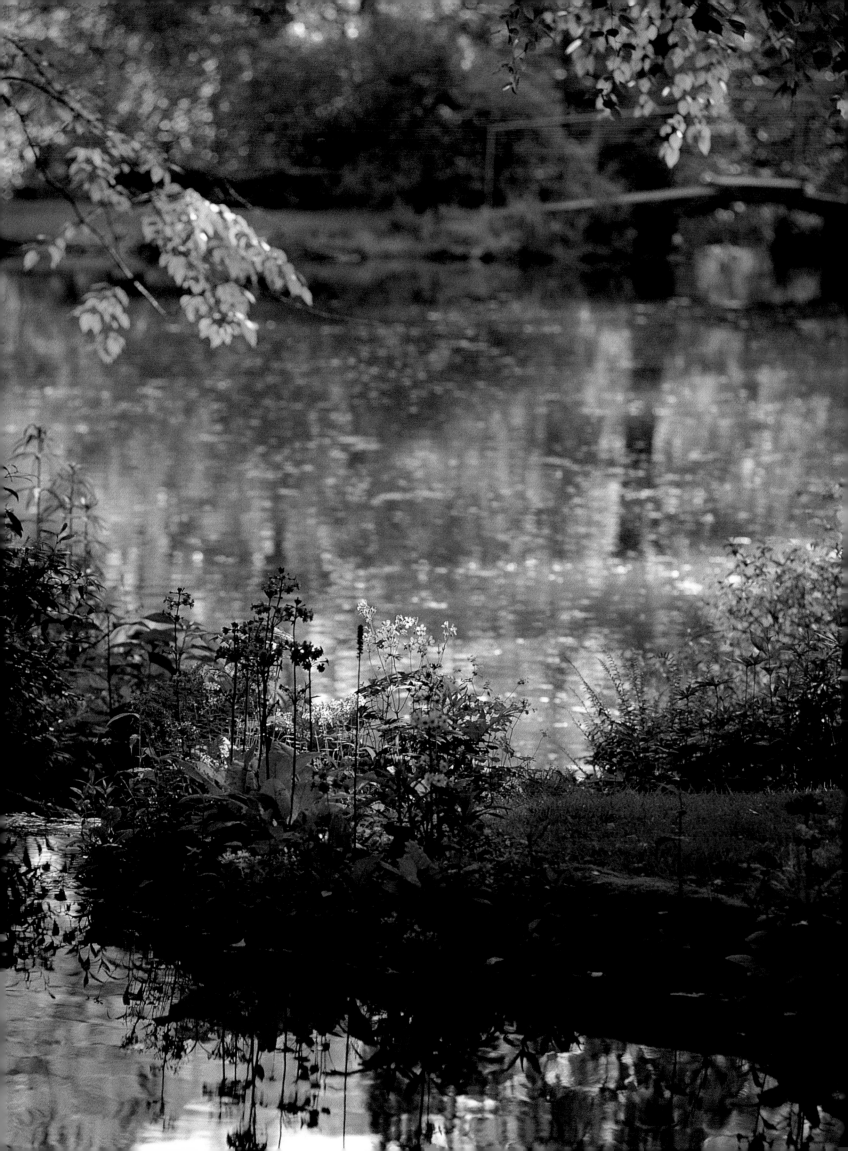

there, and has an arboretum that includes four of the original Dawn Redwood trees brought to the United States in 1948, when they were discovered in China after having long been assumed extinct. "As my wife likes to point out when something goes wrong with the house, I never cared about the house anyway. I bought it for the trees."

The Secret Garden at Mt. Cuba

*F*or the most part, the gardens at Longwood, Winterthur and Nemours are formal — graceful and as controlled as a ballet step. But the Quaker gardening tradition is also strong in the Brandywine Valley. That style encourages nature to feel less contrived, the color-matched rose borders not falling into rank in quite so stiff and military a fashion.

To view the naturalistic style of gardening in its full glory, you can't do better than Mt. Cuba, one of the last of the grand du Pont estates still privately owned. Through the hills, down old, unmarked roads so small you might miss them if you don't know exactly where you're going, Mrs. Lammot du Pont Copeland still maintains 240 acres of her original 3,000-acre estate, overseeing a staff of 26 gardeners.

At present, the ferociously private Mrs. Copeland only opens her gardens to certain groups by appointment, at certain times of the year — especially from late April to the end of May, when the delicate wildflowers are in full bloom. But the gardens will become public after her death. Under the directorship of Dr. Richard Lighty, a plant geneticist who formerly led Longwood's experimental plant breeding programs, Mt. Cuba Center for the Study of Piedmont Flora has already become influential in research on native plants, the first large garden in the country to uphold this emphasis.

Confronting Mrs. Copeland's gnarled, double-trunked trees, Dr. Lighty remarks, "People are always saying, 'How lucky of Mrs. Copeland to have found all this.' Even a horticulturally-trained person might be deceived by how natural all this seems; but it has a *calculated* abandon." It is still unusual, he explains, to see a leaning tree, "because nurseries still grow everything straight up and down, like a lollipop. But if you plant a tree at the edge of a forest, it will lean out towards the light. We're just now getting out of the mode of wanting everything straight, symmetrical and equidistant."

He suspects that in our world, naturalistic gardens provide a more pointed relief from "the sterile macadam, steel, smoke and fumes — more people want to retreat to a niche where they can be brushed by fern foliage."

Lighty sees the Center's mission as largely educational, convincing the public to appreciate and protect native plants in the wild. At Mt. Cuba, visitors can see twenty native plants that are endangered by wild collecting, and the Center encourages visitors to patronize only those sources that propagate their own plants. (Trilliums, for example, are all collected in the wild — to the point that the genus' existence is threatened.)

In his lectures, Lighty shares his techniques. He calls attention to the forces that shape growth in nature: not just light, the obvious one, but gravity, water, and wind. He encourages gardeners to aim for irregularity, to avoid predictability and straight lines. Never use mulch, he warns — instead substitute "mixes of groundcovers of various sorts and sizes alternated with unplanted leaf litter."

Mrs. Copeland began her gardens between the two world wars, amid an active national wildflower movement. But naturalistic gardens fell on hard times in the suburban '50s. It took the back-to-nature movement of the '60s to rekindle interest in native plants. Lighty is surprised that his naturalistic techniques are still so new to home gardeners. When the near-million visitors a year who admire Longwood get a chance to see Mt. Cuba, that may quickly change.

Opposite page: For garden lovers seeking a respite from the formal French magnificence of Longwood, Winterthur, and Nemours, Mt. Cuba is a sylvan wonderland of ancient specimen trees, bubbling brooks, and "natural" plantings. Although open to horticultural enthusiasts by invitation only, this last of the great du Pont gardens still privately owned is home to the Mt. Cuba Center for the Study of Piedmont Flora, the first research operation of its kind to emphasize the importance of native plantings.

Above and opposite page: *Still maintaining 240 acres of her original 3,000-acre estate at Mt. Cuba, Mrs. Lammot (Pamela) du Pont Copeland was one of the first gardeners in the country to advocate the use of native plants and naturalistic gardening techniques, a trend that has only recently caught on among garden enthusiasts. A jealously-guarded secret in the horticultural world, Mt. Cuba will be open to the public only after Mrs. Copeland's death.*

Old World Treasures and New:
Nemours and Winterthur

A visit to Hagley confirms that for the early du Pont settlers, gardens came first, houses second. The original Eleutherian Mills is a cozy dwelling, set in palatial vistas of foliage. The house was just fancy enough for comfort, but guests were always sent away with exotic fruit or rare, imported seeds for their gardeners.

No du Pont worth his salt ever settled for less than a world-class garden. But as any tourist to the area knows, the houses grew spectacular as well. Alfred I. du Pont's mansion, Nemours, with its marble sphinxes, bell tower, and 102 rooms full of silk, lace, brocade, chandeliers, and gold leaf (not to mention Marie Antoinette's musical clock) stands as a twinkling testament to the grand style that would reign in the region.

Alfred left his first wife in 1906, at a time when such things were so unthinkable that his divorce caused a cataclysmic rift within the family. Nemours was built in 1909-1910 for his second wife, but many of his relatives would never see it. The bad feelings caused by the scandal would persist for decades, until Alfred's third wife embarked on a unity campaign. With Alfred banned from New Year's Calling and the familial orbit of his cousins, Pierre, Lammot, and Irénée, his social life was totally separate. His mansion, protected from intruders by the shards of glass embedded in its high walls, was a stinging reminder of his independence from the clan.

No such sad fate would befall Winterthur. Originally built on du Pont land in 1838 by James Antoine Bidermann, the Swiss husband of Eleuthère Irénée du Pont's daughter Evelina, the estate would be passed down to their son, who preferred to stay in France and sold it to his uncle Henry du Pont, Sr. That Henry would, in turn, bequeath it to three further Henrys: Henry Algernon du Pont; Henry's son, Colonel Henry Algernon du Pont; and, finally, Henry Francis ("Harry") du Pont, great-nephew of the first owners.

In typical early du Pont style, the original house was a crisp structure with only twelve rooms. Wings and floors would be added as the house changed hands. The last and most important Henry, the collector, decided to turn his house into a museum in 1930. By 1959, the house would reach its final size: nine floors and 175 rooms, housing the world's foremost collection of American antiques and decorative art.

It was not surprising for Henry to be interested in furniture. After all, furniture is made from wood, and he hailed from a family that would mourn a tree being hit by lightning. But his passion for American antiques was his own, as was his shrewd eye for quality. When he began to collect American antiques, they were by no means a universally-shared delight; down the road, cousin Alfred was still importing his furniture from abroad.

But after World War I, a wave of nationalistic feeling encouraged a few of America's wealthiest men to recognize the charm of native furniture — so much simpler than its European counterparts, with its own history and pedigree. One of the first pieces du Pont bought was a chest from Newport; the man he outbid for that piece was William Randolph Hearst.

According to Thatcher Freund, whose book *Objects of Desire* chronicles the rise of the antique business, "Du Pont bought in such prodigious quantities that the dealers began to call him Mr. Big. He once told the [New York] dealer Bernard Levy that the hair on his neck stood up whenever he saw something wonderful. If du Pont walked into Levy's Madison Avenue shop and saw a fine table, he held his arms before him in the manner of Dr. Frankenstein's monster, and his hands began to quiver. 'It's mine! It's mine!' he would say. 'I'll talk price with you later. It's mine!' No one sold a great antique without first offering it to him."

When Jacqueline Kennedy began to furnish the White House with historic pieces, it

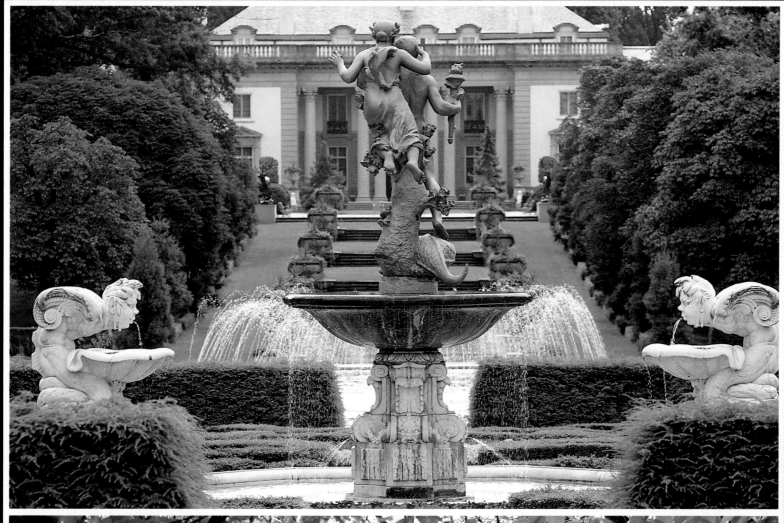

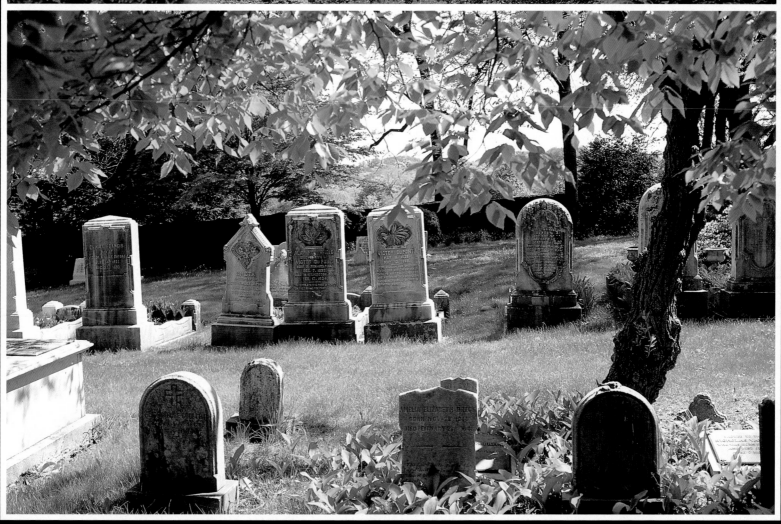

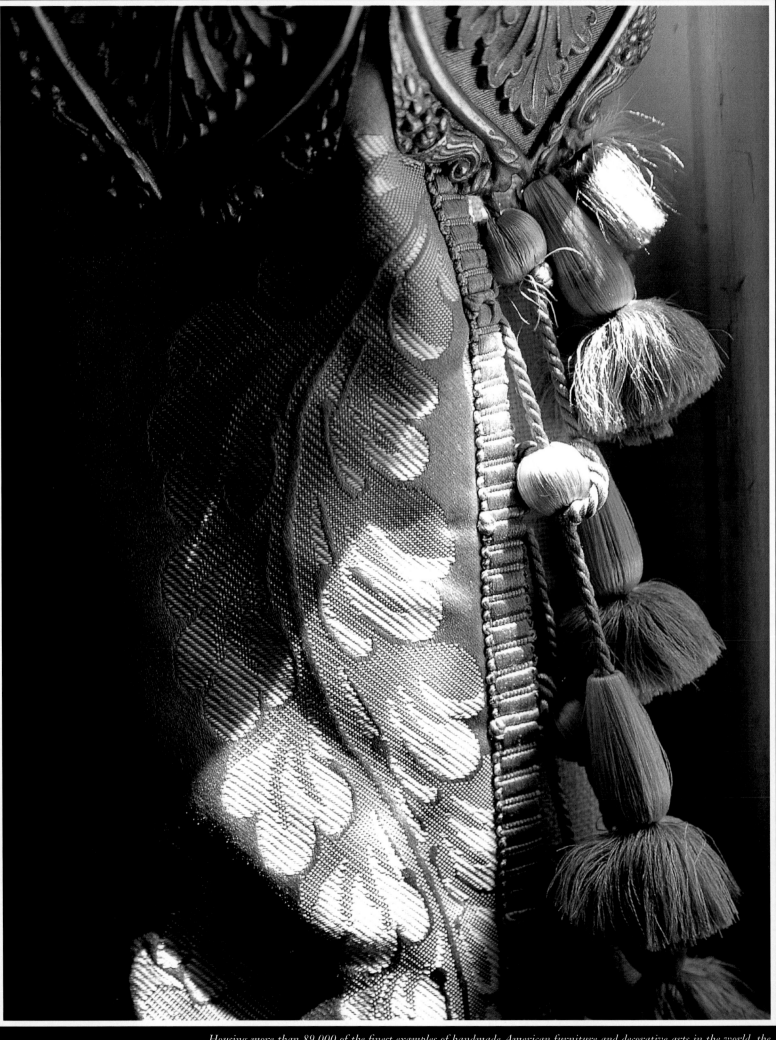

Housing more than 89,000 of the finest examples of handmade American furniture and decorative arts in the world, the 175 rooms of Winterthur, the former estate of Henry Francis du Pont, is an antique-lover's paradise. Recreated in special mills to exacting eighteenth-century standards, these richly-patterned damask draperies feature the original elaborately-wrought brass-and-iron tiebacks.

98

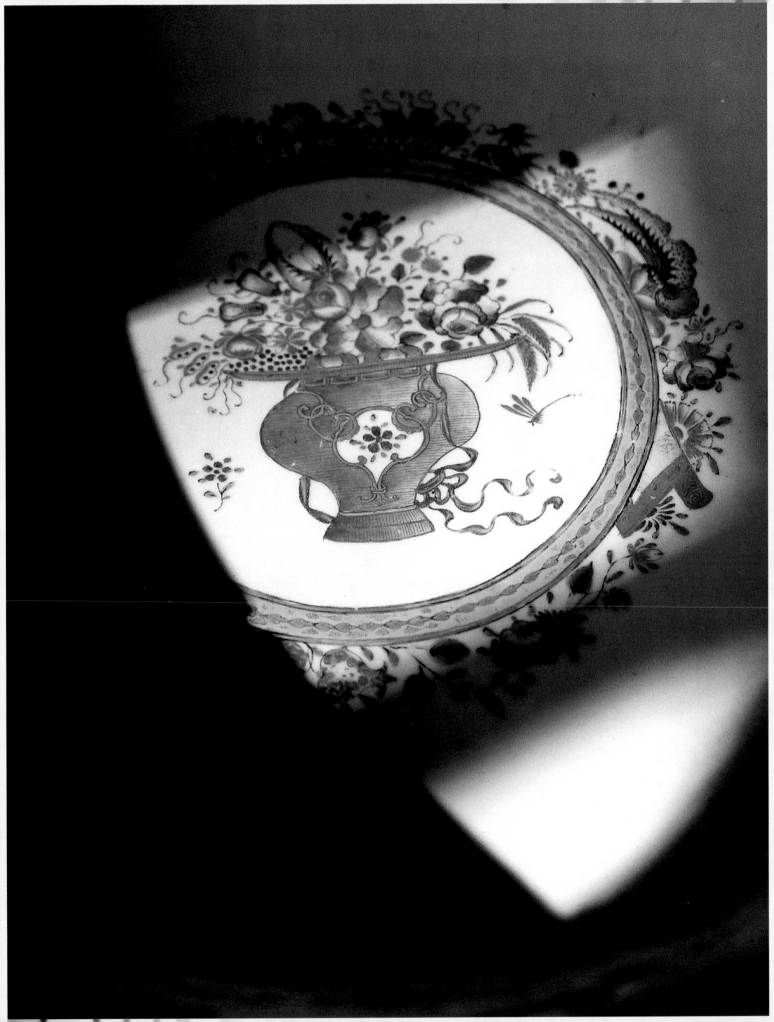

Although Winterthur's astounding collection of American antiques covers the period from 1640 to 1840, the eighteenth century is particularly well-represented with masterworks including a richly-inlaid sideboard, a pristinely preserved and monogrammed silver tankard, draperies complete with intricately woven and knotted tassels, and a superb collection of Philadelphia-style Chippendale chairs.

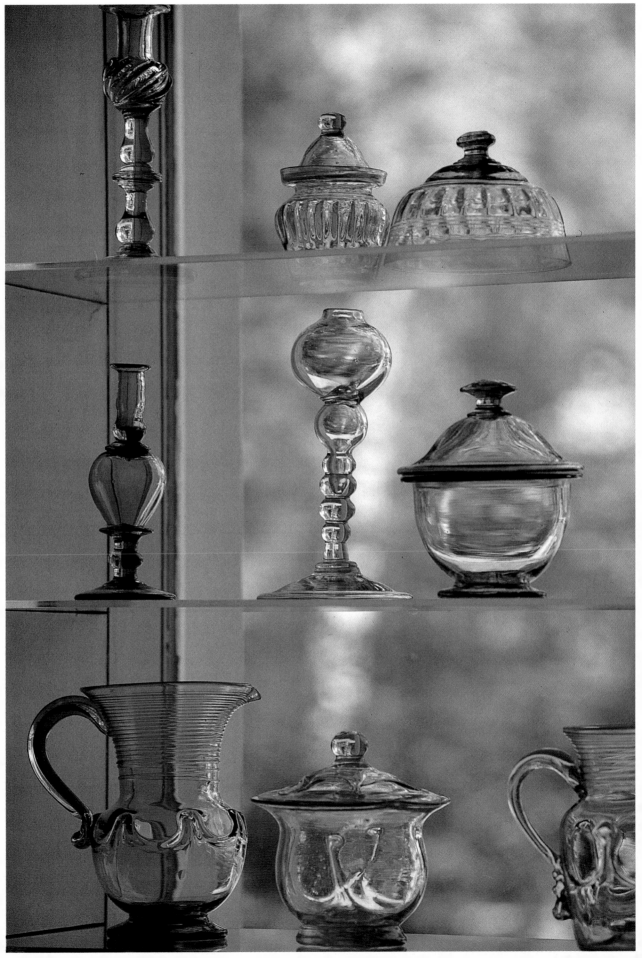

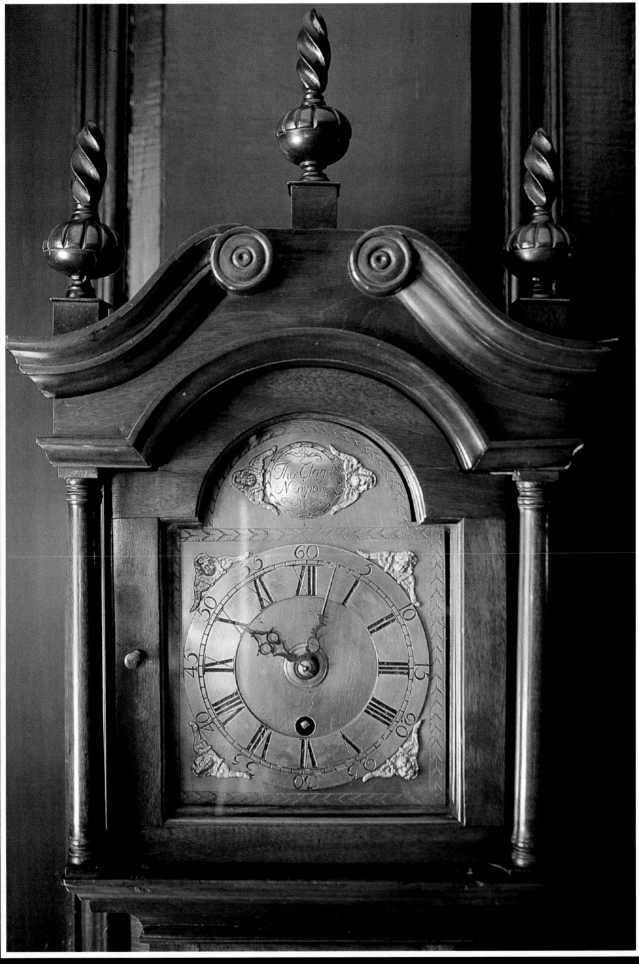

*This circa-1770 tall-case clock crafted in New York features a handsome brass dial
and the carved finials and swan-neck broken pediment typical of the day.*

Above and opposite page: *The spirit of the past is pervasive throughout the Brandywine Valley. Only a modern telephone and electric candles distract from the eighteenth-century ambience of a mud room at George Weymouth's estate outside of Wilmington. The view across the hat-strewn windowsill to the moss-and-snow-covered roof outside completes the bucolic picture.*

was Henry du Pont she called on to chair her Fine Arts Committee. On tours, she liked to tell a story about him entering one of the state rooms, pointing to the two old American tables in the room, and declaring, "Those are the only decent pieces in here" — pieces that turned out to have been donated to the White House by Henry's sister, Louise Crowninshield.

With his shrewd eye and abundant funds, Henry du Pont handily acquired the goods to fill 175 rooms of Winterthur on nine floors. The museum presently boasts about 89,000 items, including — by the best, most recent computer count — 3,693 pieces of porcelain, 1,170 candlesticks and candelabra, and 1,021 chairs.

The sheer *number* of items is staggering. On the sixth floor, you can stand at one end of the hall and get a sweeping view of endless rooms, some of which were transplanted in their entirety (the paneling and walls removed with great care) from a great house in Rhode Island or Baltimore, each crammed with priceless objects.

Now almost 200,000 visitors a year admire 66 pieces of George Washington's china, the original eagle from Grand Central Station in New York City, and the rest of the perfectly maintained and displayed items. Each table is set with the appropriate silver and china, all of it glimmering in light scientifically planned to preserve the priceless fabrics. It's hard not to reel imagining the dusting and polishing involved in keeping these rooms so perfect for inspection.

Guides at Winterthur do not like to focus on the du Pont family and the stunning abundance of their belongings. Instead, they try to keep visitors' attention on the magnificent collection that is the museum's reason for being. Through a program at the University of Delaware, Winterthur now trains most of the nation's most serious antique curators and preservationists.

Finally, despite his passion for antiques, Henry stayed true to his heritage. Although he stopped buying antiques as he got older, he never ceased to be directly involved in Winterthur's hundreds of acres of grounds. In fact, until his death in 1969, he liked to introduce himself as "the head gardener."

DAVID STOCKWELL: *"Furniture That Sings"*

If you like the furniture at the Winterthur Museum, you can pop next door to David Stockwell Antiquaries and pick up a chair or highboy of your own.

Of course, at an average price of $25,000, these gleaming antiques in their luscious woods — most with nary a nick despite their long years of service — are not for everyone. The locals snickered when the sign went up outside proclaiming "Sorry, No Busses." But unlike at the museum, where the silverware on the sideboards is secured with fish wire and large pocketbooks are forbidden, visitors can meander through David Stockwell's twenty rooms at will, lounging in the chairs, even putting their drinks down on the tables. "We just can't have fifty people wandering through at once," Mr. Stockwell says. "It's not like in the New York houses, where everything's under lock and key."

David Stockwell Antiquaries is among the three largest independent antiques dealers in the country (the other two are in New York City). He specializes in American pieces from around 1785 to 1840. Occasionally he will fudge with that cut-off date for a special piece, like an ornate gothic safe that belonged to an eccentric New York banker. He'll even fudge with "American" — he is a cherished source for Irish antiques that are so similar to American pieces of the same era that he believes "there must have been an Irish cabinetmaker who came to Philadelphia and passed on the style."

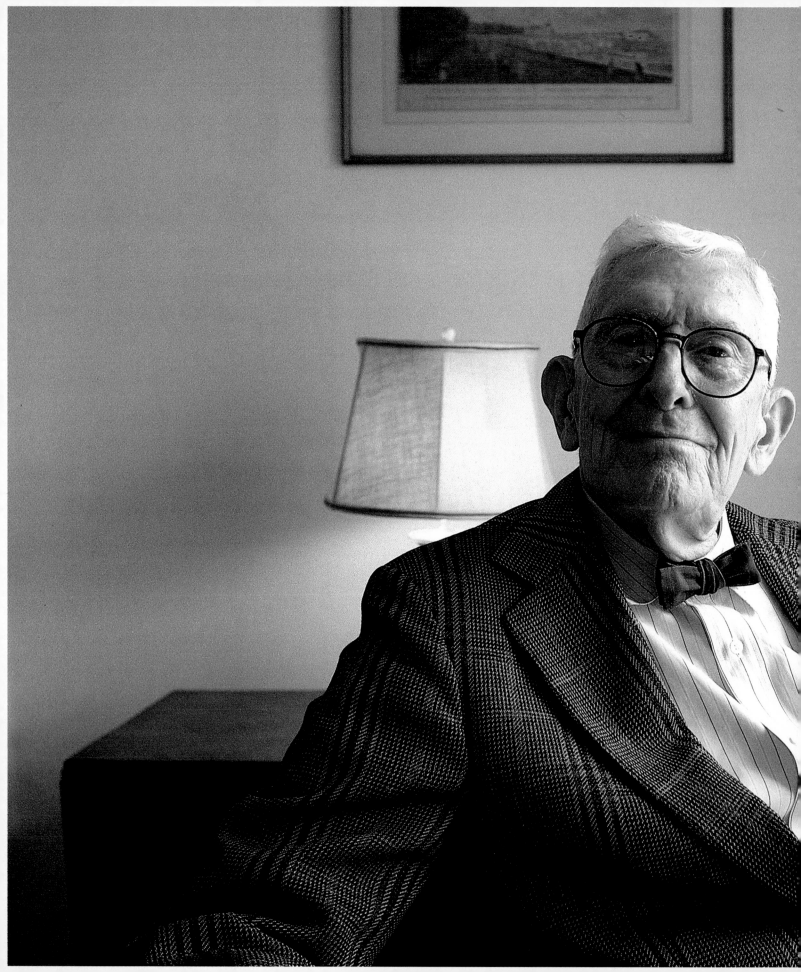

Although he retired in 1993, David Stockwell still knows the date and provenance of every piece of furniture and art housed in the 10,000 square feet of David Stockwell Antiquaries, which he founded outside of Wilmington nearly forty years ago. Remembering the days when antique collecting was a gentleman's sport, he bemoans the auction-inflated prices of fine American furniture today. "If a customer buys several things [with us], why, we make it a little less. I don't know how the auctioneers at those big houses can live with themselves."

All of his acquisitions have good pedigrees and are beautifully made. He can turn a chair over to show you how finely it is morticed through (the joint where the seat frame meets the legs). But heritage and quality aren't enough. The main requirement for all of the furniture is "if it makes itself into a poem, if it speaks to me, sings to me."

Stockwell has been in the antiques business for almost fifty years. His Main Line family "had furniture, so I was always interested in furniture." He graduated from college with a journalism degree in 1932, got disenchanted with the newspaper trade, and spent a spell as a soap salesman before apprenticing himself to the famous West Chester, Pennsylvania, antiques dealer, Francis Brinton.

Stockwell worked for free, cleaning floors and driving the trucks. Within three years he had learned his trade well enough so that Brinton named him as successor and allowed him to buy $7,500 worth of furniture to set up his own shop, first in West Chester and then in Philadelphia. Since 1956 his business has been in Wilmington, where many of his best customers lived — as well as many of his best sources for furniture.

Until World War II, Stockwell remembers, "you could still come across an attic filled with furniture that hadn't been touched." No one wanted it. "Victorian furniture was much more fussy. The industrial revolution had made people very rich and they wanted to show off. If they could make it more elaborate, all the better — wild carvings and ornate chandeliers. They gave the old pieces to their maids and poor relations. The earlier American furniture was a subtler thing. When Henry du Pont bought the Van Pelt highboy for $44,000 in 1929, no one could believe it. It was like $44 million today."

His own taste is for clean, simple lines — "the simpler, the better. Here's a clock by William Claggett of Newport, Rhode Island, that must have been made a couple of days after he got off the ship. I particularly love timepieces. I'm a widower and I live alone, but I have four or five clocks to tick and sing and keep me company."

In a small, locked room of the immense gallery, with "pieces for very special collectors who want the best," Stockwell proudly displays one of only four American ball-and-clawfoot sofas in existence (another is in the Philadelphia Museum of Art) and some rare Queen Anne chairs that belonged to the last Royal Governor of Pennsylvania (one still bearing the original upholstery). A large round table by Thomas Affleck "was from an original primeval mahogany forest — it was made from one piece of wood." He has framed a copy of the original 1779 bill of sale, for £60.

Back in 1971, Stockwell's most expensive clock was $8,600 and he worried that it would never sell. Today it would command $95,000. The antiques business has changed radically in recent years, with skyrocketing prices — partly through inflated auction-house set "floors," which can push the pricetag on a $300,000 piece up to the million-dollar mark.

Stockwell bemoans some of the changes wrought by the antique world's new glitz. "Now that the Streisands have gotten into the act, it's hard to get stock. Our source has always been buying back our old pieces or just happening upon things. But now those things get sent to auctions. When the children inherit those pieces and see the prices, they get all excited. Here, our tags are marked. If a customer buys several things, why, we make it a little less. I don't know how the auctioneers at those big houses can live with themselves."

At such prices, one can count on a fairly small number of regular customers — maybe eleven or twelve serious collectors, Stockwell estimates, though there are some surprises. Ronald Bauman, who has been with Stockwell Antiquaries since 1971 and is now president of the corporation, recalls getting a call from a New York architect insisting on a Sunday appointment for a busy client. "I opened the door," Bauman recalls, "and standing there was Harrison Ford. At that point he was doing a large apartment in

Above and Pages 112-113: *Stocking the libraries of his Brandywine Valley neighbors with rare first editions and art books just as his father did before him, Thomas Baldwin, who runs Baldwin's Book Barn outside of West Chester, Pennsylvania, sums up the region's appeal: "I know everyone, and everyone knows me. I shop at merchants I went to school with. I've travelled around the world — but I always love to come home to the beauties of my own area."*

New York, on the park" — and he furnished it with pieces from David Stockwell Antiquaries.

Bauman also remembers Andy Warhol dropping by with a whole long-haired hippie entourage. "Mr. Stockwell pulled me away and said, 'Who the hell is that?' We sold him a pair of marvelous Empire sofas. He paid $9,000. Those pieces sold for $40,000 at Sotheby's auction [of the late artist's estate]."

David Stockwell has been retired since 1993, and doing a great deal of traveling — his last trip was around the horn of South America. Ronald Bauman has succeeded Stockwell, just as Stockwell succeeded Brinton. But Stockwell can still show a visitor around the 10,000 square feet of prize furniture, naming every cabinetmaker, remembering every date, explaining why the couches were so deep (to accommodate the ladies' dresses) and why the pier table had such low mirrors (so the ladies could discreetly check their petticoats). His love of the furniture gleams as brightly as the woods.

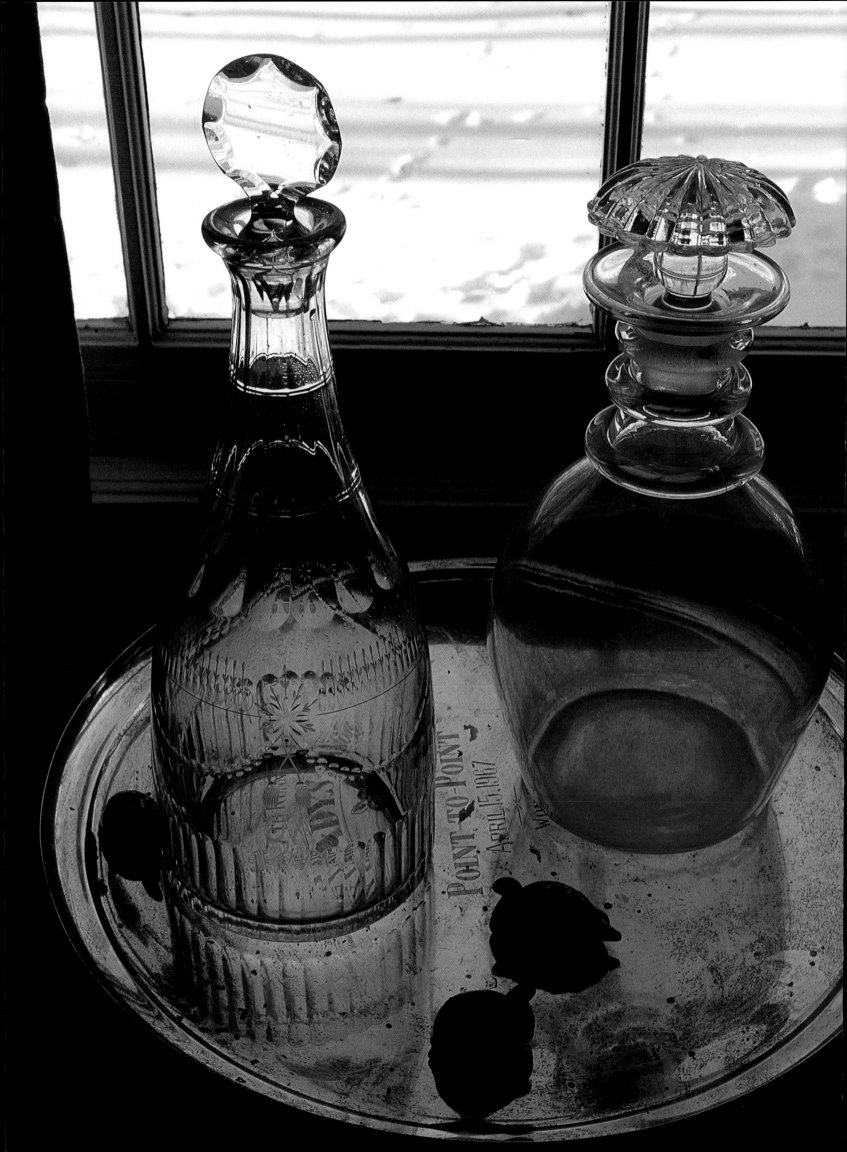

HORSES AND DOGS
A Day at the Races

*I*f you want a crash course in the Brandywine's social order, there's no better place to start than the Winterthur Point-to-Point Races, held annually on the first full weekend in May, the day after the Kentucky Derby.

Just look at the map for the races: where the $10 General Admission Parking is, way over that hill yonder, and where the numbered, permanent, $2,000 parking spaces are, right here within view of the finish line. (Since 1978 when the races began, Irénée du Pont, Jr., has stationed his 1918 Cadillac in Parking Space Number One.) Look at the recently-established "Corporate Loop," with its overview of the paddocks and the starting line, where for $6,000 and up a tent of some of Wilmington's new money, mostly in banking, can host parties to rival the most happening event of the day — the lunch in the immense J. P. Morgan Tent, over there by the backstretch, with actual sinks and mirrors in the bathrooms for its partygoers rather than Johnny-on-the-Spots.

Many of the people catching up with friends in The Morgan Tent own racehorses, and will sneak away from the champagne and caviar to wish their trainers and jockeys good luck before the races. What binds these owners and the picknickers with blankets on the grass?

The love of animals unites them. They are here to see the horses, because they love horses as they love all animals. Look at the bumper stickers — "I ❤ My Irish Setter." "Only Elephants Should Wear Ivory." Notice how everyone studies the Carriage Parade that precedes the races with awe: the magnificent horses with their harness brass glittering and their hooves oiled to a black opalescence. If you need further evidence of the Brandywine Valley's love of animals, consider this. As the first race is set to begin, the announcer clears his throat and ominously transmits the following news over the loudspeaker to the assembled multitudes:

"There's a sponsor with a Honda Civic with a dog in your car and the windows are rolled up. It's a hot day. Get to your car *immediately* or I will have to break your windows."

Silence falls on the crowd. "Did you hear that?" one spectator almost gasps. "That person should be shot."

Dog may be only man's *second* best friend in the Brandywine Valley. Most people here know how sweet a horse can be when he nudges you, or rubs your back with his mouth as you rub his neck. Anyone who sees these jockeys and trainers with their horses — brushing, stroking and sweet-talking them, whispering their barn names (which are different than their official racing names) — will realize how close the relationship really is. They know how much is involved in training horses, who are, in the words of one fanatic, "about as naturally responsive as deer." To discipline a horse represents man's best, kindest triumph over his environment.

The interaction between man and horse is made all the more intense because the equine passion is a family affair here, the skills treasured and honed for generations among a group devoted to the steeplechase, a sport that is rarified even within the elite world of horse racing.

Steeplechase racing has its origins in Ireland, the first recorded event having been held in 1752 in County Cork, with its hilly, church-rich landscape (hence the name). Both steeplechase racing and its sibling, timber racing (where the hurdles are all made from natural wood or logs) are closely linked to fox hunting — to hunting's speed and jumps. Those elements have always made steeplechasing particularly strenuous and

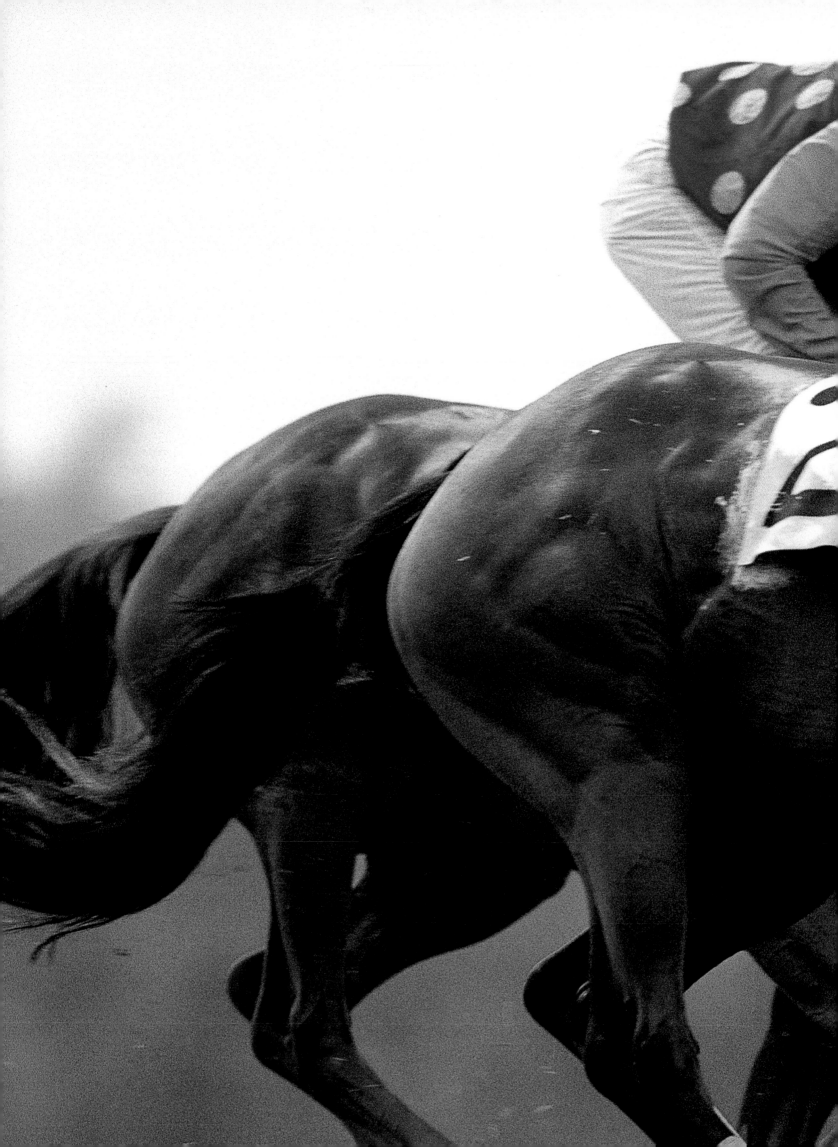

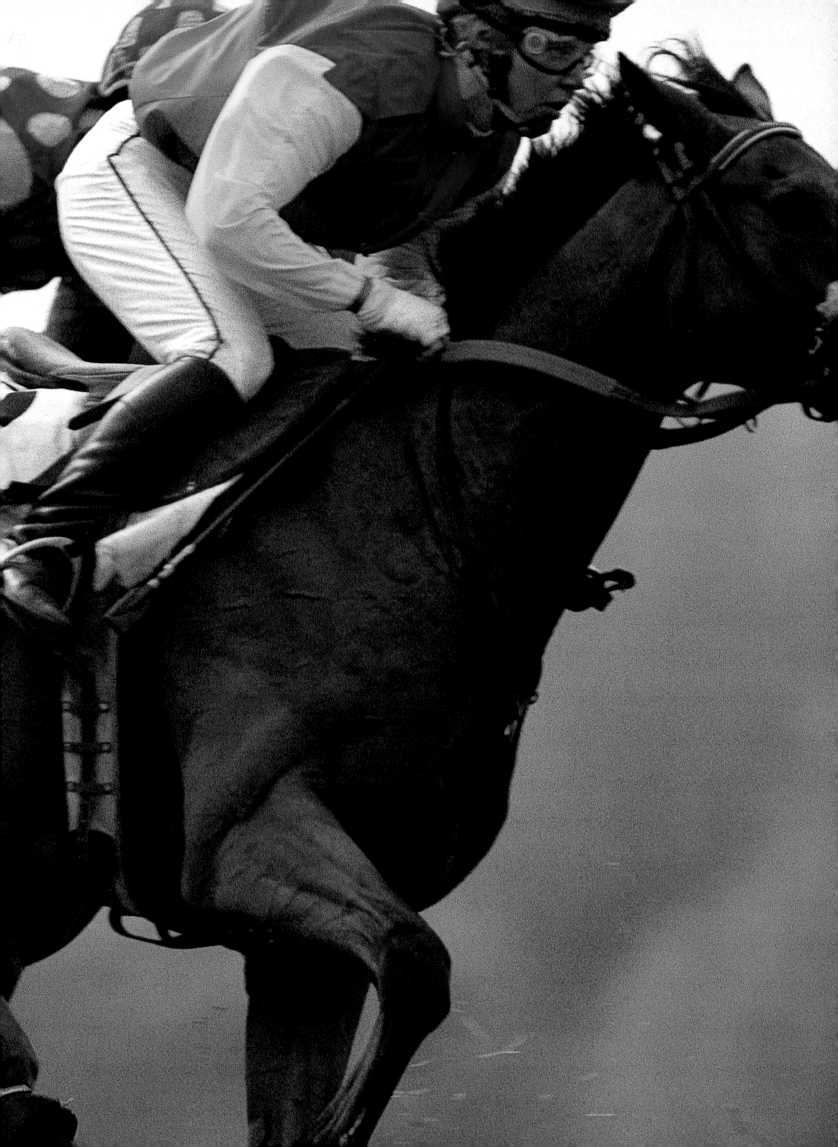

chancy, so steeplechasing has never attracted betters the way flat-track racing has.

Although owners have paid upwards of $100,000 for a steeplechaser, the average top-notch thoroughbred steeplechaser costs closer to $50,000 (not including room, board, and training, or the vet and blacksmith bills). With such prices, and the purses so much smaller than those for flat racing, it is not terribly surprising that steeplechase racing has always been a rich man's sport. In England, Prince Charles and Princess Anne are enthusiasts; here, the du Ponts, Phippses, and Mellons have kept interest alive. Although Maryland and Virginia have been the traditional strongholds for steeplechase dynasties, Unionville, Pennsylvania — "one of the horsiest areas in the country, if not the world," in the words of one enthusiast — has made some real inroads.

"The land here is as good as it can get," explains local Bruce Miller, a Cochranville, Pennsylvania, trainer whose successes include Lonesome Glory, the 1993 champion horse. "There's so much open land that has been protected, and that has brought the type of people who like horses. There are lots of hills, and the turf on the hills draws well. The soil is good for cattle, and whatever is good for cattle is good for horses."

So it is no surprise that Jonathan Sheppard, the most successful steeplechase trainer in the country, with seventeen national championships out of the last twenty years, lives here. So does Burly Cocks, widely agreed to be the dean of steeplchase training, who first taught Sheppard. So does George Strawbridge, Jr., the top-winning owner. And so does Bill Lickle, who owns Victorian Hill, the all-time top money winner.

Daughters and sons alike are bestowed with the horse legacy. In the crowd today, for example, is Betty Bird. "Well, Betty is a Bosley," anyone can tell you, and they all utter the name *Bosley* — a famous Maryland horse family with three generations of Hunt Cup wins — with the same reverence. Betty's brother rode; her mother trained the renowned horse Chase Me; her husband, Charlie Bird, was Master of the Mead in Ireland.

"Girls just rode show horses then," explains Chris Browne, a New York equine dentist who does business in the area (his business card boasts "Have Float Will Tote"). "But Betty rode with the men and beat the men. She was fearless."

When the horses take off, some of the 15,000 Winterthur Point-to-Point spectators press up against the fence marking the 3 1/8 mile course. From here you can see the veins bulging out and pulsing on the horses' necks, the whips hitting their flanks. The percussion of hooves gives you some sense of the velocity, and the risk — when the announcer utters, hushed, that one of these 1,000-pound horses is a "faller," and the owners and trainers run toward the scene, collective concern for both jockey and horse is palpable. But the other jockeys keep going, determined as soldiers, unflinching in the machine-gun fire of the horses' hooves.

Given the thunderous competition, you might expect animosity. But most of the competitors here are friends, and there is a great deal of give-and-take. Bruce Miller's operation only trains four steeplechase horses and four fox hunters on seventeen acres of land, but "I'm very lucky," he says, "because I border George Strawbridge, who has 2,000 acres that I can use." Miller's daughter, Blythe, and son, Chip, are both accomplished jockeys who have gone on to victories on horses owned by George Strawbridge, and trained by Jonathan Sheppard. In the afternoons, Blythe finishes helping her father train his horses and then goes a mile down the road to help train Strawbridge's horses. There she might bump into her roommate and best friend, Cassandra ("Sanna") Neilson, George Strawbridge's stepdaughter, herself a trainer — in fact, a horse Neilson trained for Strawbridge, Luke a Duke, won the Champion's Cup with Blythe's brother, Chip, as the jockey.

Got that? In this very small world, steeplechase owners, trainers, and riders follow each other's successes with intense good will, and a healthy hint of jocular competition.

JANET ELLIOT, BLYTHE MILLER, AND SANNA NEILSON: *"We Take It Very Seriously"*

*B*ruce Miller still remembers when his daughter, Blythe, got her first horse at age five. "She took her pony into the house, it pooped in the kitchen, and she has been riding ever since." She began fox hunting the same year with her grandfather, Fulmor Miller, head huntsman for an estate in Bucks County, Pennsylvania.

At twenty-four, Blythe Miller became the first woman to win a steeplechase stakes race, the prestigious $250,000 Breeder's Cup. She also rode Lonesome Glory, a 20-to-1 long shot that her father trained, to victory in the Sport of Kings Challenge, becoming the first American jockey ever to win a race on English soil. In 1994, she was second in the standings, with twenty-one wins to the top jockey's twenty-two — "very frustrating," she admits — and the only woman presently competing on the circuit, with Victoria Schlesinger of Maryland injured.

"I always thought I'd ride flat horses," Miller recalls. "But I couldn't ride flats and go to college; with steeplechasing, I could just compete on the weekends." Steeplechase racing, she has found, is "a lot more demanding athletically. We're going twice as far; the horses are stronger and fitter, more trained for endurance. Flat racing is more of a speed sport. In our racing, the fastest horse won't necessarily win."

Like her friend Miller, Sanna Neilson also took the steeplechasing world by storm when she became the first woman to win the Virginia Gold Cup on her first start in 1991. In 1992, she was the first woman to win the Colonial Cup, and even she admits that "it was kind of a big deal to win both." She has also won the Maryland Hunt Cup twice — once beating out her father, Louis ("Paddy") Neilson, himself the winner of three Maryland Cups since 1958.

Despite her early and impressive successes as a rider, Neilson is presently concentrating her efforts on training. "It's too much pressure to both train and ride the same horse," she explains. After eight years of experience training with Jonathan Sheppard, she now trains fifteen horses on her own, many for her stepfather, George Strawbridge, and already boasts an impressive 50 percent win rate.

With a smaller stable than many of her competitors, Neilson finds that she is able to give horses the kind of attention they might not receive elsewhere. "One horse, Casual Flash, was a weak, weedy little horse that came over from England two years ago. He won his first race this spring, but then he was just acting kind of dull. When we did the blood work, it turned out he actually had a problem with his adrenaline gland — a simple problem but not necessarily an obvious one. Pregnasone got him back on track in a couple of weeks, and he made a complete turnaround. In a bigger barn, he might have just gone down the ladder."

Like Miller, Neilson stresses consistency in training, as well as "mutual respect — you can't treat a horse like a go-cart. You have to know if they're going well, or struggling." One of the intrigues of training steeplechase horses is that you never know for sure how a horse's career will go. "A $5,000 horse can turn out to be a great steeplechaser," Neilson explains, "and a $50,000 one can turn out to be a big flop."

Janet Elliot, who currently trains about twenty-five horses — predominantly steeplechase and timber horses, but some flat as well — agrees that past performance on the turf is by no means a perfect predictor of how the horse will perform on the dirt. One horse she trains, Victorian Hill, the all-time money-winning steeplechase horse with close to $700,000, is unusual in having run every year for the past seven years. "I have other horses that are even better than Victorian Hill, but haven't been able to run consistently. Census was a wonderful horse, but every other year he missed because of injuries, problems with tendons and ligaments."

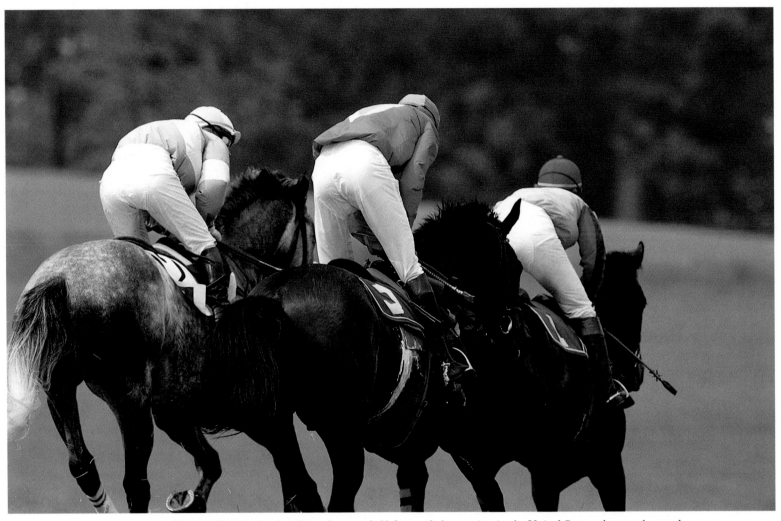

Although Virginia has long been the stronghold for steeplechase racing in the United States, the sport has made great inroads in the Brandywine region in the last few decades. At Fair Hill, near Elkton, Maryland, these racers have just successfully completed the strenuous course.

Originally from County Cork, Ireland, the birthplace of steeplechasing, Elliot has been in the area for twenty-three years. In 1992 she was the first woman ever to lead in steeplechase training, besting her teacher, Jonathan Sheppard. In 1993 she was second in steeplechase purses, with eighteen victories for the season.

Like Neilson, Elliot allows each horse the time it needs to learn jumping. Some horses graduate in a couple of months from leaping over logs to conquering four-foot hurdles, but the time can vary a great deal. "We had a horse here once that took a year to get to jump. I hate to say it, but it wasn't worth the effort; he pulled a tendon his first start."

Miller, Neilson and Elliot agree that they have encountered very little sexism in their sport. "We take it very seriously," Neilson says. "We don't try to play up that we're women, or butter up, or ask for anything special." Only very rarely, Elliot says, "you will meet that isolated person who will behave differently around a woman, and try to push his weight around," but it is most decidedly the exception in this intense, competitive sport.

Since jockeys do not, for the most part, have binding contracts with trainers or owners, "they ride for whoever needs it," Elliot says. Thus, Luke a Duke, trained by Sanna Neilson, was ridden by Chip Miller to win the Future Champion's Cup, while Blythe

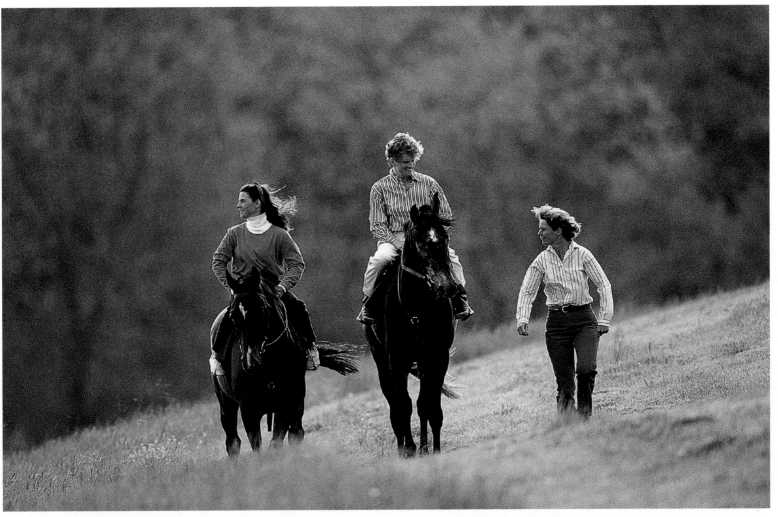

The Brandywine Valley is home to two of the best steeplechase riders in the country: Blythe Miller (left), the first woman to win a steeplechase stakes race, the $250,000 Breeder's Cup, and Sanna Neilson (center), the first woman to win the Virginia Gold Cup and the Colonial Cup, an impressive double victory. Janet Elliot (right) is the long-time trainer of Victorian Hill, the all-time money-making steeplechase champion owned by Bill Lickle.

Miller rode the Sheppard-trained T.V. Gold in the Colonial Cup — against horses run by their father, Bruce Miller, who feels nothing but pride in his children's victories. Blythe gives first call to Jonathan Sheppard, and Chip gives first call to his father. As much as Sanna would like Chip on her horses, "sometimes I just have to find someone else" to serve as jockey for a particular race.

Like other sports, racing allows a small window for peak performance. A jockey is at his or her prime from twenty-five to thirty years; after that there is increased risk of injury, and it becomes more difficult to stay fit, keeping weight down to meet the limits for riders. But a passionate horseperson can keep training. In racing, you can feel how smooth the transition is between riding and training, how deep the pride in passing on the skills. Around these parts, seeing a friend or relative win is the next best thing to crossing the finish line yourself. After all, if Burly Cocks trained Jonathan Sheppard, who trained Sanna Neilson and Janet Elliot, who trains horses ridden by Chip and Blythe Miller, who may win against horses trained by their own father, it's hard for anyone to flat-out lose.

Pages 122-123: An Irish groom tends to his horses during an annual picnic held by carriage enthusiasts overlooking Wyeth country the day before the Winterthur Point-to-Point races in early spring.

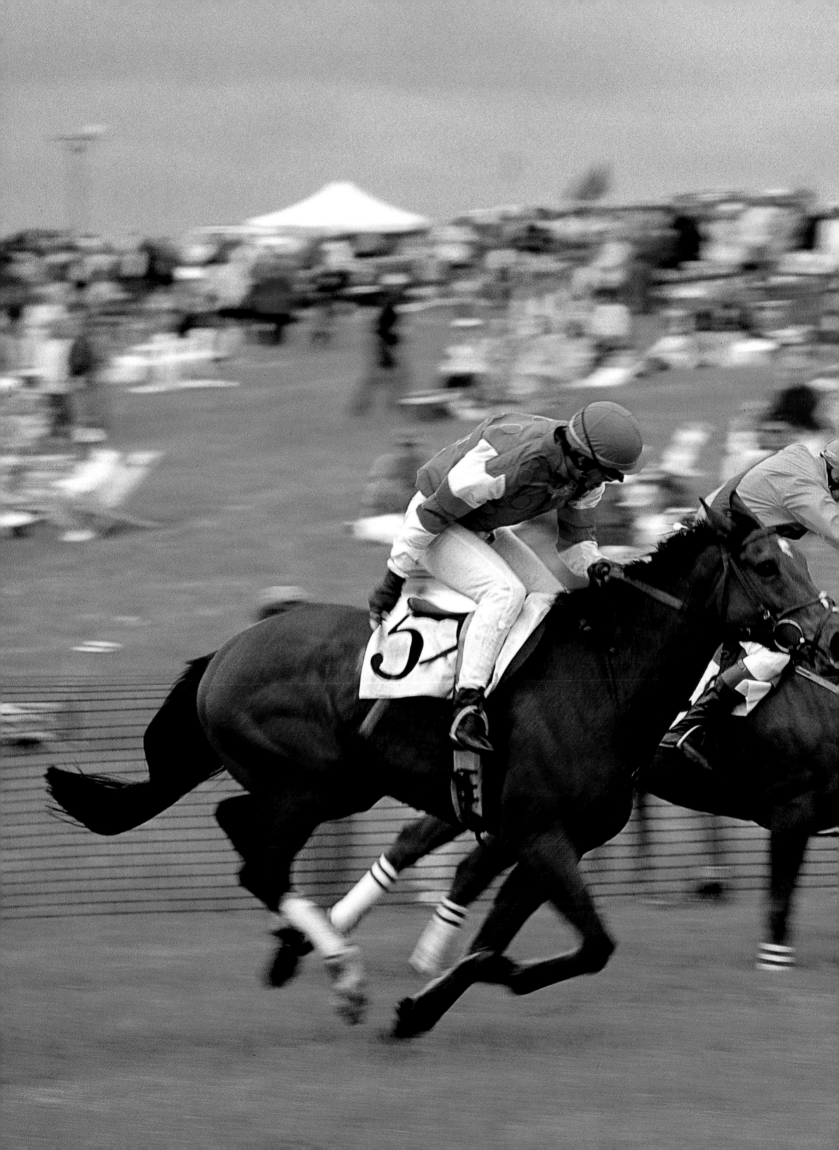

Pages 124-125:
The drama of a full dash to the finish at the Winterthur Point-to-Point races, the apex of the Brandywine Valley horse-racing season, is heightened by the brilliance of the Irish-green turf and the vivid silks of the jockeys.

Right:
One of the region's most celebrated horsewomen, Mrs. Elizabeth C. Bird was riding with the men ("and beating them") when most girls were still riding show horses. The daughter of a famous Maryland horse family with three generations of Hunt Cup wins, the former Betty Boswell married Charlie Bird, the Master of the Mead in Ireland, and today continues to train, breed, and ride her stable of beloved thoroughbreds.

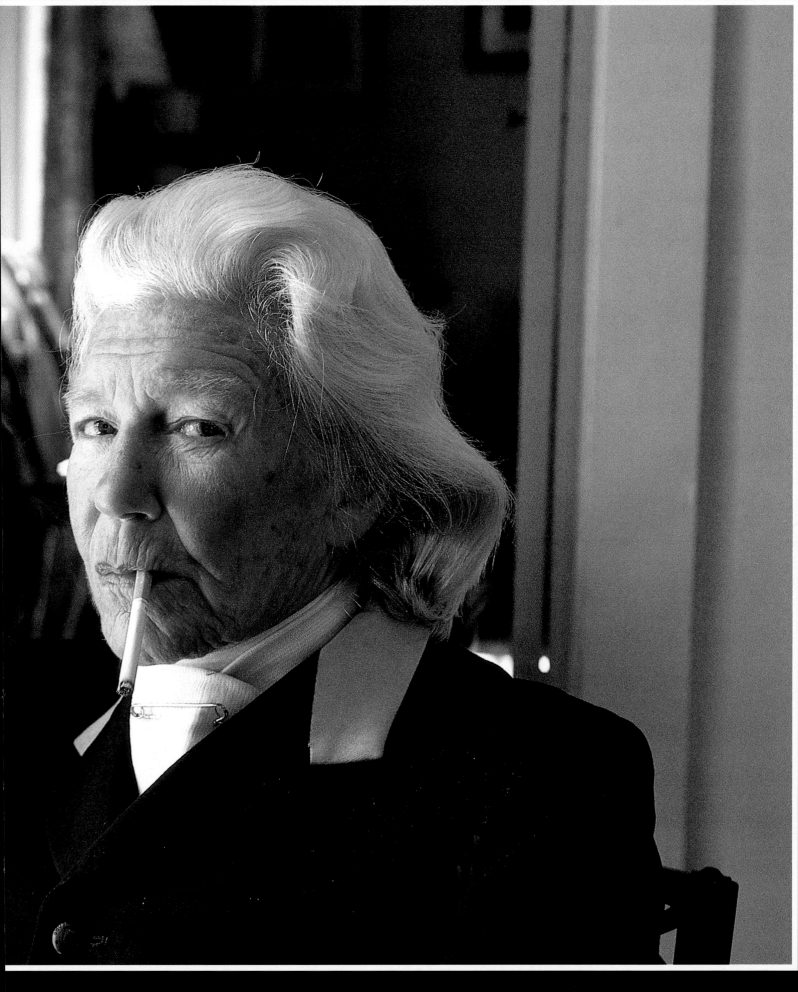

BETTY BIRD

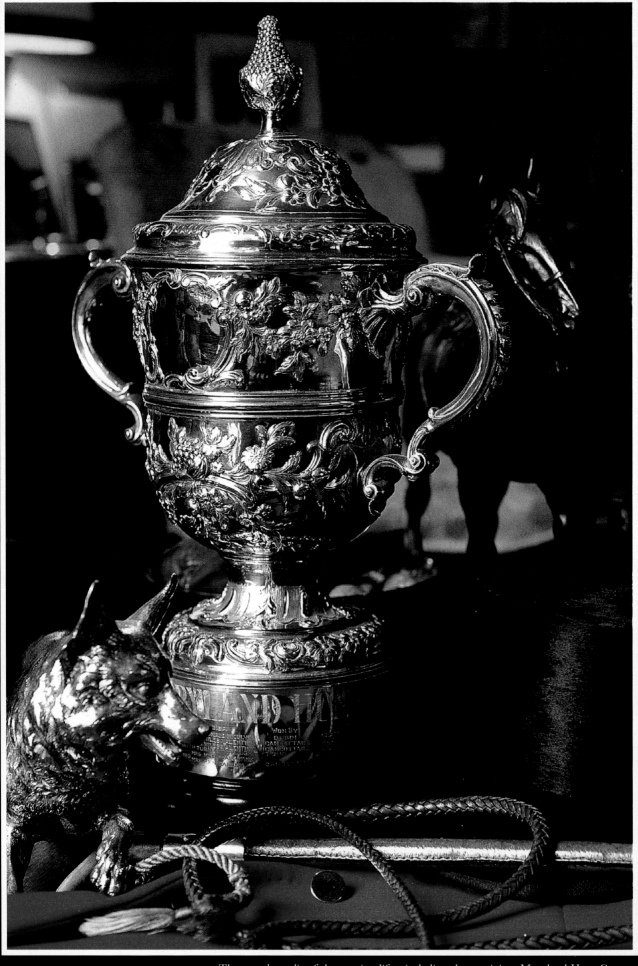

The paraphernalia of the sporting life—including the prestigious Maryland Hunt Cup —

A very formal shad-bellied tail coat such as this would rarely be worn to the hunt these days.
A century ago, a top hat and white breeches would have finished the look.

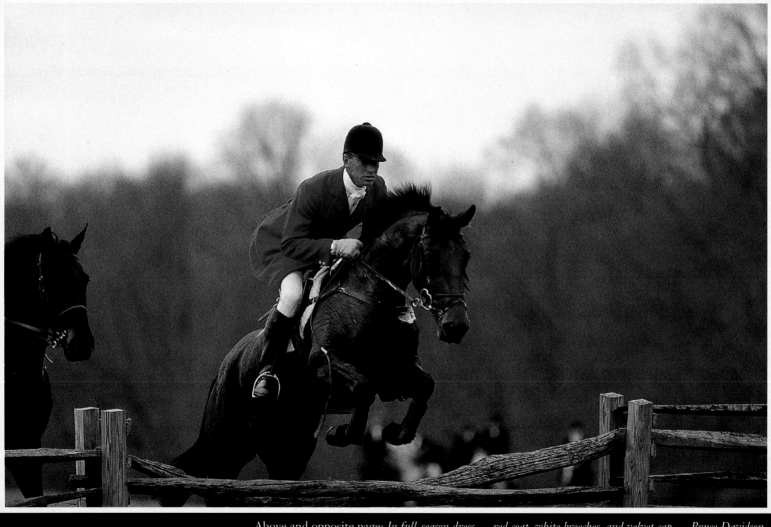

Above and opposite page: *In full-season dress — red coat, white breeches, and velvet cap — Bruce Davidson, one of the country's top steeplechase jockeys and an Olympic equestrian three-day-eventer, leads the field of the Cheshire Fox Hounds during a winter hunt. His mother-in-law, Nancy Hannum, trains and breeds the foxhounds for the club.*

Pages 132-139: *Scenes from the Brandywine Valley hunt country, including huntsman Joe Cassidy (left) leading the field of the Cheshire Fox Hounds during the informal "cubbing" season in late summer (132); a field master signalling that a fox has been drawn during a winter hunt (134); foxhounds spilling over a timber jump thoughtfully placed on private property (136); and the formally dressed field during a high-season hunt waiting for a fox to be drawn beside an ancient woodlands clearing (138).*

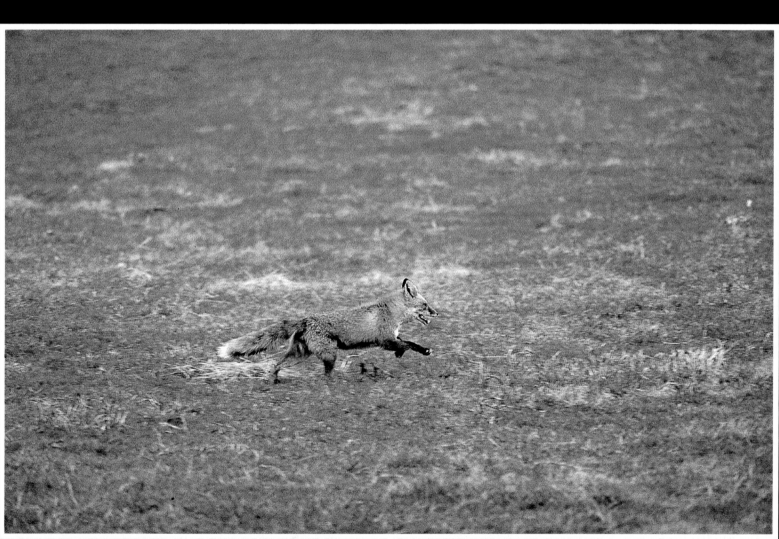

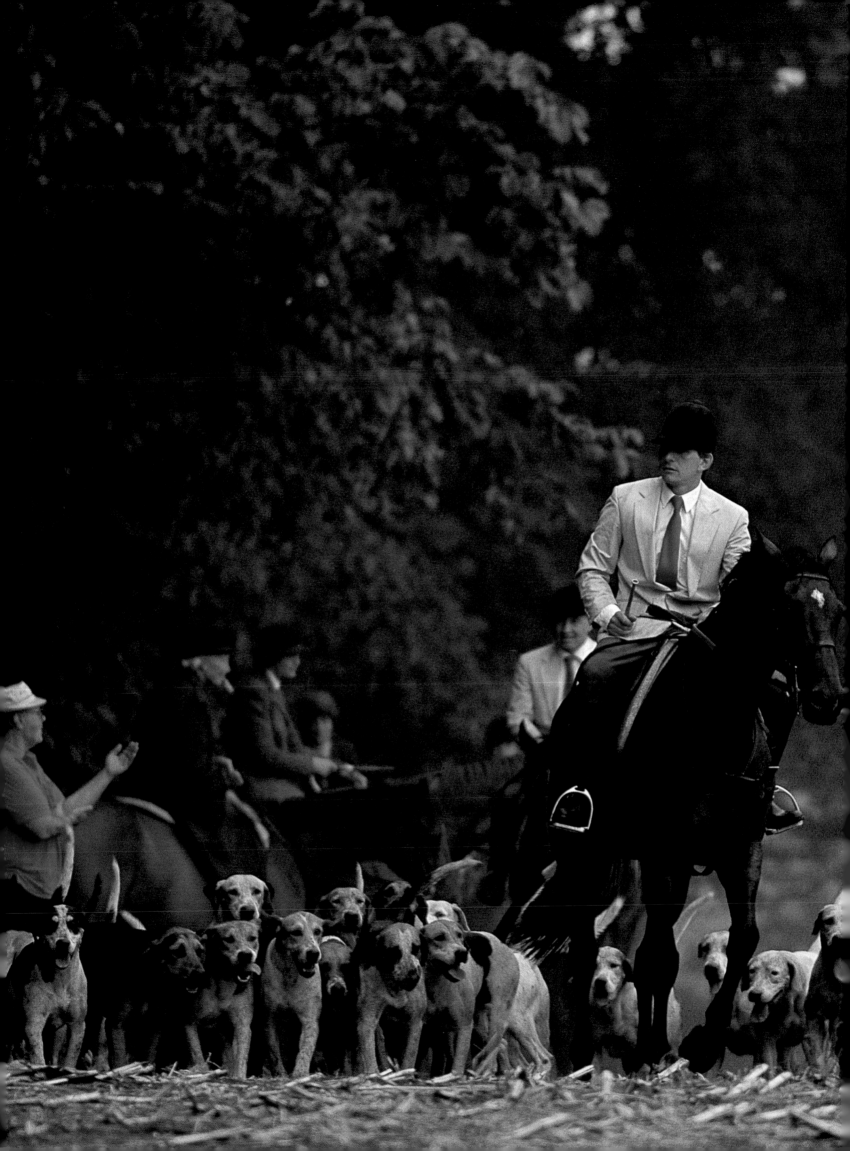

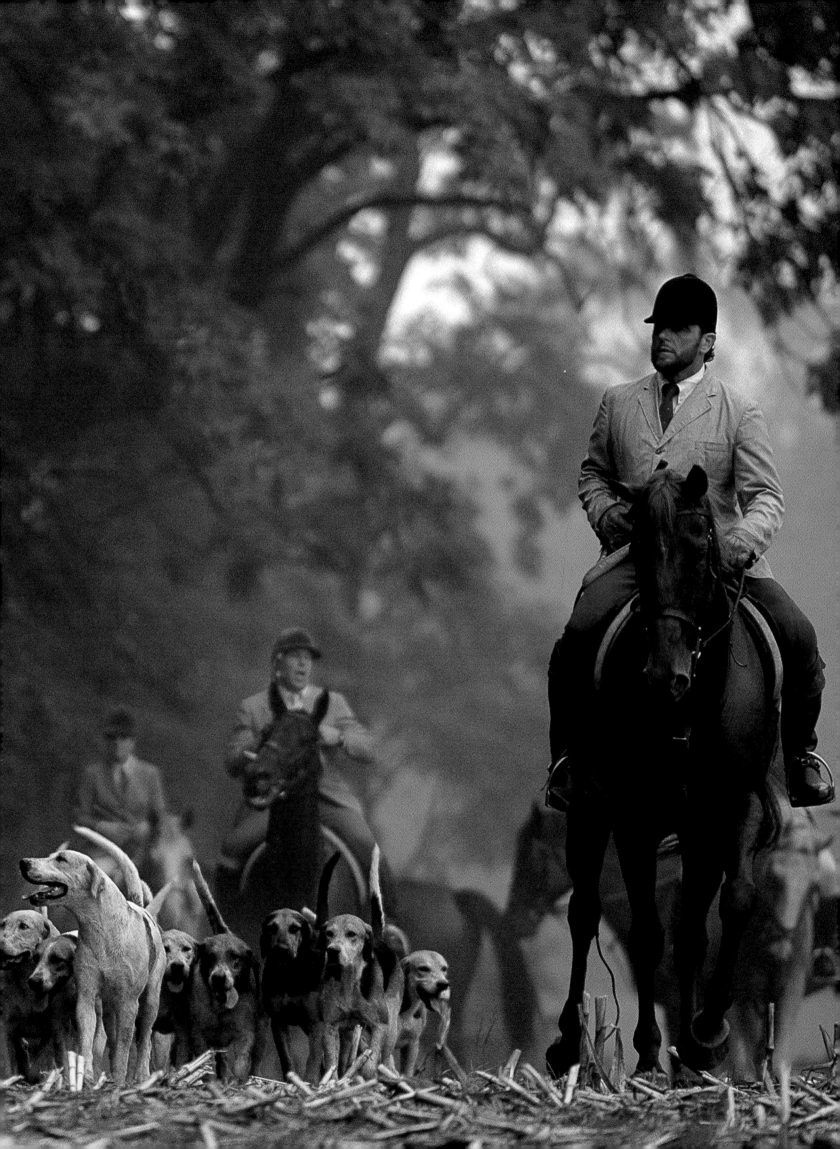

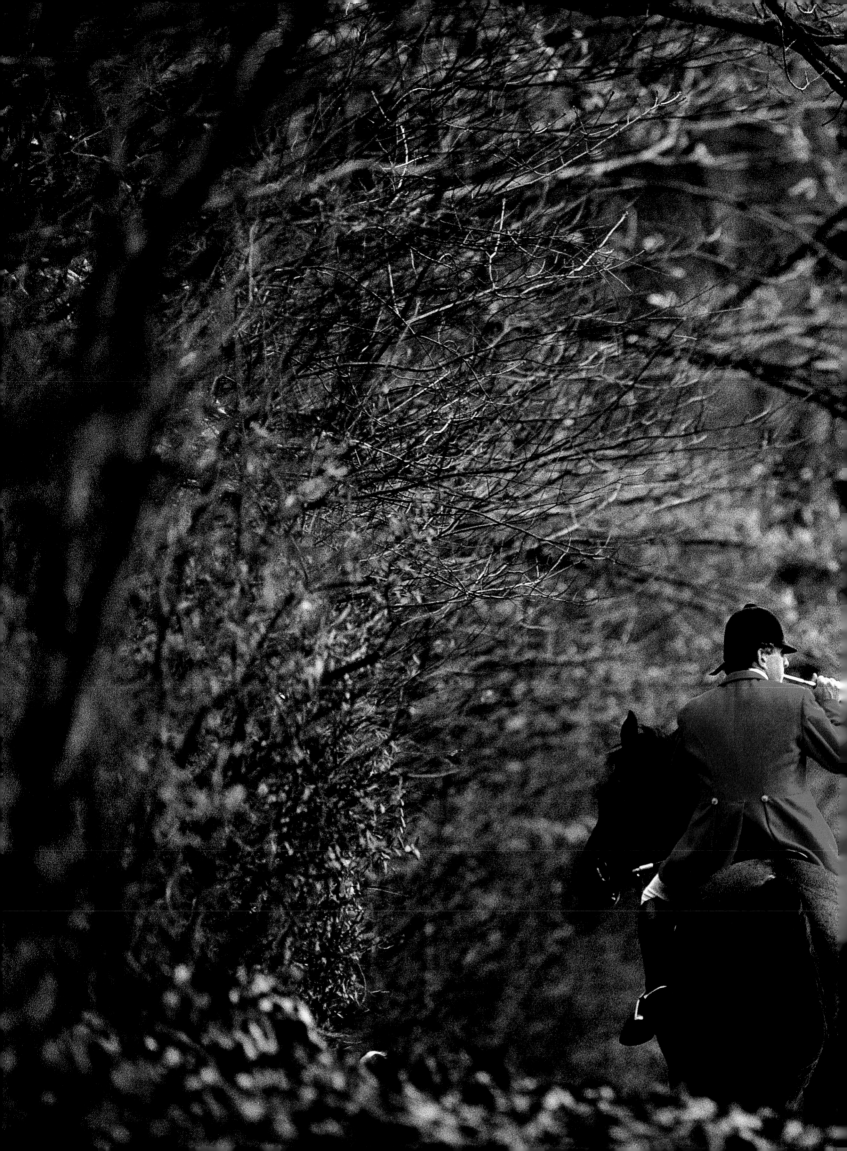

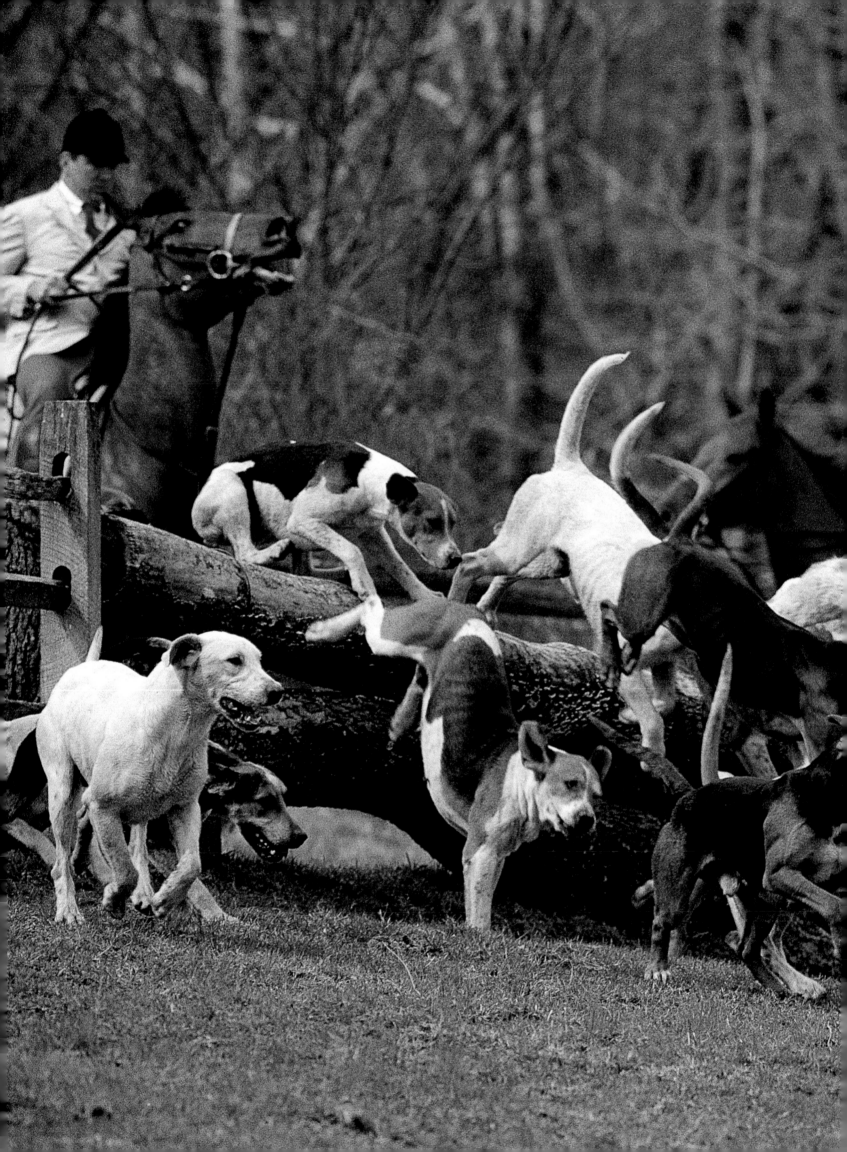

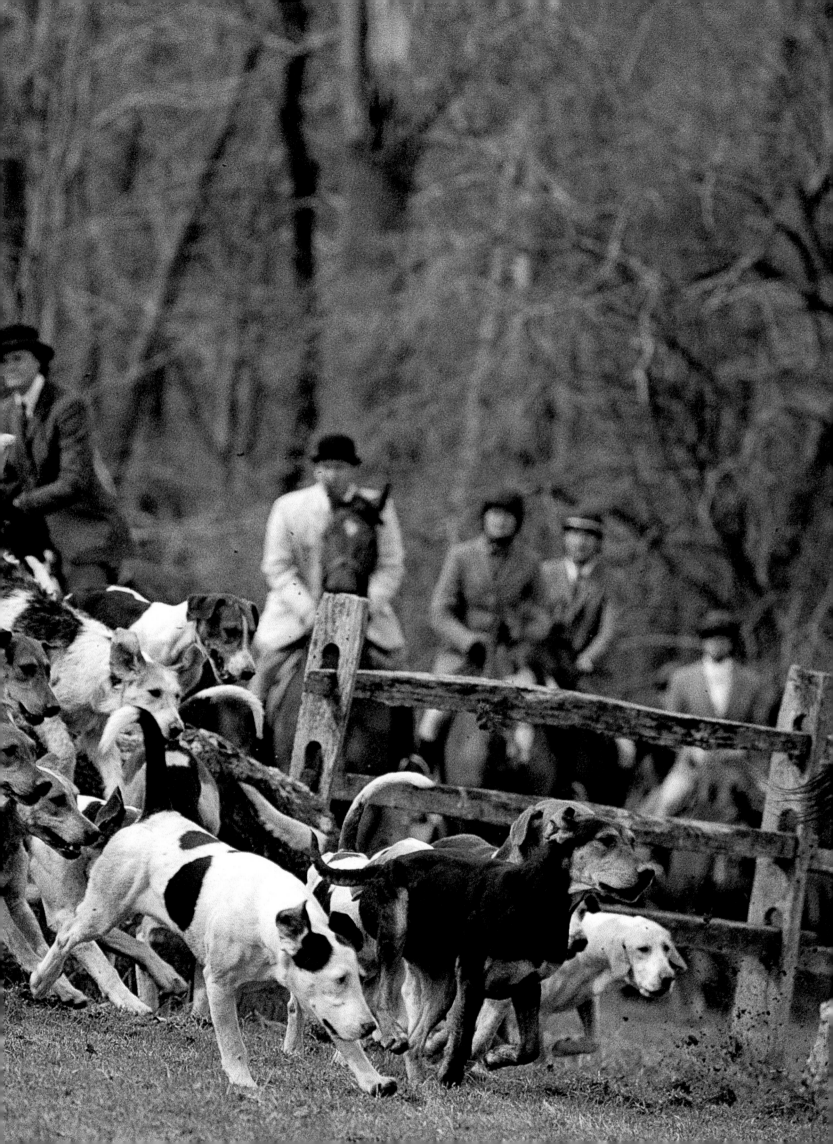

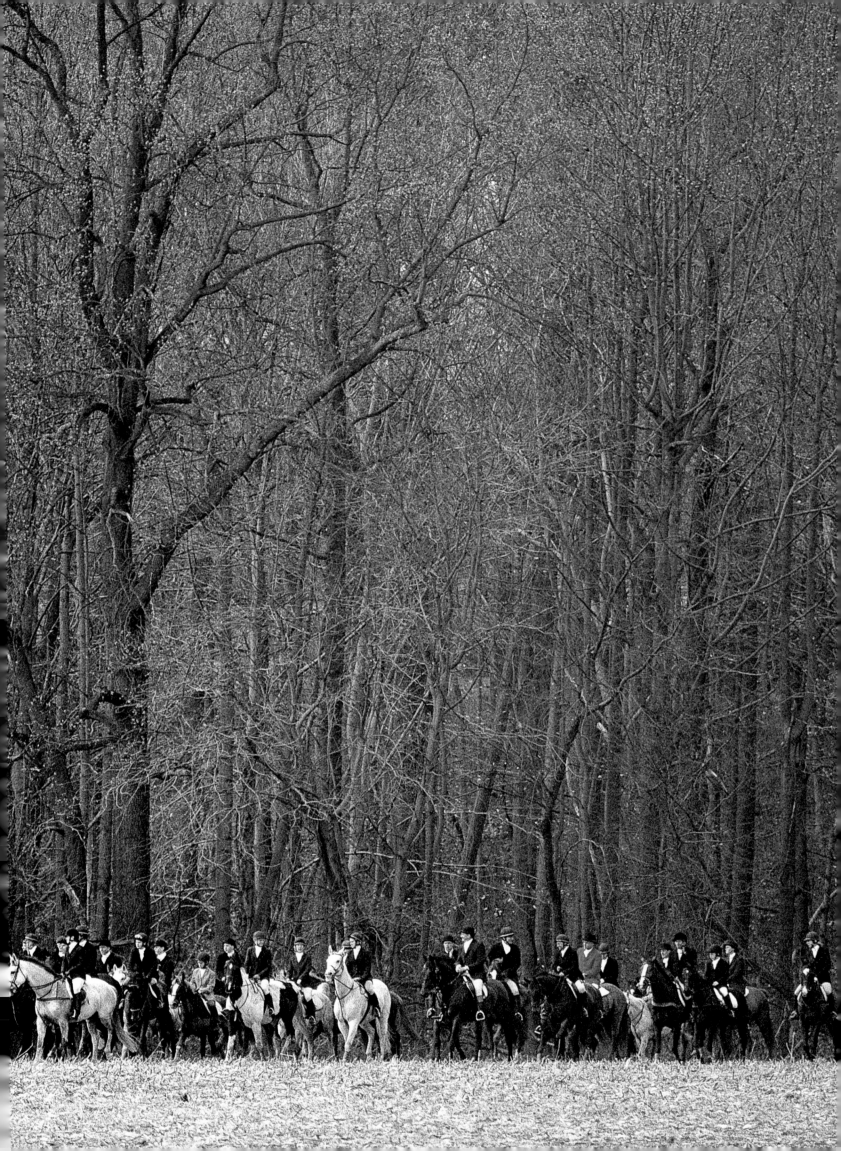

Above and opposite page: *An impressive collection of racing silver and a vintage shad-bellied hunt coat attest to a life-long love of horses in a well-known horsewoman's Pennsylvania home.*

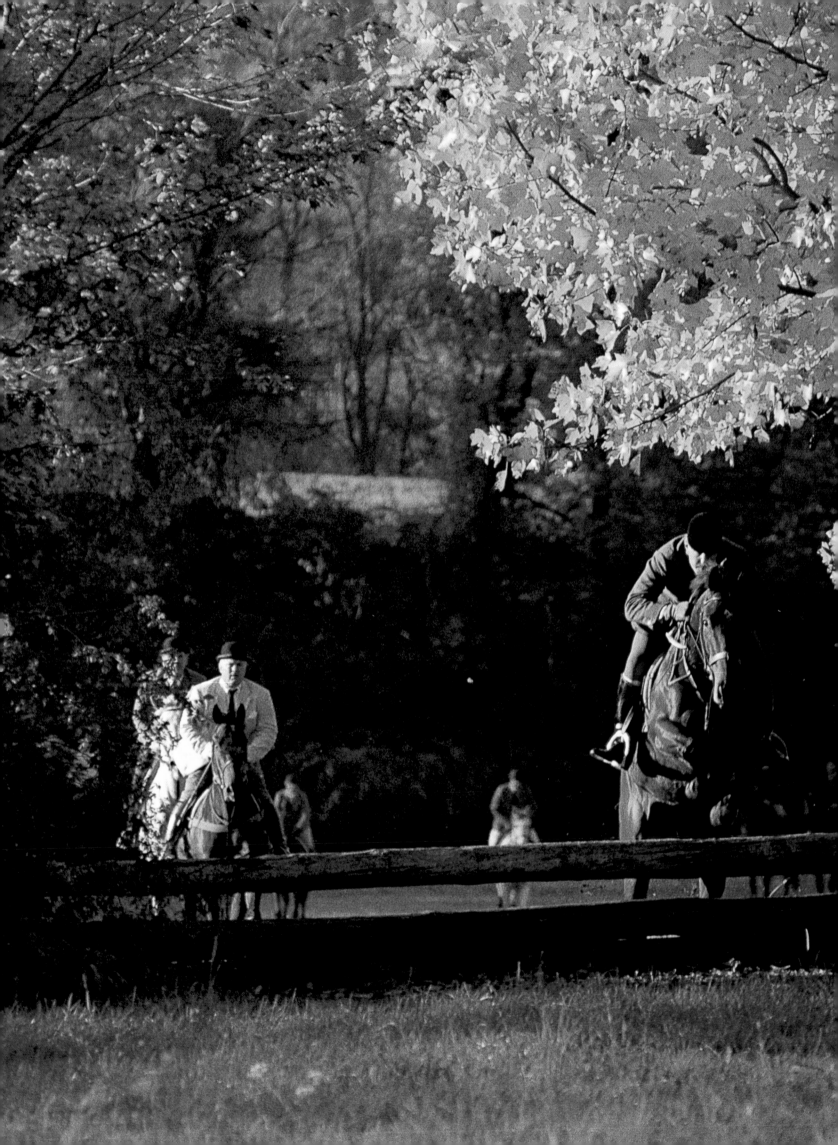

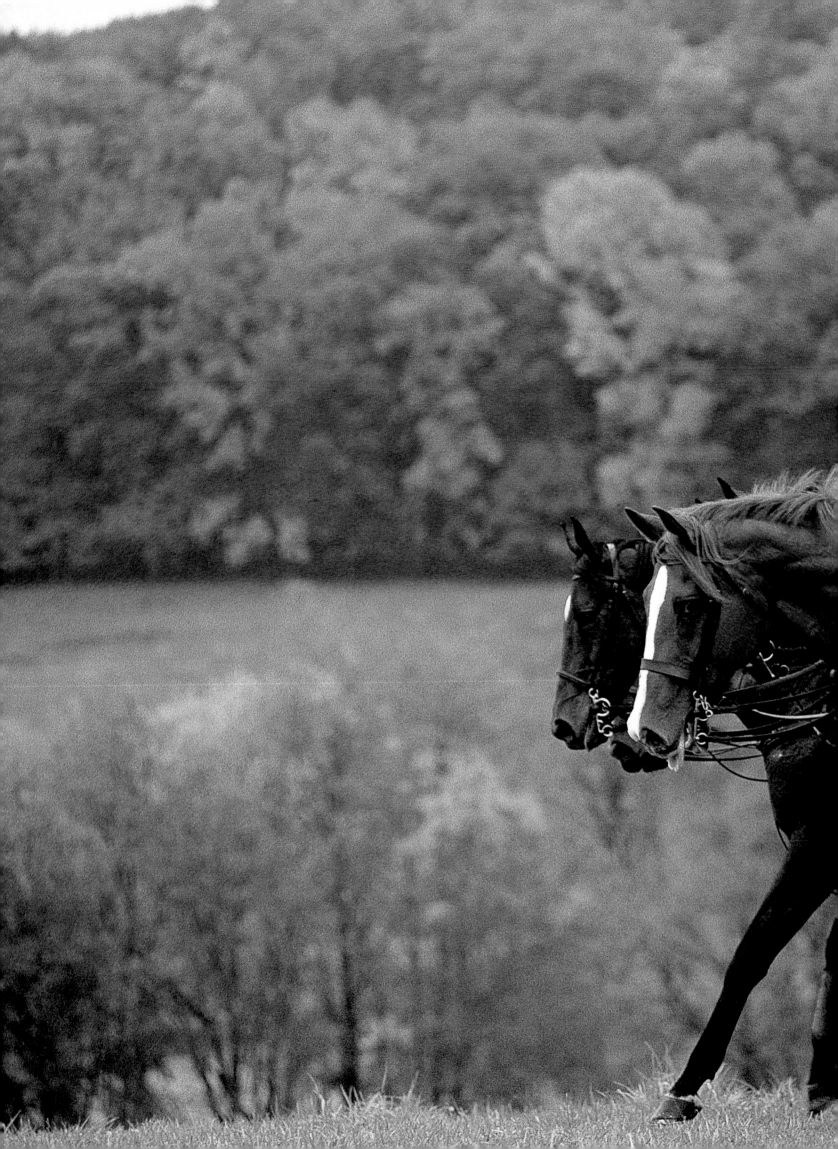

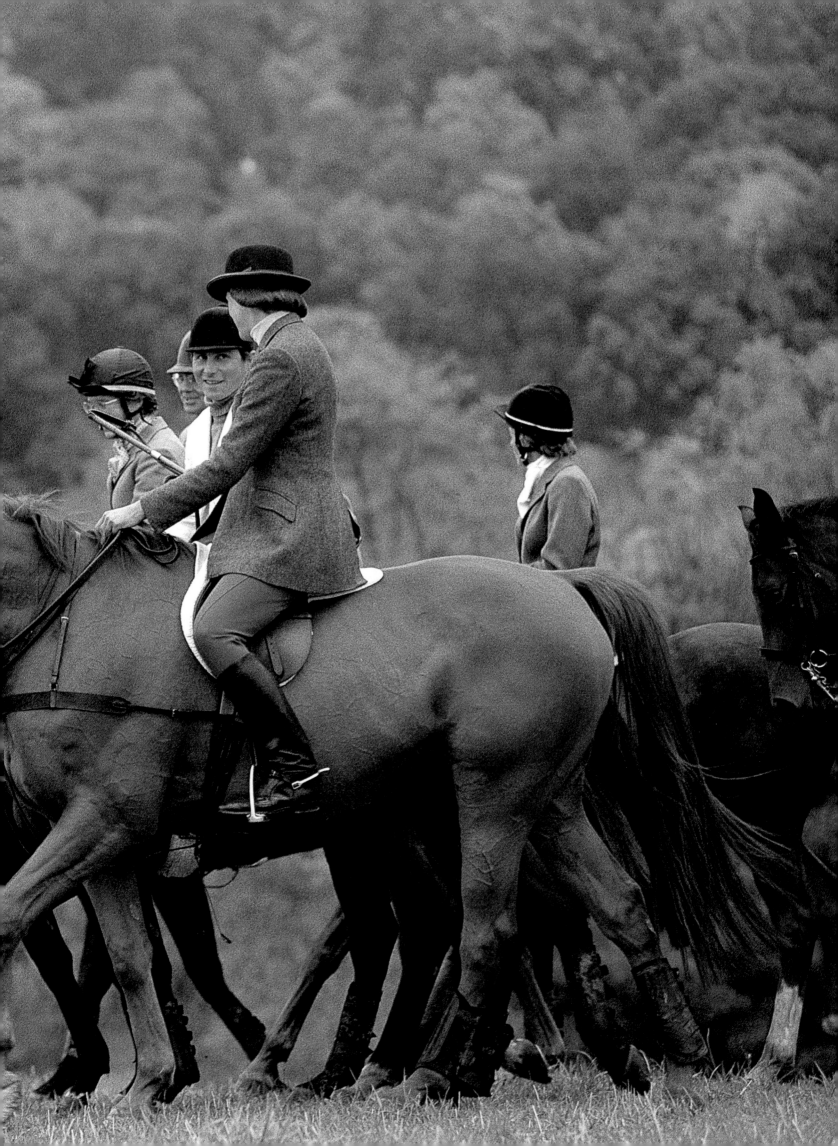

Tallyho

*A*t the height of the season, as many as two hundred people may comprise the "field" for a fox hunt, the riders all turned out in narrow red coats and gleaming leather. But it's April now, the official season over, and unseasonably cold. A terrible winter has shortened the number of serviceable hunting days — you can't ride a horse at these speeds, on these steep hills, in ice — and by mutual agreement, the members of Mr. Stewart's Cheshire Fox Hounds in Unionville, Pennsylvania, have agreed to lengthen the season. The occasion is for diehard hunters only, about thirty of them, some in cubbing clothes (breeches and boots, tie and coat — maybe the brown coat called a "ratcatcher"), some just in jeans. The field also includes three or four groups of spectators in pick-up trucks by the side of the road, known around here as "car hunters."

Extending the season does not turn out to be a good idea. Although the farmers gladly agree to have the hunt club use their land, it makes them uneasy; they don't want horses trampling newly-planted crops. Mares have foals being born, thus are easy to spook. And vixen have just had their cubs; no one is eager to kill a brand-new mother.

There is no fox at the moment. The field stands around chatting on horseback, talking shop ("The good horses are gone in a week," one rider complains, "before you even have a chance to take 'em around"), waiting for another fox to be drawn. Many of these people have hunted together for decades, and you could almost be deluded into thinking this is merely a social occasion, as relaxing as a cocktail party — until a fox glints in the distance, its luscious auburn coat bright as a crossing guard's, the huntsman blows the horn, and the riders are off, following the field master, as finely-tuned a pack as the hounds themselves.

Fox hunting is not a competitive sport. The challenge is to ride a horse that can keep up with the group — many horses simply can't — and still manage to be well-mannered, well turned-out (or at least as spiffy as you can expect, for an animal that has just vaulted through mud). Some of the animals are racehorses whose trainers are giving them a break from the relentless day-to-day work of steeplechase training, although many racehorses can't fox hunt — "they're just too wired," a hunter explains, "like a guy on steroids." Some are ex-racehorses, sold when they failed to perform up to expectations, or got too old.

Trying to photograph a fox hunt, or watch it from the side of the road as many locals do, gives you an inkling of the pleasure the field must take from being on the scent, in the moment. No two hunts are ever the same. The field meets at a different location for each day's hunt, so the terrain changes constantly, bringing new surprises — a stream to cross, a fence to leap. The risk of injury is real. But those who love the sport tend to love it for life.

Joe Cassidy, the huntsman who leads the Cheshire Hounds, left a successful career in racing to return here. And Oscar J. "Monk" Crossan, the whipper-in (who follows the pack), started practicing his job as a little boy with a stick, when his father was doing this very job on this very land.

Two common misconceptions about fox hunting bear correction. Despite its upper-crust origins, fox hunting is egalitarian. As Bruce Miller, a steeplechase trainer and former whip, points out, "You can fox hunt cheaper than you can do just about anything on a horse." And although one would tend to assume that any hunting is cruel, fox hunting is decidedly not.

Linda Clark, an artist, horsewoman and club member who lives in Unionville, has only seen a fox killed once. "The foxes are so smart and calm," she says. "Especially in the fall when the leaves don't block your view, you can watch the hounds go in after the

Pages 142-145:
Maryland Hunt Cup winner John B. "Jock" Hannum takes a jump during an autumn hunt (142), while, earlier, members of the field took a moment to talk shop and catch up on local gossip while waiting for a fox to be drawn (144).

scent in full cry, and you'll see the fox is relaxed, considering his next move. He'll trot one way, stop, trot another — it's not like he's running for his life."

With more than four foxes per square mile in this rich countryside, more foxes are killed by cars. These hunters adamantly do not wear fur. In fact, in winter, the hunters have been known to feed the foxes, to keep them fit for the chase so central to the region's past and pride.

NANCY HANNUM: *"The Pleasures of the Hunt"*

*E*ven her friends, it seems, don't call her Nancy. To one and all she is Mrs. Hannum — imposing, almost regal. Mrs. Nancy Penn Smith Hannum breeds and trains the hounds for Mr. Stewart's Cheshire Fox Hounds, a club that has met for fox hunting since 1912, when her stepfather, W. Plunket Stewart, established it. So enamored is she with the chase that for years irritating problems like broken bones or arthritis couldn't keep her off horseback.

Now she mostly hunts in an old Jeep, with seats as cracked, oiled and supple as that of a good saddle. The way she floors that Jeep as it leaps over the hills of the 30,000 acres of pristine countryside that her club hunts, you would think she held reins instead of a wheel.

To enter the compound where Mrs. Hannum's hounds are bred (remember to say *doghounds* or *bitches*, never *dogs*) is to enter another world, one that has not significantly changed since the early days of fox hunting. Indeed, to speak with Mrs. Hannum — whose accent is clipped and vaguely British, like Katharine Hepburn's in *Philadelphia Story* — you need to learn the lingo, so you can understand lines like "The huntsman is making the ground good with the thought that the fox probably did go to ground." (Translation: the man responsible for keeping the pack on track is circling the hounds back to the place where the lead hounds last had a good, strong scent.)

The countryside around Mrs. Hannum's house is seductively quiet — until you approach the yards. Then you are confronted by the barking of 140 happy hounds ready for the breakfast. These hounds require about three tons of dry food a month, supplemented by dead cows and horses cut up and skinned right here in the slaughterhouse, on the stainless steel Butcher Boy, so that nothing is wasted.

Perhaps not surprisingly, a pack of hounds this disciplined will listen to all commands, even at frenzied feeding time. Before a meal, the dogs are led into the "drawing room," and since all the dogs are excited, any dog that seems off — listless, feverish, a little thin — can be spotted easily. The kennel man will shout, "Stand back!" and the pack obliges, letting those needier dogs come through to get first dibs.

Mrs. Hannum rotates doghounds and bitches on Tuesdays, Thursdays, and Saturdays, and their hunting styles are very different. "On a given day, the doghounds may be unsurpassable, running hard with brilliant cry. But for a real, authentic hounds-man, the bitches are quicker and more malleable. The doghounds are more independent, but they're slower and more deliberate, so they can be better for a beginner."

Because the male and female styles are so different, the club never mixes the pack. "You'd only be saying, 'Oh, that Admiral, he's so slow today.' To hunt, the hounds have to be uniformly athletic, so if one's too slow or too fast, you knock 'em on the head — it sounds cruel, but it's really kinder. A hound who was once in the lead gets his heart broken when the pack runs away from him. A hound is at his peak at the fourth season — he can control his vices and his virtues are at a peak. Some you can keep in the kennels as stallion hounds, but they can't become housepets; all anyone needs is a hound's stern — we call the tail the stern — swooshing over their coffee tables."

Referred to by one and all as "Mrs. Hannum," Nancy Penn Smith Hannum has been breeding and training the hounds for Mr. Stewart's Cheshire Fox Hounds, founded in 1912 by her stepfather, W. Plunket Stewart, for as long as she cares to remember. Having ridden to the hounds since she was four years old, these days the indomitable Mrs. Hannum often follows the hunt in her four-wheel-drive Jeep, fearlessly maneuvering across the hunt-country estates of her neighbors with as much agility as if she were on horseback. Her love of the sport is unflinching: "You have to be fit and courageous to keep up; no wimp can do it."

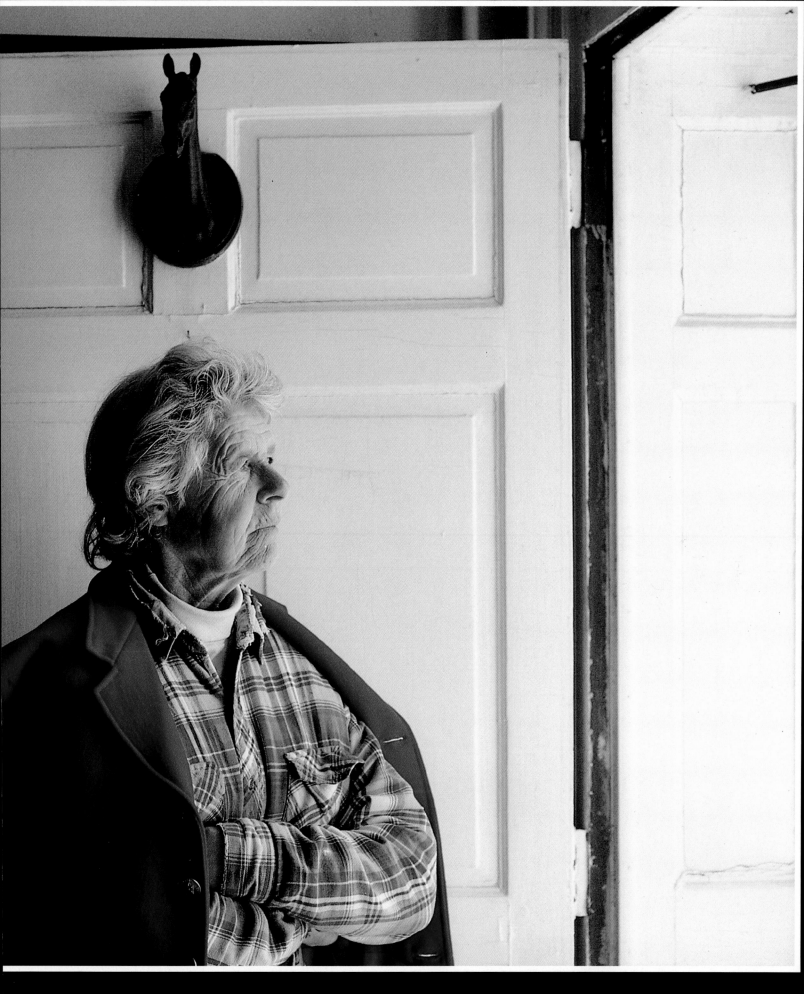

NANCY HANNUM

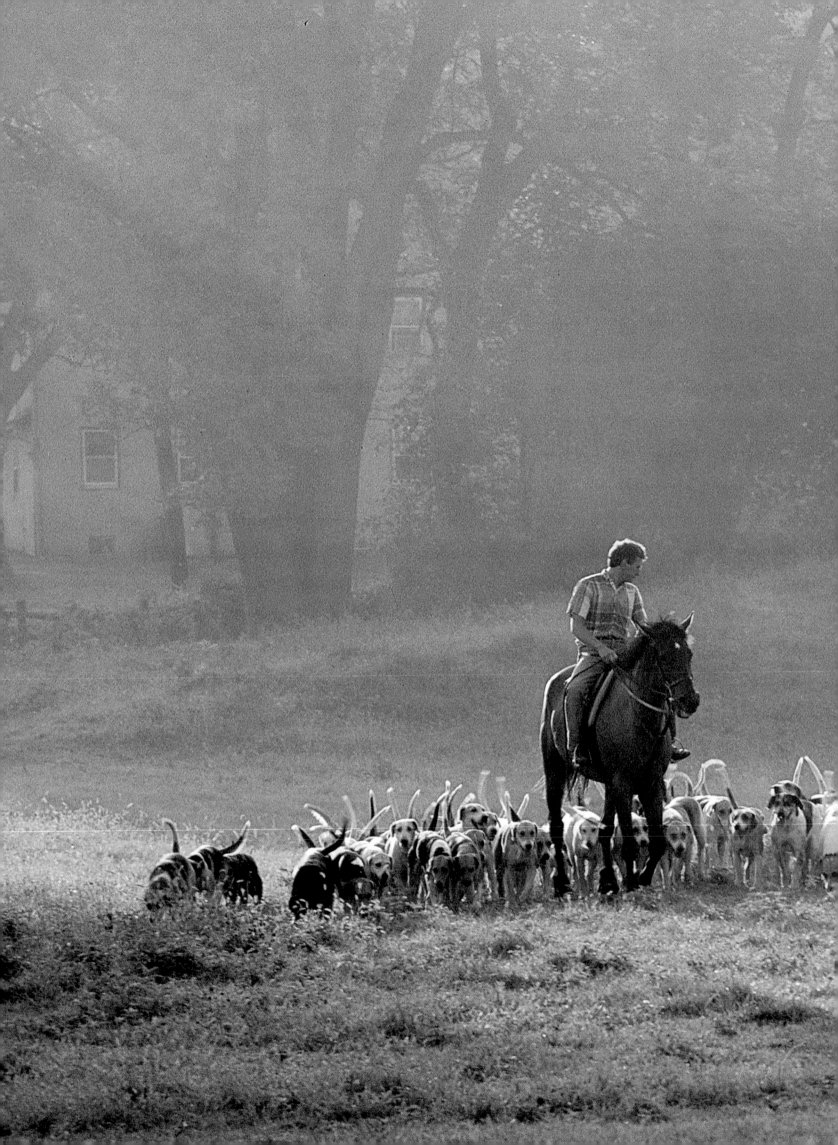

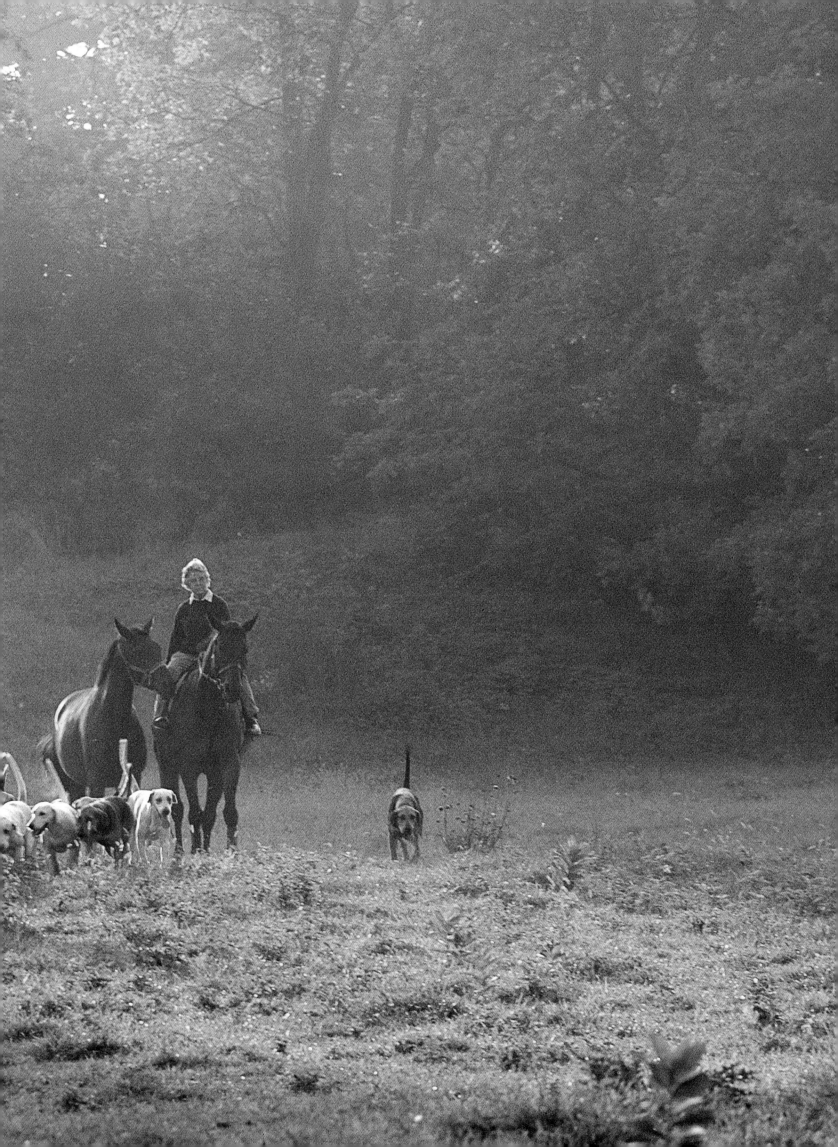

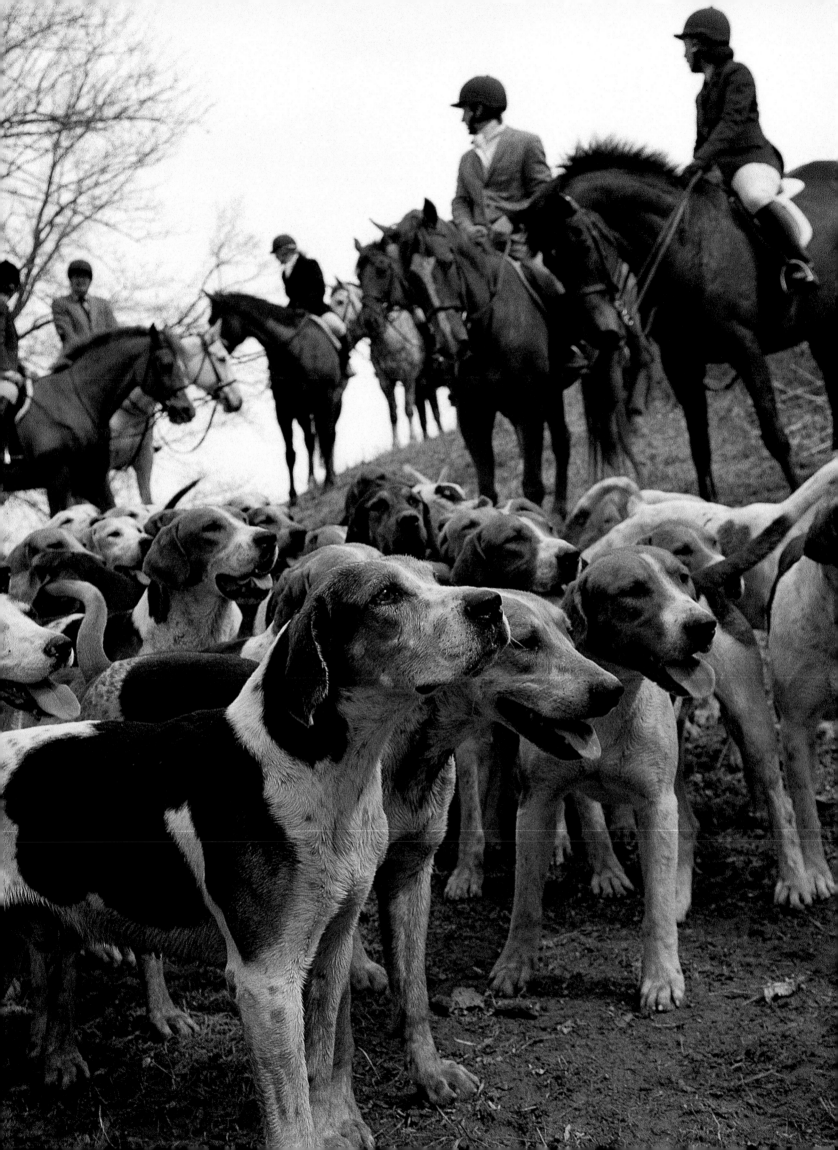

Mrs. Hannum has been hunting since she was four years old. Her maternal grandfather led the Orange County Hounds in Plains, Virginia. Her mother married R. Penn Smith, another hunter, who became friends with hunter Plunket Stewart; when Smith died, and Stewart's wife died, Mrs. Hannum's mother and Plunket Stewart married each other. "It was a very sensible thing to do," Mrs. Hannum says, "and they were very happy until they died within three weeks of each other in 1949 and went to heaven together." The huntsman retired the following year, and Mrs. Hannum took over "because I couldn't find anyone else to keep it up to our standards."

According to Mrs. Hannum, "The interest of fox hunting is threefold. First, a beautifully-disciplined pack of hounds is as magnificent to watch as a triple-play in baseball. They have very bad eyesight and run it blind with their nose. Then there's the pleasure of galloping a good horse across the country. You have to be fit and courageous; no wimp can do it. Lastly, there's the beauty of the countryside. Even on a bad day, you have that."

A bad day might be one like this afternoon in March when, Mrs. Hannum complains, "Foxes everywhere and you can't run a skunk — what a disappointing morning." The problem, she explains, is that "during a winter hunt, because the ground is so cold, scent is nonexistent." So even though she has "put Journey through the earth to bolt him" (Journey is her little Jack Russell Terrier, who leaps wildly between the back and front seats of a Jeep until he is let loose to enter and check the foxholes), five different foxes have been lost.

They don't kill the fox, incidentally. "On a good sunny day the hounds will run a fox to kill. But in a game of pursued and pursuer, the fox has it all on his side — he knows the land and when he gets tired of the game he goes to ground."

Having hunted here since she was ten, Mrs. Hannum may know the countryside as well as the foxes do, and she certainly knows her hounds — every single one, in fact, by name. Horses have remained very much a family passion. Both of her sons, R. Penn Smith ("Buzzy") and John B. ("Jock"), have won Maryland Hunt Cups. Her daughter, Carol, is married to Bruce Davidson, one of the nation's top steeplechase jockeys and an Olympic equestrian three-day-eventer. And now even her grandson, John B. ("Jeb") Hannum, is riding in steeplechase races.

Between Mrs. Hannum and her husband, John, a retired Philadelphia judge whose father was also a houndsman and who rode in four Maryland Hunt Cups from 1948 to 1951, it's hard to imagine children growing up with more passionate teachers.

A lonely pup, too young yet to join the hunt, anxiously awaits the return of the older hounds.

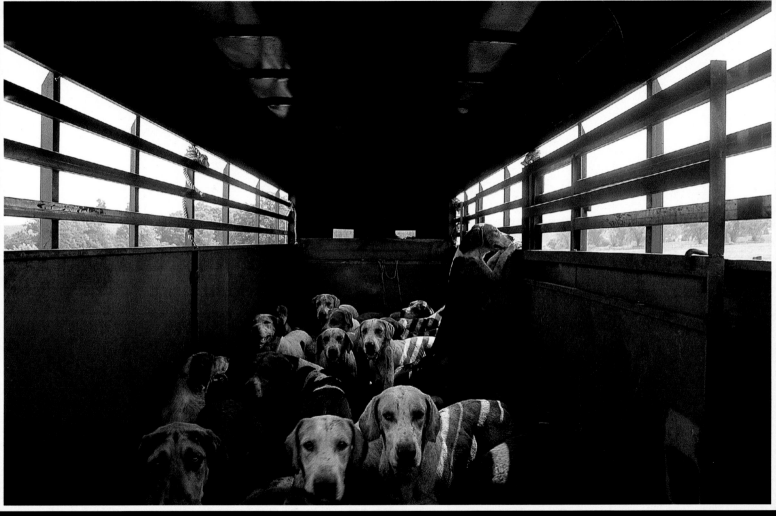

After an exhausting day chasing the sly fox, these doghounds are happy to be transported home by van.

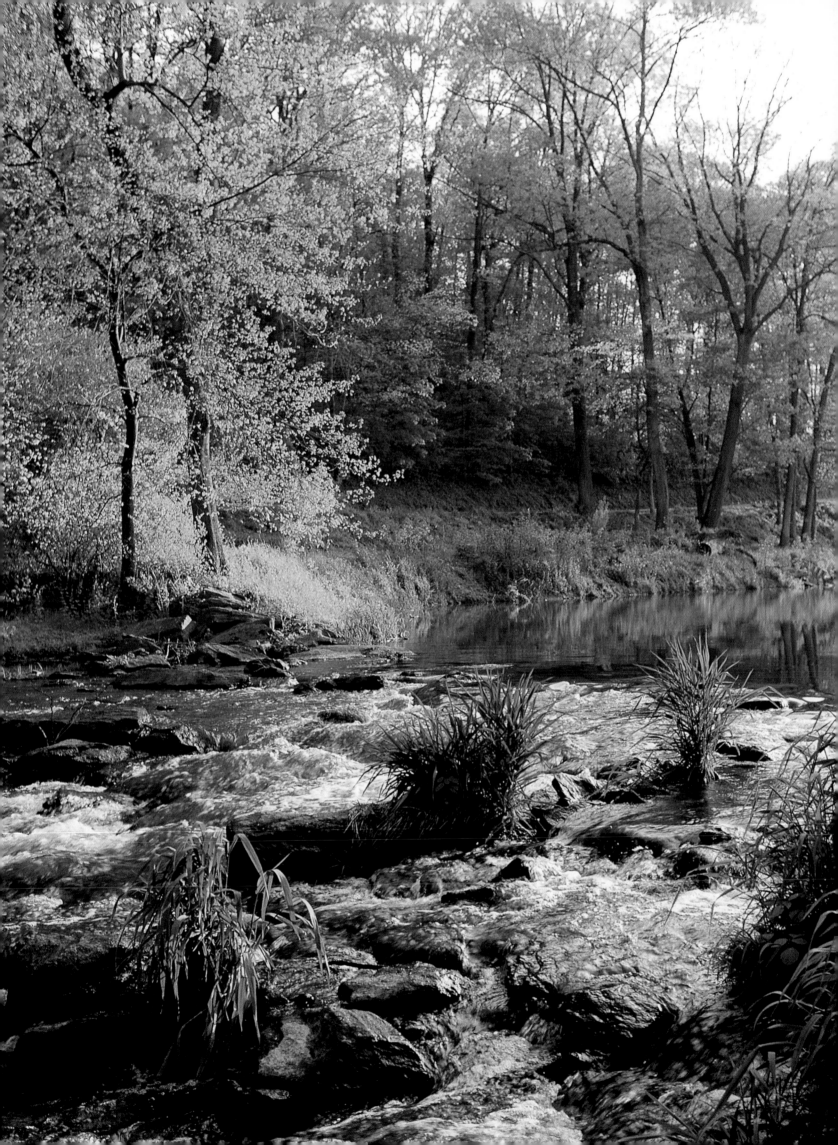

THE LAND
The Battle for the Brandywine

There is a meadow in Chadds Ford, Pennsylvania — up high in the hills, past where the Buck and Doe Runs converge — where you can look all around you and see nothing but trees and hills, green and sky.

No convenience stores or houses. No street lights or high-tension wires. No traffic — so you don't hear anything, either, except the occasional bird. No truck engines idling or gunning; not a single car's tires snicking on asphalt.

Even if you've never stood in a spot quite this isolated, the view is familiar, from nineteenth-century landscape paintings. A few deer in the distance complete the pastoral. It's not Mount Everest, after all; the undulating landscape seems friendly, inviting, scaled for easy enjoyment. But the silence is a real surprise, almost eerie. The quiet feels like a reproof: our world is so saturated with the detritus of civilization that it has become this hard to escape.

In fact, there are not many such spots left to us. We are in The Laurels, a 771-acre nature preserve founded by the Brandywine Conservancy, and our panoramic view represents one of the largest unbroken woods in Chester County, Pennsylvania. The only reason we are able to celebrate the view today is that the slopes here were too steep to cultivate.

This land has always belonged to the farmers. The Laurels were carved from the 5,367 remaining acres of The King Ranch, a Texas cattle farm that for over thirty years reigned here. Originally Lammot du Pont's Buck and Doe Run Valley Farms before he sold to Texan Robert Kleberg in 1947, the tract of land originally encompassed over 12,000 acres.

In the early '80s, when The King Ranch went for sale, the Brandywine Conservancy — which had already protected 3,000 acres of land and established the Brandywine River Museum — went to work. No one was thrilled with the prospect of having the 2,000-plus houses that conventional zoning would have permitted here. Imagine what the roads and cars and support services for those houses would mean. Start by imagining the sewage.

As James Duff, executive director of the Conservancy, explains, "The water has always been our primary concern." The Conservancy knew that it needed to protect the water shed in these high streams that feed into the Brandywine, for once the water here becomes polluted, the water supply of Wilmington would be seriously threatened. "Sewage treatment facilities have become our biggest problem," Duff says. "With more and more development, the plants just can't keep up."

With the help of twenty-two original partners, the Conservancy divided the property into thirty-eight parcels, then sold them with restrictions in place, called easements, to control development. Houses are allowed here — but only three houses per hundred acres. Conservancy easements specify that the houses cannot be in a flood plain or a wetland, they cannot require cutting down trees, and they must be out of the "public view shed," virtually invisible from surrounding meadows.

So from our spectacular perch atop The Laurels, we cannot see the house of Ralph Roberts, Comcast Chairman, who bought Parcel Number F-14. We can't even see the pond he was allowed to build, so long as it occupied no more than one percent of total land mass.

The Conservancy has now put easements in perpetuity on 23,000 acres of land — over thirty square miles. Staff diligently polices to make sure owners uphold their ease-

ments. That means farmers cannot pile manure within a hundred feet of streams. They can place no toxic containers or materials anywhere on the properties. Trespassing is forbidden — The Laurels are only open to its 4,000 members for approved recreational purposes, like wildflower walks or the popular Owl Prowl.

No cars at all are allowed, in fact. Well, just one — Nancy Hannum's Jeep, which often accompanies the fox hunt. As Master of the Hunt and the stepdaughter of Plunket Stewart, the man instrumental in convincing Kleberg to buy this land from Lammot du Pont, she is widely agreed to have that right. Unfortunately, other vehicles tend to follow her in. And the only other vehicles allowed in here must bear a Conservancy logo on their doors.

Oh, one more important rule. No stray dogs. Riders on horseback are allowed to bring dogs, but all pets should wear bells, since they tend to slink back here at night once they've learned the paths, and the main threat to neo-tropical birds like scarlet tanagers and ospreys, whose populations are down as much as twenty-five percent, turns out to be housepets. While the preservation of wildlife is not the Conservancy's focus, "we will gladly garner sympathy for a rare bird," Duff says, "if it'll help us preserve the water table."

These woods house no more black bears. A single ranging black bear needs fifty acres; even a nature preserve this size cannot support a bear population. But one animal that is decidedly *not* endangered here is the deer, which only needs one square mile for home range. An ideal deer population is eight to eleven per square mile. In some urban areas, there are 80 to 110 deer per square mile by a conservative estimate.

So despite public outcry, the Bambis must be controlled, or the ecological balance of the region becomes threatened. Similarly, the honeysuckle and wild rose and oriental bittersweet must be cut back — though preferably never in summer, when the birds nest.

"The concept of benign neglect is dead," explains David Shield, senior land planner for the Conservancy. "If you just let a meadow go, it will become overgrown, and it'll be decades or longer before it becomes a forest — the old-timers used to call it 'the twenty-year uglies.'"

One of the Conservancy's most important — and difficult — jobs is controlling the cattle. In the good old days, farmers were not adverse to draining the wetlands in order to gain ten more acres for grazing. Although scientists were aware of the importance of wetlands as a buffer and purifying system, wetlands hardly had the widespread sympathy of deer or eagles. In fact, the public still thought of wetlands as unglamorous swamps, mere breeding grounds for mosquitoes.

"People were all concerned about the evergreens and prairie potholes," says H. William Sellers, director of the Conservancy's Environmental Management Center, "but they weren't terribly concerned with what they were doing in their own back yards." Similarly, it has taken the Conservancy some time to convince farmers that it is necessary to install electric fences, so the cattle can't go right up to the streams and drink. Why would anyone object to such a pleasing picture — cattle dipping their heads to the cool water God gave them? Because heavy cattle trampling the banks so close to the stream was causing erosion, not to mention the pollution problems of the waste and urine, and the erosion causes sediment, and the sediment kills the fish.

Muses Dan Hegarty, assistant land planner, who prowls The Laurels to insure compliance with the easements, "Many farmers use the same methods as their fathers and grandfathers, and don't see why they should have to change. But the population is bigger now; you simply can't do things the way you used to and get away with it. If a bald eagle nests in a tree up here, would it continue if cows were underneath? The farmers care about eagles — they just don't want the federal government putting up a fence and

telling them to stay 300 yards away. So they tell me, 'Oh, you college boys, you don't know what the world's like.'"

Part of Hegarty's work is socializing with the farm managers and trying to make it worth their while to change. They like fishing, for example. Convince them that the sediment is hurting the trout — and more than a centimeter of sediment in the stream will kill the trout, which is, Sellars says, "an exquisitely significant and sensitive species" — and they become more cooperative.

While giving a tour of The Laurels, Hegarty must stop his truck to saw down an immense tree limb that has fallen on the road during a heavy rain. We are near McCorkle's Rock, a huge boulder where, during the Revolutionary War, lore has it, a double-agent horse thief named McCorkle, a.k.a. Sandy Flash, used to hide the horses he stole from both sides in caves behind the rocks. In a twist of fate, the Conservancy does not own the .89 acre of the Rock, although the imposing stone juts right onto the trail. An old man with smallpox is rumored to have lived in a shack here, and so afraid were his descendants of contagion that when he died the property was abandoned, the deed lost. The Conservancy is only now working with the old man's descendants for an easement.

The same heavy rain that knocked down the tree has washed out many of the horse trails, and those trails are essential to the happiness of a horse community. After all, horses and their owners are vitally linked to this land: the Stroud Water Research Center, on the cutting edge of stream research work for so long, sponsors the annual Willowdale Steeplechase, featuring thoroughbreds owned by some of the area's major landholders; the Radnor Hunt, another long-standing meet, directly benefits The Brandywine Conservancy.

Riders aside, trail erosion is a major issue for the Conservancy. Left alone, the limestone stream that is the Doe Run is cool as it emerges from a canyon, a full six degrees cooler than the Buck Run — so where the streams converge, you can put one foot in one stream, one foot in the other, and feel the difference in temperature. The Doe Run is the right temperature for trout to inhabit all year long. A team is in the process of erecting speed bumps (or "thank you ma'ams," as they're called around these parts) to slow the velocity of the water off the trails, so the sediment doesn't flow into the streams.

The carriage riders don't object to the electric fences, but many complain bitterly about the speed bumps. As always, keeping everyone happy — those on horseback, in carriages, and on foot, the honest-to-God farmers and the gentleman farmers, the cattle and deer and birds and trout — is not an easy task. Luckily, everyone agrees on the job's importance, and as Sellars notes, "One of the most enduring advantages of the region for conservation work is the Quaker tradition — it's consensus-building."

The Conservancy has been a trendsetter in water conservation since its establishment in 1966, and now lends its considerable expertise in land planning and waste management to states as diverse as New York and Kentucky. As testament to the Conservancy's success, try standing near McCorkle's rock as the stream rustles beside you. In the quiet shade near McCorkle Road, with a solitary Henslow's sparrow just visible darting through the treetops, you'd never know how close you are to U.S. Route One, where gargantuan trucks barrel from Maine to Florida. When Duff moved here in 1973, he marvelled that he could be halfway between New York City and Washington, D.C., and yet buy his *New York Times* each Sunday morning at a Sunoco station without seeing a single other car on Route One. Thanks to the work of the Conservancy, others can experience that exquisite sense of isolation for some time to come.

Pages 164-169:
Through strict zoning and dogged fundraising, the Brandywine Conservancy has ensured that the timeless rural charm of the upper Brandywine Valley will remain unchanged for years to come. Picture-postcard scenes of the region include a father and son fishing along the river's banks in early spring (164); an immaculately-maintained fieldstone barn in the heart of Wyeth country near Chadds Ford (166); and a late-summer stand of corn along a traffic-free stretch of road near the Delaware-Pennsylvania border (168).

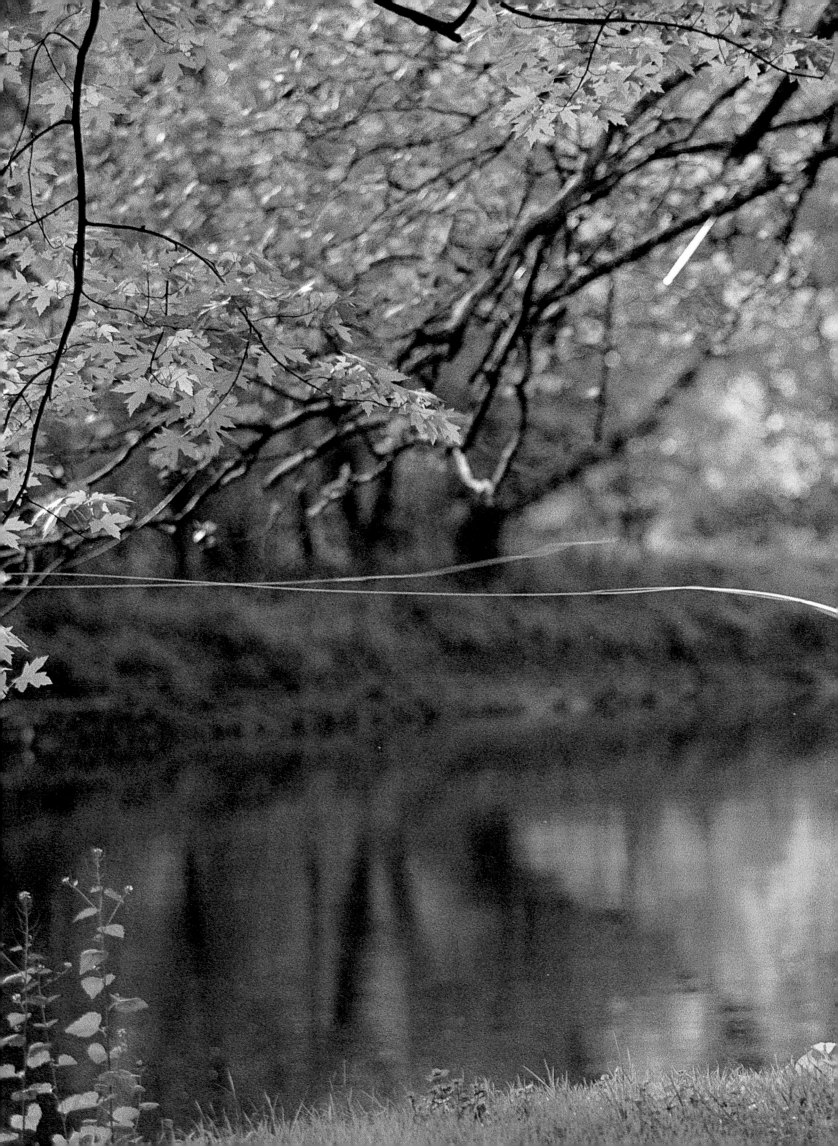

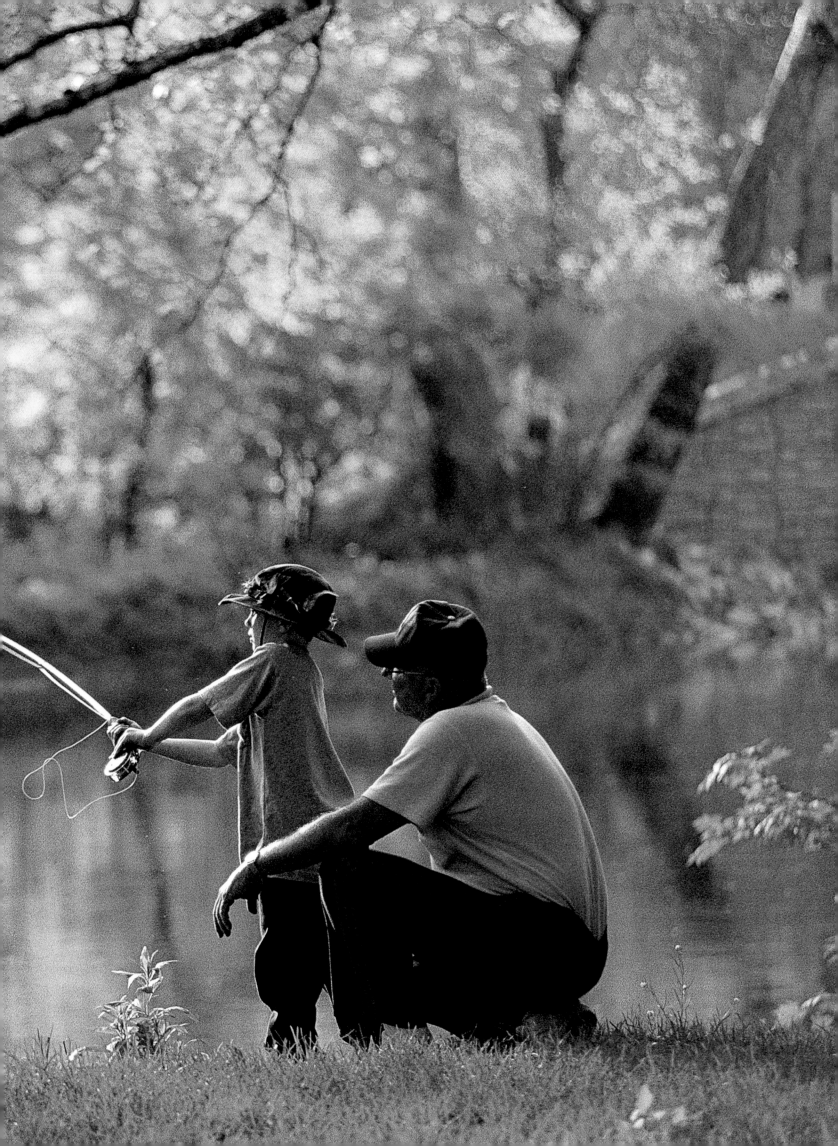

SAM WILSON: *"We Don't Eat Our Pets"*

*O*n a cloudless spring day, Sam Wilson's disposition is less sunny than usual. One of his calves is suffering from a breathing problem. The veterinarians can't determine the cause. The two-month-old calf has been given a tracheotomy so it can eat and drink. Still, the calf is skinny and slow-moving. Cows are rumored to be among God's dumbest creatures, but you wouldn't think so watching the calf's mother, who stands by protectively — her doleful expression part worry, part hope — as the cattle farmer examines her offspring.

"The economical thing to do would've been to put it down," Wilson admits. "But I'm inquisitive. I want to know why it happened, whether it's inherited or something environmental. The vets kept telling me it wasn't worth it, but wouldn't you know they just saw a thoroughbred filly with the same problem. [The calf] tried to bawl the other day, to call her mother, and that's the first sound I ever heard her make. I don't care if she bawls or not, but we need to know what's the problem."

At week's end the calf will have surgery. "We're gonna operate, take part of those flaps in her throat out." Wilson gives the calf's back an affectionate pat. "You're free, honey, until Friday morning."

Calf #51 doesn't have a name, but Sam Wilson certainly knows its personality. "They don't look too bad today," he says, with a barely-suppressed hint of pride. "This cow here, I raised her on a bottle." As he drives a visitor around the two hundred acres he rents for his commercial cow-and-calf operation, he checks out each one, including a day-old calf that nestles beside her mother. Some come up to the rolled-down window of his truck, friendly and curious. "You have to stay in the truck," he warns, "because I have a couple of calves here that would like to put you on top of the car."

Sam Wilson began cattle farming at age fourteen. Until 1965, when his father died, he worked for his father. His father, in turn, had been cattle farming since 1921, when he graduated from Penn State and Lammot du Pont wrote to the college asking for someone with experience in beef cattle for his Buck and Doe Run Valley Farms.

"He was with them for 27 years," Wilson recalls. "When du Pont sold the property and it became The King Ranch on January 1, 1947, my Dad used to say we were sold with the property."

The King Ranch was a Texas operation known for its Santa Gertrudis cattle — the only breed ever recognized by the USDA as an original American breed. The distinctive red cattle was developed for the adverse conditions of the Southwest, bred to tolerate high heat. At that time, the cattle were sent by rail from Texas to Lake Charles, Louisiana, to the Swift processing plant. "But by the time they got to the slaughterhouse, there'd be a lot of shrinkage and bruising. They wanted somewhere closer to the markets."

The new King Ranch's cattle would go to a plant in New York City. "They'd take cattle right into downtown New York, put 'em in an elevator, kill 'em upstairs, and each floor down they'd break 'em down."

When those Santa Gertrudis cattle first saw the grass at their new home, Wilson speculates, they must have thought they'd died and gone to heaven. "Look at this grass. We had some steers gaining four pounds a day just on this grass."

Until 1975, Wilson's business was strictly a steer operation. All were brought in by rail from Texas. But "the rail cars were getting a bit ragged. Some of the roofs were missing; the cattle would get here with their heads sticking out of the side of the car." Nineteen seventy-three was the last year cattle were received by rail. For two years, they brought the cattle up by truck — but by then they saw the handwriting on the wall, and shifted to a cow- and-calf operation.

"With a cow-and-calf operation you maintain your cows twelve months a year and every cow gets bred," Wilson explains. "I did a lot of work with the breeding. Everyone claimed that a bull should not have more than 25 cows. But my theory is that if the cow is in good shape inside and out, and your bull is in good shape inside and out — if you give them plenty of minerals, salt and feed all the time — they'll cycle at the right time, and he can do 45."

These days, animal husbandry techniques are so advanced that all of the breeding could be done scientifically. "We could give the calves a shot and artificially inseminate them. But it's expensive and I'm old-fashioned — I'd rather blame it on the bull. The real thing is getting your calving done in a 45- to 60-day period so they don't all get born on the same day, and timing it right. I'll turn the bull out about May 20. I had a calf born on New Year's Eve this year and that wasn't the best time."

When The King Ranch broke up in the early '80s, the Brandywine Conservancy worked with the residents to parcel the land. Now these rolling hills are home to as many deer as cattle, Wilson guesses, and some dangerously roving dogs — house pets that are "supposed to be tied up at night, but they get out and run." This land is still perfect for fox hunting, though Wilson himself has not done so since he was a boy and saw his pony get killed by lightning in front of his house.

He does hunt here for pheasant, squirrels, and rabbits. He may be unusual for area farmers in admitting that the populations of certain animals seem reduced due to pesticides. "I don't know what happened," he admits. "Maybe the Atrazene in the corn."

He does eat beef, incidentally, but not his own. "Unless I sneak it by, the family complains," he says. "They don't like to eat their pets." That includes his son and daughter, who are now partners in his business.

The land Wilson rents is owned by Dorothy Alexander, granddaughter of the original King Ranch owner, Robert Kleburg. The house where Wilson was born and raised is on the property; presently used as a home for unwanted dogs, it is for sale. The barn where he stores his hay was built in 1890, with lumber sawed on the property.

The question "How much cattle do you have?" draws a gentle chiding. "If a person has cows, you never ask 'em how many they have, because it's just like asking how much money they have in the bank."

One thing is for sure: the animals couldn't appear happier. "My family says I spoil them," Wilson says, referring to his custom hay and daily, detailed surveillance of their welfare. "But this is the only income I have. I'm at their mercy. They're not fancy cattle, but as I always say, you don't eat the color."

This country lane near Chadds Ford, Pennsylvania, has changed little since Washington's troops were defeated near here over 200 years ago.

Pages 174-175:
A gentleman's farm near the Delaware-Pennsylvania border provides the perfect backdrop for a typical summer scene along the Brandywine.

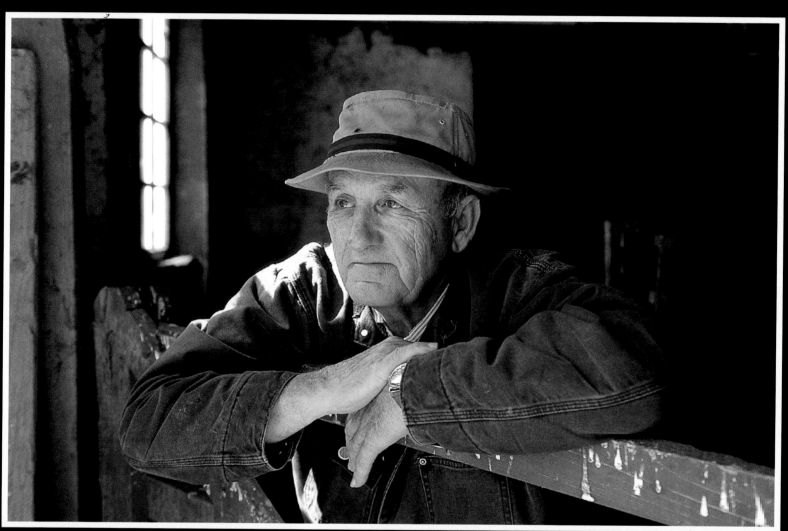

Sam Wilson, whose father was hired by Lammot du Pont in 1921 to run his Buck and Doe Run Valley Farms, owns his own successful 200-acre cow-and-calf operation that mixes state-of-the-art farming techniques with a bit of traditional Brandywine Valley wisdom. "We could artificially inseminate the calves. But it's expensive and I'm old-fashioned — I'd rather blame it on the bull."

Above and opposite page: *The protected waters of the Brandywine are now the year-round home to waterfowl of all varieties.*
The swans, herons, and ducks of springtime are replaced by an ever-growing population of Canadian geese in the winter.

Pages 178-189:
The Brandywine Valley's exquisite sense of isolation can perhaps best be experienced after a fresh snowfall, when every tree and house looks like it stepped straight out of a nineteenth-century winterscape. Enchanting scenes of the region include a new-fallen snow on a private estate near Rockland, Delaware (178); artist Clayton Bright exercising his pack of beagles along a frozen Chester County, Pennsylvania, hillside (180-185); and Joe Cassidy, the huntsman for the Cheshire Fox Hounds, running Nancy Hannum's hounds on her estate outside of Unionville, Pennsylvania (186-189).

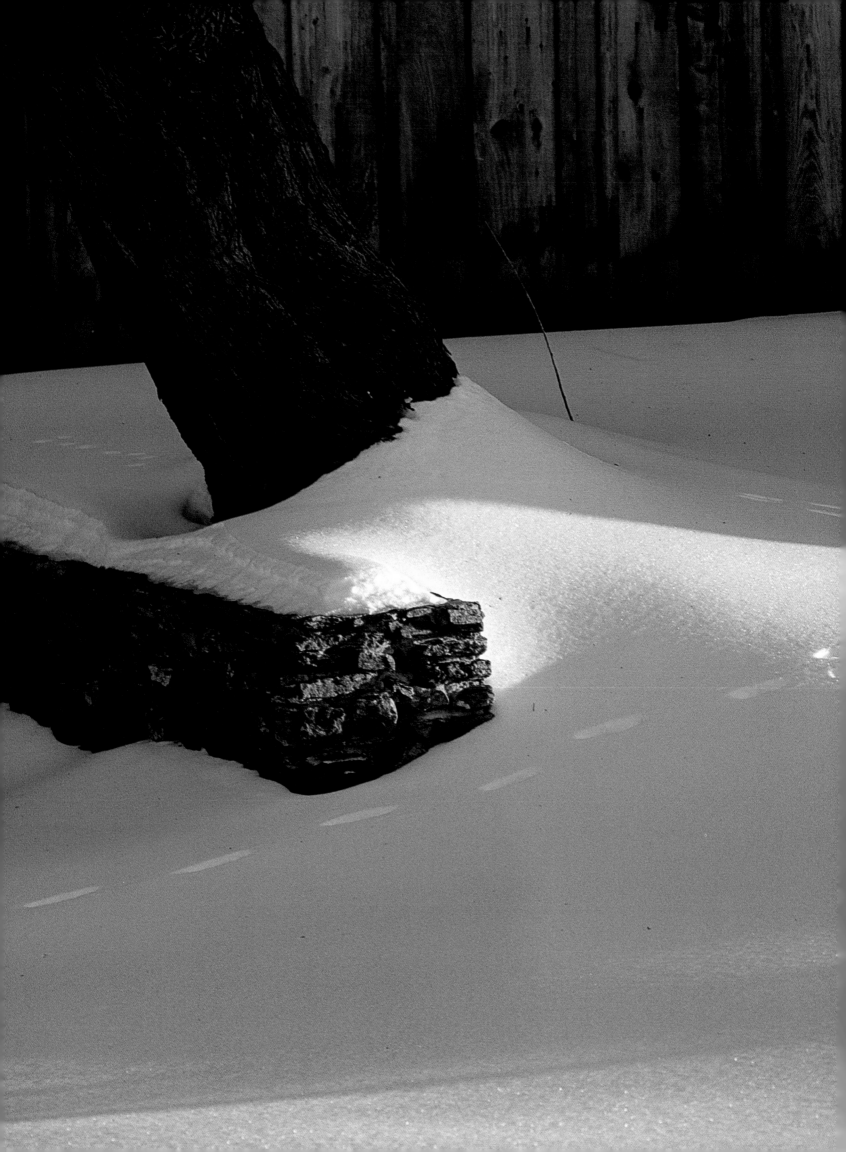

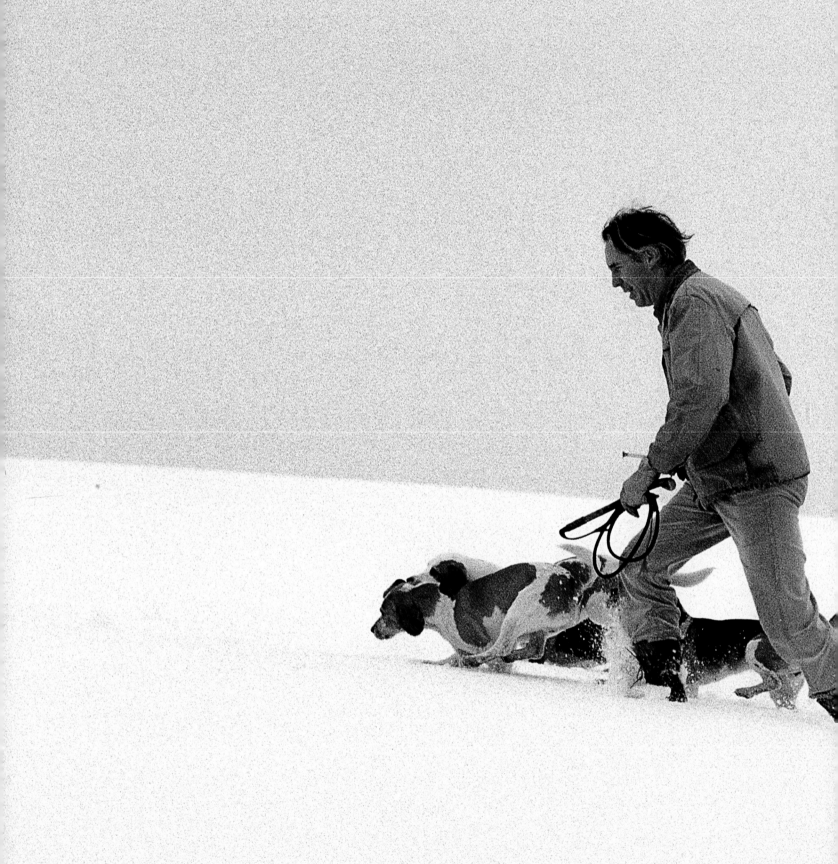

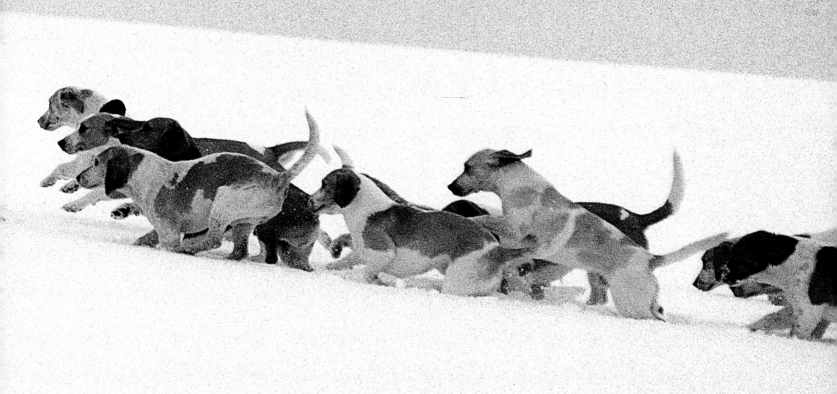

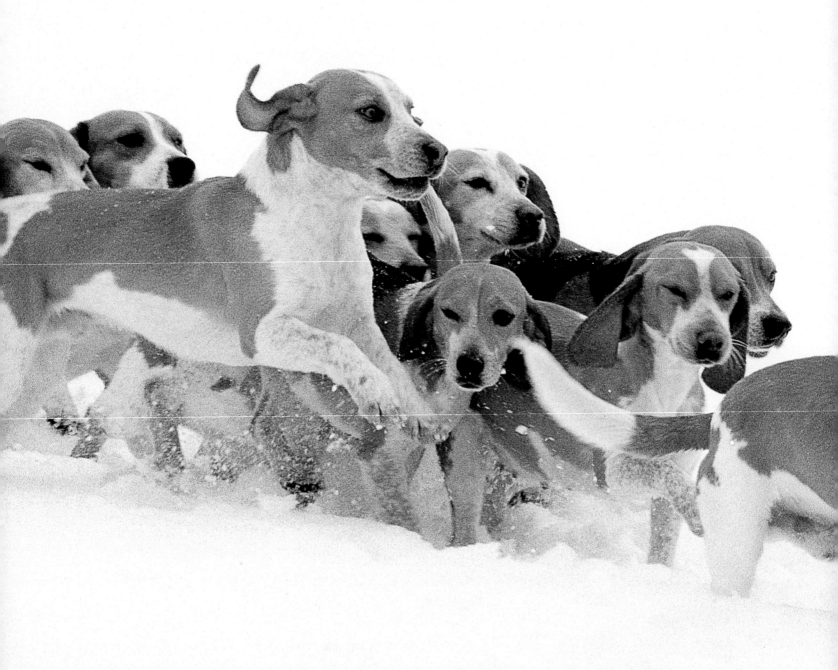

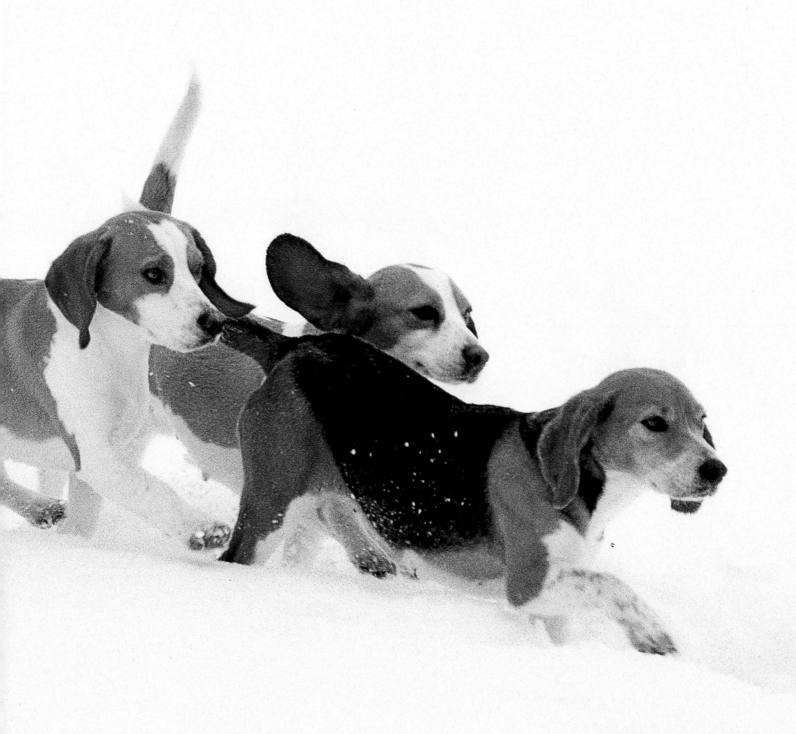

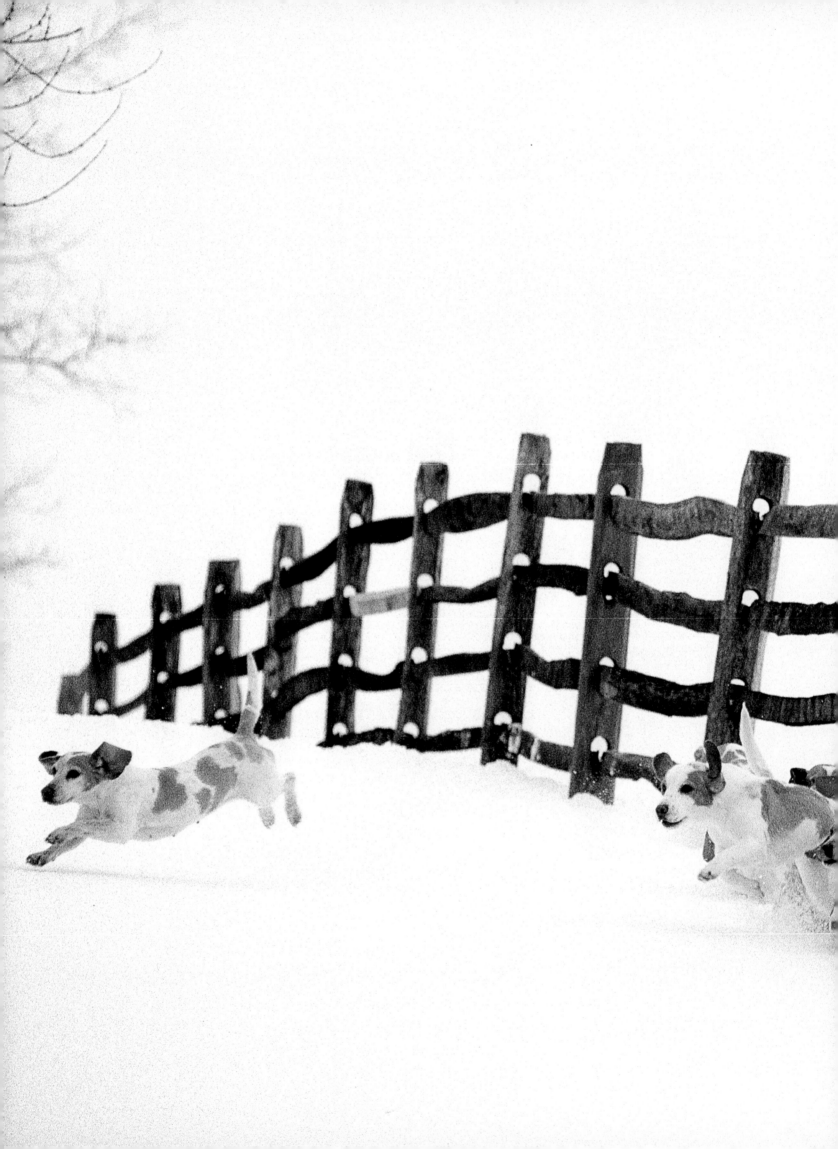

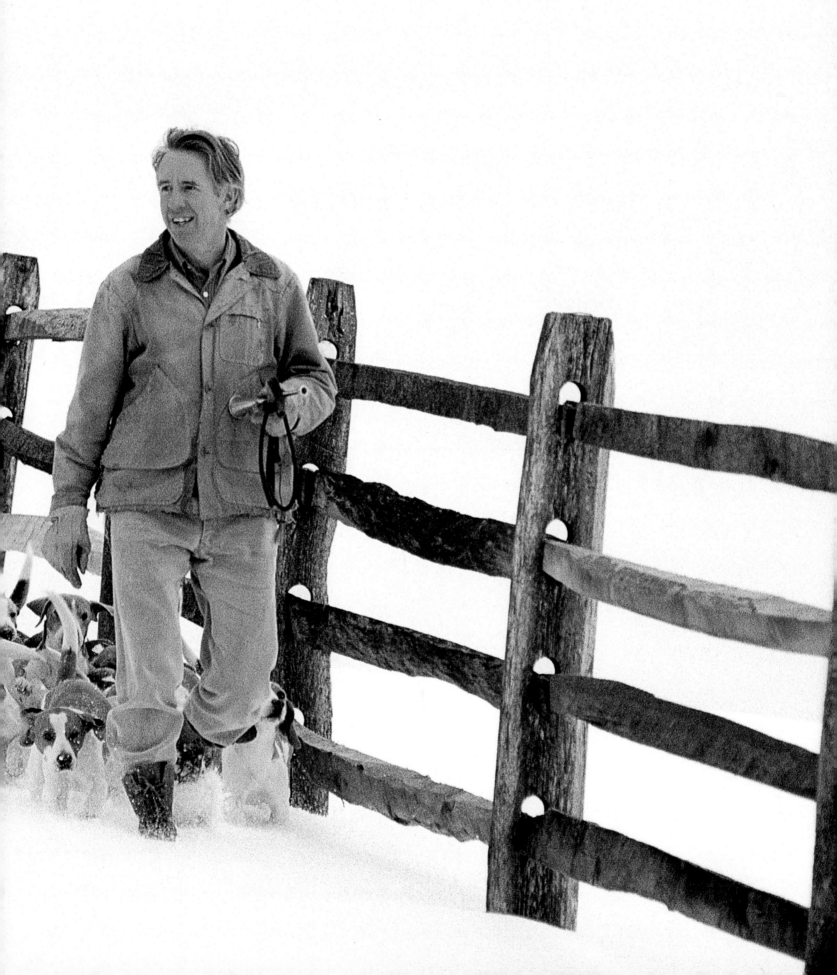

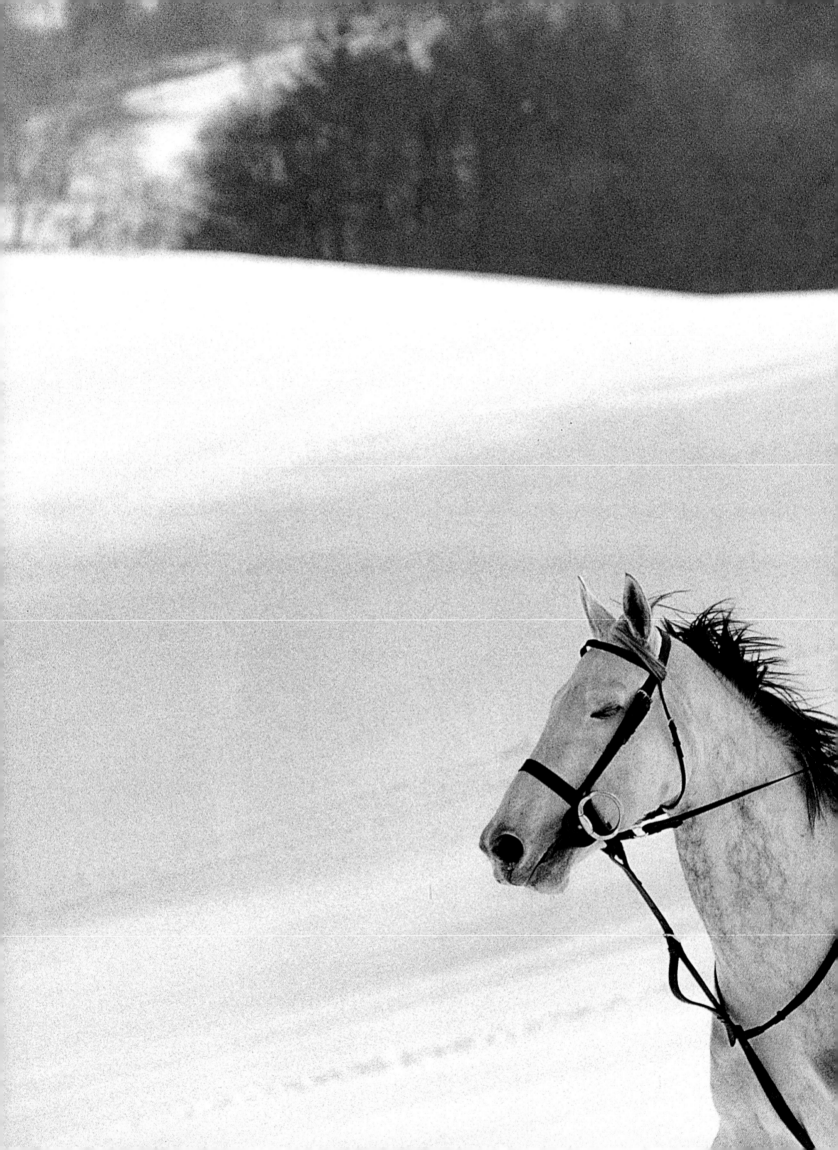

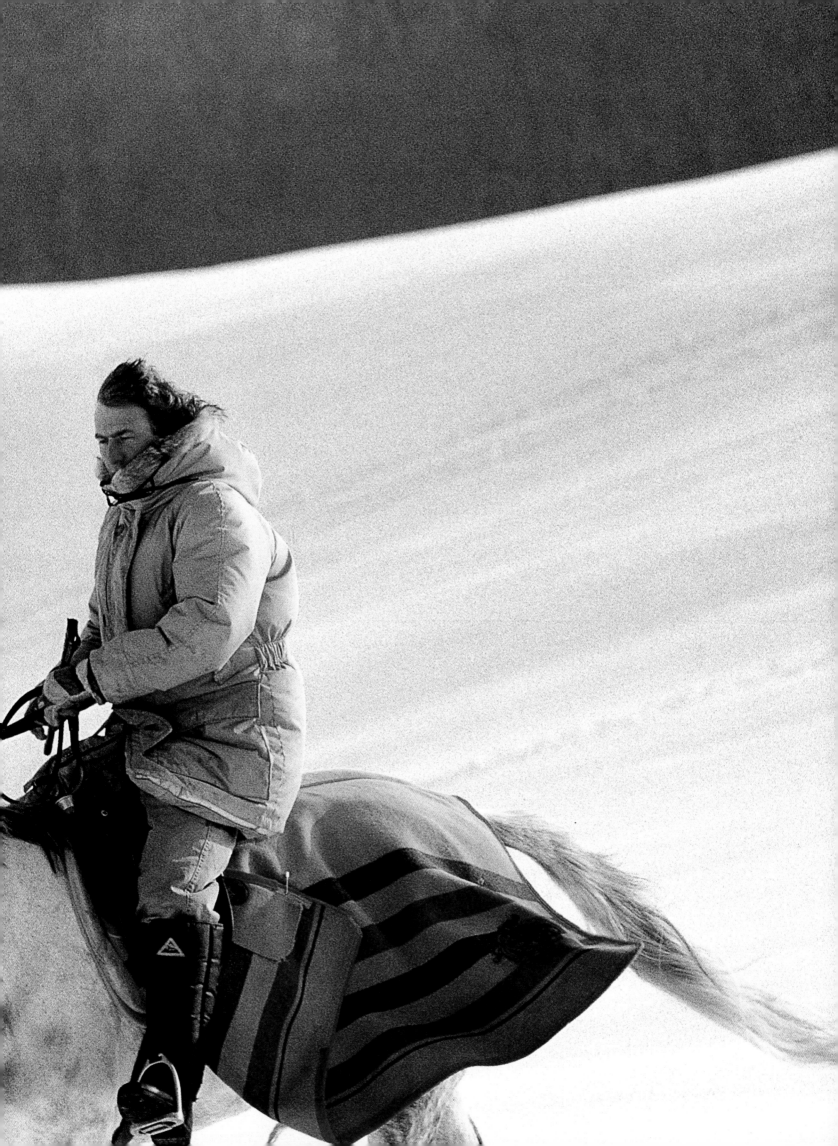

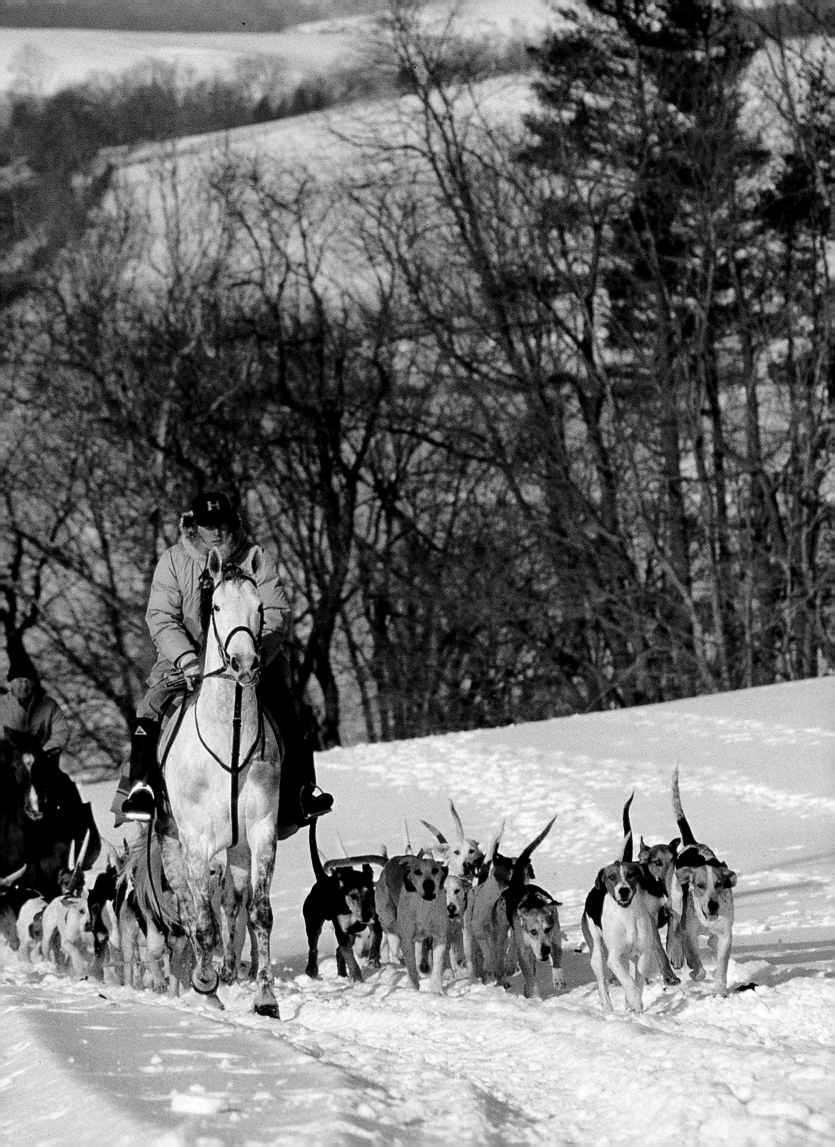

THE ART

The Delaware Museum of Art and the Brandywine River Museum

At many museums, you pass through the air-tight doors and enter the pristine world of Art. The tall walls are white; your shoes resound on acres of plain floors. So as not to interfere with the art, the surroundings are as sanitized as a hospital's.

At the Brandywine River Museum, with its rustic wood, if you find yourself getting a museum migraine from staring at all that art, you can look out the windows. Lots of windows, with views of the trees and river and wildlife that are, after all, the subject of many of the paintings and sculptures displayed here. The art and the natural world that inspired it are linked by design. A cow lazes by the Brandywine, so convincing in its life-sized repose that viewers may do a double-take when they realize the tail isn't likely to flick away flies, because it's bronze.

This is, after all, the Brandywine River Museum *and Conservancy*. When the land here went for sale in 1967, and an oil-tank company threatened to move in, conservationists acted quickly. The museum was almost an afterthought, deemed a suitable use for the abandoned gristmill on the property and a place to display the work of Andrew Wyeth, the region's most famous chronicler.

At the time that construction was set to begin, in 1971, Baltimore architect James Griest was the only bidder proposing to keep most of the original mill structure intact for the museum. As in much else, the Brandywine Valley's instinct towards preservation turned out to be prescient.

Originally, the museum was supposed to be open to visitors a couple of months a year. But interest was so great, it quickly opened year-round, and now gets around 200,000 visitors annually. Tourists often plan a double-hitter day of delights: the Brandywine Museum and Longwood Gardens. Whereas other museums inspire a kind of hushed awe — viewers standing a safe distance from the art with their arms crossed with somber mistrust — the Brandywine Museum makes visitors feel so secure and bubbly they might be standing before the tulips at Longwood.

The art is unthreatening, down-home. It is not unusual for people to stop before André Harvey's sculpture *Pigs!* and actually try to stroke the little critters as they exclaim, "Aw, aren't these *cute!*" The landscapes inspire a day-in-the-country feeling of leisure. Harvey's warmth towards the animals he portrays is palpable; you don't need to feel puzzled by his intent, even if you don't know that he grew up only feet from the Brandywine, looking for arrowheads and playing with snakes and turtles.

The art's accessibility has proven to be both a blessing and a curse. Popularity often carries that old critical dismissal: *not serious enough.* Throughout its history, the technically accomplished painters who made this valley their home have faced the accusation that they are "merely illustrators," capable of representing the world, but not capable of suitably *transforming* what they see.

As usual, the Brandywine Valley has stuck by its own. Dynasties of painters have grown up here, along with the dynasties of horse trainers, cabinetmakers and gardeners, devoted to their family's skills. International art trends have come and gone. Some would accuse the region of a quaintness, a dangerous insularity. Others would argue that these artists have existed outside of the mainstream as artists are supposed to do, sometimes intersecting with public taste and sometimes not, but always retaining a brave sense of their own mission, an adamant refusal to be blindsided by trends and critics.

In order to view the foundations of "The Brandywine School," you need to go down the road to the Delaware Museum of Art, which boasts the nation's largest collection of paintings by Howard Pyle. Decidedly romantic in mood, Pyle's canvases feature mermaids and sailors and, most famously, brooding pirates of awesome heft and glower — the Schwarzeneggers of their day. Pyle, born in Wilmington in 1853, was inspired by the English pre-Raphaelite paintings so popular at the time and which are also amply represented at the Delaware Museum, thanks to the estate of Samuel Bancroft, a cousin of Pyle's by marriage, who collected works by Dante Gabriel Rossetti and his contemporaries.

But Pyle's work is darker, less stylized than that of his English counterparts. Having witnessed actual Civil War soldiers marching through his hometown, Pyle could root his historical themes in his actual landscape, not just in the world of Arthurian legends and fairy tales that he so loved.

Pyle started his career as an illustrator, as did Winslow Homer and John Sloane. His artistic success came in a period known as "the golden age of illustration," in which dramatic, intricate pictures in magazines like *Harper's Weekly* were widely admired. The students who came to study with Pyle would have had no thought of their work being dismissed as "too commercial"; the distinction between painting and illustration was far more flexible than in our own age.

In 1902, Newell Convers ("N.C.") Wyeth joined the growing number of students who moved to Wilmington to study with Pyle. Wyeth's father was opposed to his leaving Massachusetts to pursue such a flighty occupation, but within months, N.C. had sold his first illustration to *The Saturday Evening Post*. Like his teacher, Wyeth was drawn to romantic and mythic images, in particular of the American West with its cowboys and Indians. Most famous for his illustrations for *Treasure Island*, Wyeth would become even better known for pirates than Pyle.

The images may seem quaint to us now, but it is essential to remember how raw and dark, how nakedly authentic and American, they seemed in their day. Wyeth learned well Pyle's lesson about searching for the personal, emotional content of a scene. "A man can only paint that which he knows even more intimately," Wyeth said. "He has got to live around it, in it, be a part of it."

Despite his success as an illustrator, N. C. Wyeth yearned for a different kind of artistic accomplishment. He feared that he had "*bitched* [himself] with the accursed *success* in *skin-deep* pictures and illustrations! . . . day in and day out I feel those insufferable pangs of yearning to express my own life as it is in this beautiful home and these hills."

Andrew Wyeth, N.C.'s son, is so famous now that it's easy to forget how very celebrated was his teacher, how easily he could have been eclipsed by his dominant, opinionated predecessor. It is also possible to forget that Andrew was hardly the only child in his family to take up the brush. His sisters Henriette Hurd and Carolyn Wyeth painted as well. With sister Ann having pursued a career as a composer, only one of N. C.'s children, Nat, was *not* an artist. Fully twelve of N. C.'s thirteen grandchildren have taken up artistic careers. Their work is by no means identical, despite the tendency to lump them all together as nothing more than sentimental celebrants of simple country life.

In fact, the artists who live in the Brandywine Valley work intensely in solitude, like artists everywhere, and hardly see themselves as members of a club. Although André Harvey doesn't concern himself with artistic labels — "Talk is cheap," he jokes — his sculpture, friendly though it may seem, is still borne of "a personal struggle that's not for sharing. If I see Jamie [Wyeth] or Charles Parks, it's at a show." And Harvey reminds us that, as he earns a living as a sculptor — a rare accomplishment these days — most of his clients are out of the area, in places as far-flung as Los Angeles and Tokyo.

But one thing that links all of the artists represented at The Brandywine River

Pages 192-193:
Thanks to the estate of Brandywine Valley textiles industrialist Samuel Bancroft, the Delaware Museum of Art in Wilmington boasts 250 works by Howard Pyle (1853-1911), the noted American illustrator acknowledged to be the father of the Brandywine School of painting. Housed in the museum's underground vaults are many of the pre-Raphaelite paintings which so influenced Pyle and his contemporaries and which constitute one of the most important collections of its kind in the country.

Pages 194-195:
The Delaware Museum of Art is justly celebrated for its impressive collection of the works of the English poet and painter Dante Gabriel Rossetti (1828-1882), one of the founders of the pre-Raphaelite school of painting. His sensuous, highly-stylized works — and especially his pen-and-ink drawings — inspired local artists ranging from Howard Pyle and Maxfield Parrish to three generations of Wyeths.

Pages 196-197:
A restored nineteenth-century gristmill on the banks of the Brandywine near Chadds Ford, Pennsylvania, The Brandywine River Museum is home to three generations of Wyeth paintings, as well as works by acclaimed local artists such as Howard Pyle, Frank Schoonover, Jasper Cropsey, and others. A notable architectural restoration in its own right, the light-flooded museum offers dramatic views of the countryside that inspired the founders of one of America's best-loved schools of art.

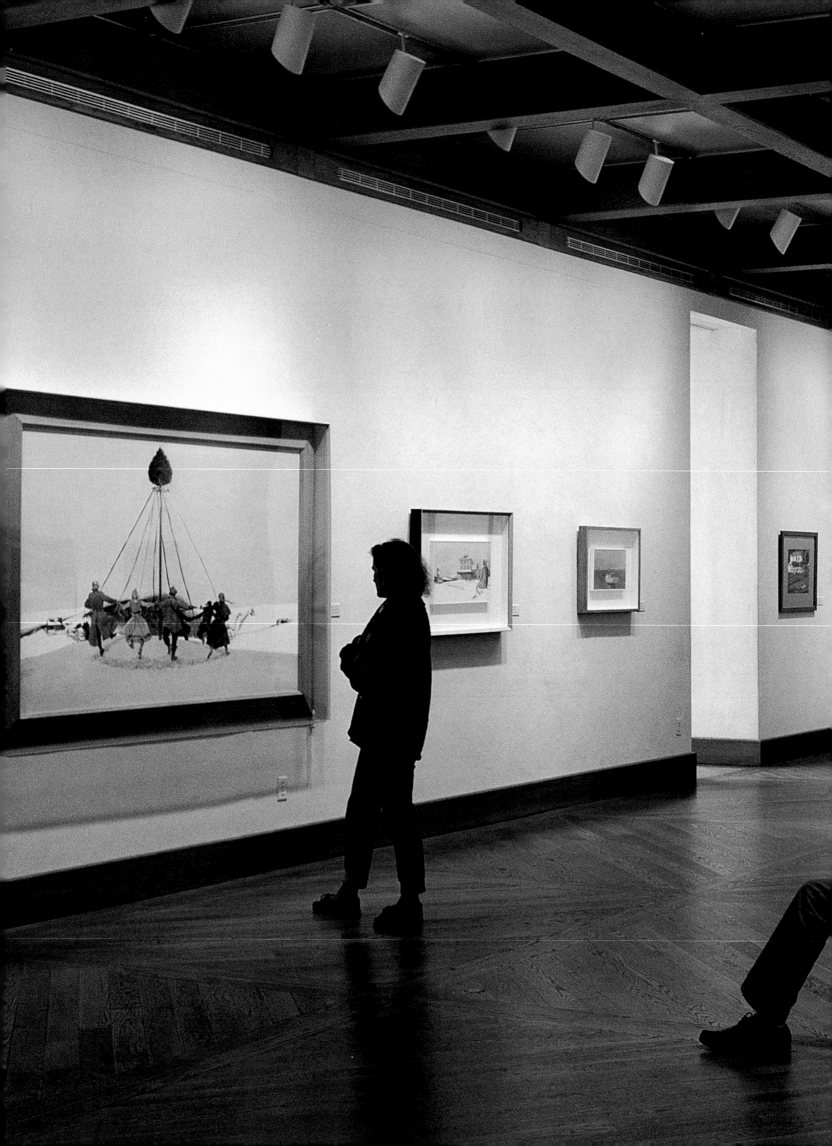

Having grown up along the Brandywine's banks, sculptor André Harvey now works in a restored mill just downstream from Winterthur. His endearing bronze figures of people and animals — especially his signature pigs — are as popular with clients in places as far-flung as Los Angeles and Tokyo as they are with local collectors.

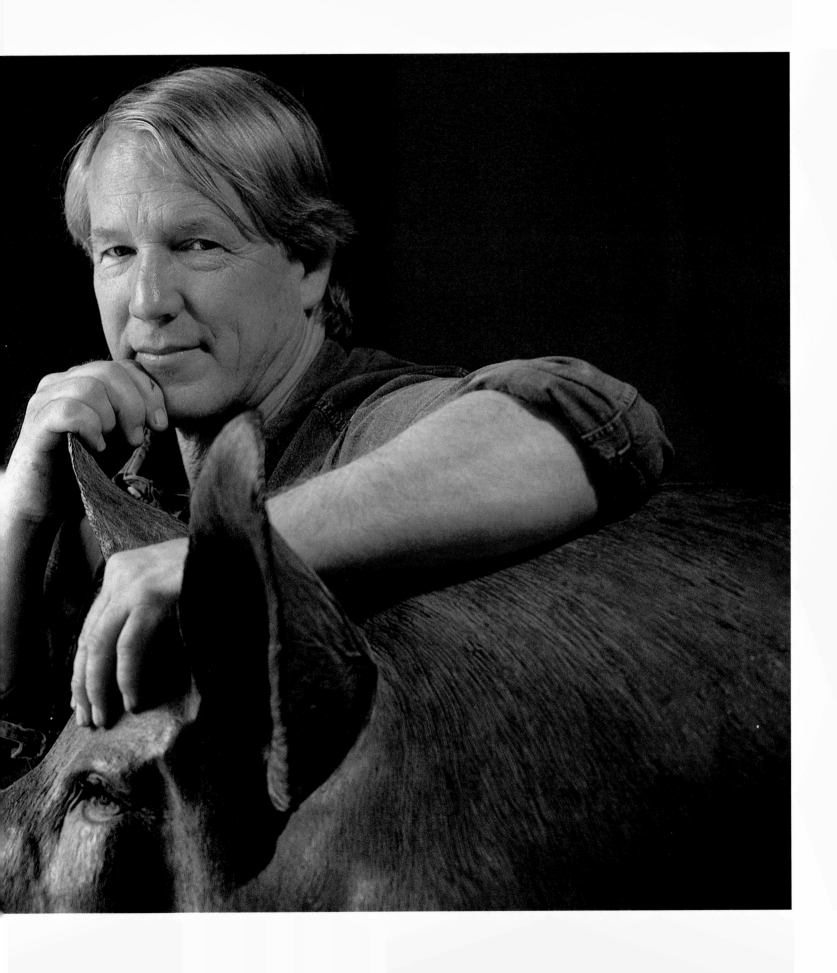

Museum is their devotion to the area. "I feel limited if I travel," Andrew Wyeth has said. "I feel freer in surroundings that I don't have to be conscious of." Many of Wyeth's images are so well-known, and have such a graphic punch, that you almost feel you know them in a split-second of viewing — but it's decidedly not the case. With more serious study, the paintings open up, reveal new depths. And that is fitting, for a man who has gazed at a beloved landscape for the better part of a century.

CLAYTON AND STARR BRIGHT:
"Working from Life"

Sculptor Clayton Bright likes to joke that Starr married him for his name. Some women might look far and wide for a man who could give them a name like Starr Bright. But in fact, Clayton and Starr have known each other since their childhoods in nearby Villanova, where they whipped in for the same pack of beagles.

Now they are building a life for themselves and their two daughters that includes art, politics, and animals. They represent a younger breed of Brandywine Valley resident who chooses the life here for its tranquility, its closeness to nature, and its possibilities for involvement in and control over all aspects of their lives.

Clayton Bright, who is known mostly for his sculptures of animals — his cows are particularly well-loved — did not train as an artist. He didn't attend art school; he went straight from boarding school into the army. He was a stockbroker, in fact, when he began to sculpt. "The first piece I did was of a standing cow," he recalls. "One always sees sculptures of bulls, not cows. But I like the bone structure of the cow, and I realized that I could commission my sculptor-friend to do the bronze — or I could try to do it myself."

In his sunny, cluttered studio next to his house, Bright can show a visitor the elaborate measurements he does as a way of getting the proportions and movements of his subjects exactly right. "When he did me," Starr recalls, "he drew on my leg to see where each muscle inserted." But he emphasizes that he uses the measurements only as a way to check himself. "You can't sculpt by the numbers, but if the neck doesn't look right, maybe the head's too small."

Except for one sculpture of a dragon that he made as a wedding gift for friends, Bright always works from life. "You can't get both the physical form and the personality of an animal from a photo. You can't follow a curve in a photo." Using live animals as models has its disadvantages; when he once attempted to do a sculpture of an attacking goose, "it was winter, and I couldn't get my models to do a thing."

There are certainly a lot of live models to choose from surrounding the Brights. Just outside the studio window, the artist can survey the pen of beagles that he breeds. "We hunt them as a pack," he says. "The other day my girls were with us as the dogs devoured a rabbit, and they joked, 'Those dogs aren't sharing' — this despite the fact that rabbits are their favorite animals." Walking around the Brights' swimming pool are two brilliantly-colored bantam mille-de-fleur roosters, Rick and Bucky. The girls also have two ponies.

Starr Bright, too, is very involved with animals. She is a veterinarian who trained at the University of Pennsylvania's large animal facility, The New Bolton Center. But her veterinary career has been cut short in surprising, unhappy fashion.

A moderate Republican, Starr Bright decided to run for County Committeewoman because of her concern about the Christian Coalition's involvement in Chester County schools. "The more I found out, the more I wanted to run. Last time I lost by eight

votes. So this time I campaigned door to door, trying to tell people what I stand for: I'm for the separation of church and state. I'm for women's rights. I'm for gun control — which people around here understand has nothing to do with hunting."

While campaigning, Starr Bright was shot by a mentally unstable person. Her injuries were serious, but "I was walking in about three weeks. I had incentive — my daughters were three and one. When I was in the hospital they weren't worried, they were just thrilled that the bed went up and down." Now, "it feels like there's sharp glass pressing into my foot all the time" — but she has trained herself to walk, and to live with the pain.

As well as her political activities (at the time of this writing, she had just won the Republican primary for Committeewoman), Starr Bright serves as her husband's business manager, and also does some wild bird rehabilitation on a part-time basis, since she is no longer physically able to work with horses, dogs, or cats as she was trained to do.

Clayton and Starr's home is sunny, spacious, and inviting, but it wasn't always so. "My grandfather used to have a place out here for hunting," Clayton recalls. "I built a studio and it upset a lot of people, so I went to a local realtor and asked what was the cheapest place in town. One person who looked at the house literally ran out and threw up because they were breeding cats here."

"He had vision," smiles his wife. "Our relatives used to come in and cringe. One time Clayton's aunt walked in with a vase of flowers and said, 'I'm going to find a nice place to put these.' She came back five minutes later, totally defeated."

But those days are over. The plants in the greenhouse are fragrant; one daughter practices the piano, while, outside, another daughter walks near the sparkling pool, past the cow sculpture, chasing the roosters. It is a charmed life, hard-won.

JAMIE WYETH: *"Not Just Pretty Pictures"*

The driveway at painter Jamie Wyeth's farmhouse is a mile and a half long. Not only can't you see the road from his studio, you can barely see the duck pond. Yet for half of every year, Jamie escapes to Monehegan Island in Maine, a spot so isolated that it makes the Brandywine Valley seem like a bustling metropolis.

"In a way," he says, "this area is as much an island to me as Maine. I see very few people here; I see almost no one in Maine. I'm more focused if I reduce my boundaries."

Jamie Wyeth's paintings — of both famous subjects like John F. Kennedy and Rudolph Nureyev, and of animals (especially his beloved pet pigs) — evince that intensity of focus. He tends to live with his subjects, getting to know them, studying them in motion, "watching how their mouths move when they eat." His portraits, always stunningly precise in detail, often dark in mood, represent a joyful distillation of such close study.

He does paint rural scenes, because he lives in the country, but "if I grew up in L.A.," he says, "I'd probably be painting the freeways." He regrets the fact that "many people visualize the country as romantic and nostalgic. That's the great danger I fight in my work. It can just be pretty pictures. Some people think of pigs as Miss Piggy, sweet and cute — but in fact pigs can be incredibly mean. The pig in *Night Pigs* ate the chicken I also painted. Once you get to know animals, you see something deeper."

Jamie Wyeth knows the different personalities of his geese and chickens. He took it as a high compliment that Roger Peterson, the great ornithologist, expressed interest in his paintings of geese, ducks and swans. "He understands there's a lot more to it than feathers and wings." In Maine, he paints gulls and seals, although he did transplant some

Sculptor Clayton Bright doesn't have to look far for inspiration for his art. Outside the home he shares with his veterinarian wife, Starr, their two daughters, and a pack of yapping beagles are the horses, dogs, roosters, and cows that provide all the fodder he needs for his work. Bright can't imagine not working from life: "You can't get the personality of an animal from a photo."

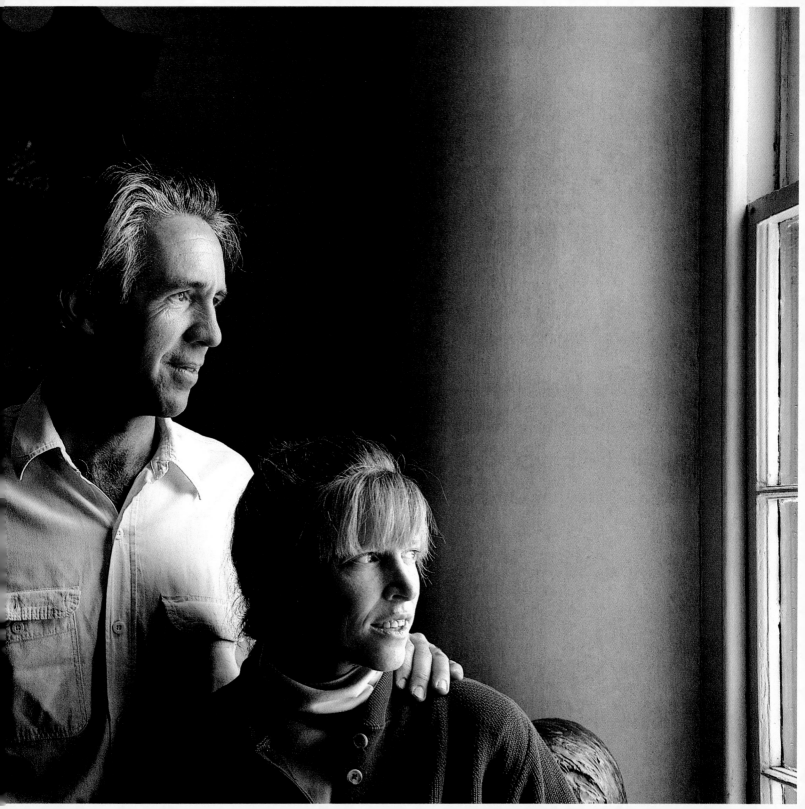

The scion of the Brandywine Valley's most illustrious clan of artists, Jamie Wyeth has been painting continuously since he left school amid a swirl of controversy at the age of twelve. Eschewing the area's social whirl, Wyeth is monkishly devoted to his art: "I pretty much paint all day, every day." He captured his wife, Phyllis, behind the reins of a horse-drawn carriage in a painting that hangs above the fireplace in their Delaware home.

JAMIE WYETH

geese from Chadds Ford to Maine — "I turned them into sea geese," he laughs. "The fishermen were a little bewildered."

For Jamie Wyeth, part of the challenge of painting realistically is finding the right balance of the technical and the expressive — the sitter's soul, if you will. He never uses photographs in his work, because he feels that the photographer has already imposed a vision on the subject, limiting the painter's field. "Painting is so interpretive," he explains. "Photography is, too, though not to the same extent. Take the JFK portrait I did. Here was a man who had used TV and photography to its full extent, perhaps the first president to have done so. And yet the painting I did of him is now the national stamp of Ireland. Why not a photograph? It's peculiar."

With the exception of Rudolph Nureyev, who was "so conscious of his every movement, of how he was viewed," most of Wyeth's subjects, animal or human, have shared one quality: a lack of self-consciousness. For a famous early painting, *Shorty*, he convinced a homeless recluse who lived by the railroad tracks to pose for him; the man had spoken to no one for fifteen years, and really had no idea what posing meant. "I like the idea of recording being sort of workaday — the subjects have no thought of it being a memorial."

Thus in New York, while studying dancers for a portrait of New York City Ballet founder Lincoln Kirstein, Jamie Wyeth began to visit the morgue. "I was just curious. Usually at art school you observe a stomach being cut open — what good is that? I wanted to know what made the creases, how the body was articulated. But on another level, to spend the day with the dancers, who were so conscious of every movement and nuance, and then go down there with the corpses, where it was quiet, was a great contrast."

Jamie is a du Pont by marriage — he married painter Frolic Weymouth's cousin, and Frolic Weymouth married his — but he has very little to do with the Brandywine social scene. "I used to like to go to New Year's Calling, sneak into all the bedrooms and see the art," he admits. Nor does he much socialize with other painters — engage in a great deal of shop talk — although he counted Andy Warhol as a good friend. "Andy used to come here a lot. He said the TV reception was better here. We talked mostly about toys. I have a huge, elaborate train set that he and I bought together."

As a young painter, he would track material for his work by combing the surrounding countryside. But now, he says, "I don't go out looking for scenes. I don't really need to go further than the driveway to look for subjects."

Jamie has been painting devotedly since childhood. In fact, he left school after sixth grade, at age twelve, to great controversy. Home schooling was not an option then, although his father, Andrew, had left school because of illness, so there was a precedent. "I was thrilled to leave school," he admits. "Everyone was hoping I'd feel lonely, but I didn't. I wanted to paint." His artistic education was not primarily with his father, but with his Aunt Carolyn, herself an accomplished artist.

Needless to say, given Andrew Wyeth's fame, he tends to be lumped with his father. "Both of us are viewed as bucolic," he says, although their work is, in fact, very different. But like his father, he has the problem that "any kind of public acceptance is really the kiss of death. If it's too accessible, it's assumed to be garbage. Look at Mr. Frost. He's derided, but read the poems. 'Stopping By the Woods on a Snowy Evening' — that's taken to be a sweet little poem. It isn't."

All in all, he feels that the positives of being a Wyeth outweigh the negatives. He and Andrew Wyeth have a strong relationship, although with their work schedules, they don't see each other that often, even when they're both in Maine. "The other night I went over to his island and had dinner with him," Jamie says. "We talk mainly about our work. Yes, he's my father, but we're also talking as people in the same field, so we have a camaraderie."

He stresses that he also likes N.C. Wyeth's work a great deal. He didn't know his grandfather, but the work has inspired him "since I was a child, when I saw them in books. When my aunt died recently, I had to buy some of N.C.'s easel paintings from the IRS."

Like Andrew and Jamie, N.C. was somewhat cursed by popularity. "One thing that really does appeal to me about illustration," Jamie Wyeth states, "is that it gets away from the artiness. Stravinsky always had two questions when asked to do a score for a ballet: how long and how much money? Yet within those restraints, there was an excitement, an exuberance, and it reminds me of my grandfather. The illustrations were huge — why did he do them so big for these tiny books? Painters today are so intellectual. When people charge me with being a 'mere illustrator,' I'm delighted."

With his wife, Phyllis, devoted to environmental causes and maintaining a Washington, D.C., apartment so she can pursue her activism, much of Jamie Wyeth's life is almost monkishly devoted to his art. And he wouldn't have it any other way. "I pretty much paint all day, every day."

ANDREW WYETH: *"What's Under Your Feet"*

*T*he Brandywine Valley's most famous citizen is also its most ferociously private — quite an honor in a region where most everyone cherishes his privacy. Notorious for not giving interviews or discussing his craft, Wyeth is secretive enough about work-in-progress that he could paint one woman — his Chadds Ford neighbor, Helga — for fifteen years without revealing his subject to even his wife. When the 240 works now known as "The Helga Pictures" were unveiled in 1986, the national furor about his methods and motives so dismayed Wyeth that he became even more guarded.

Born in 1917, Wyeth paints still, in Chadds Ford and Maine, with the same vibrant, almost electric intensity of focus that has always defined his work. "My subjects become more and more me and things that mean a lot to me," he says, "and always, those feelings are within a very few miles. What's under your feet can be just as important as what's in the distance."

Wyeth's social life revolves, as it always has, around his family. His voice softens when discussing children — "I loved every minute of them crawling out of my pockets," he confesses.

After so many years in the public eye, Wyeth is clearly bored with art criticism and its evaluations of his realism. "I paint things as I see them," he says flatly. "I stick to the true colors of Pennsylvania, which to some people are too somber." He likes to joke that "you have to be good to be an illustrator, so I became a mere painter."

Wyeth grew up "playing and running around the hills" of Chadds Ford. What clearly appeals to him about the region is its enduring familiarity. "There are still sections that are untouched," he says. "And even if you put up an ugly building, you can't change the curve of a hill."

ANDREW WYETH

*Trained by his father,
the noted illustrator N.C.
Wyeth, and the father
of artist Jamie, Andrew
Wyeth has remained the
Brandywine Valley's most
famous resident since his
first one-man show in
1937. His paintings of
the people and places
of Chadds Ford, rendered
in a style so intensely
naturalistic as to often
appear surreal, have
made this tiny corner
of southeastern Pennsyl-
vania familiar and
beloved the world over.
And the artist himself
has never waned in his
life-long love affair
with his native home.
"I am never truly happy
in any other place."*

CONCLUSION
Tradition and Change

When people call the Brandywine Valley "Wyeth Country," they don't just mean that Andrew Wyeth has provided a map of the region's geography. They mean he has captured the *spirit* of the place. Wyeth's people look out windows at a landscape we can't always see, lost in thoughts that are secret to us. But we can identify with their veil of wistful self-enclosure. Christina Olson inching through the parched grass towards the foreboding house on the hill: so emblematic of a certain bittersweet state of mind have Wyeth's paintings become that it's easy to forget he *invented* this mood. He may be realistic, but Christina hardly paused mid-crawl and held up a sign saying "Paint Me!"

Those who deem Wyeth's paintings too adorably rustic may be revealing more about their disdain for the country than about their taste in art. Fall foliage, to them, looks merely cute; but to Wyeth, who actually lives in the country, it has a much more complicated content. "Everybody talks about fall colors and all that crap," he has told an interviewer, "but I can't look at it that way. [In fall] all my past seems to roll out in front of me." Edward Hopper, who mined a realistic tradition similar to Wyeth's (if in less technically accomplished a form), certainly never suffered the same kind of accusations of being "a mere illustrator." But then Hopper's diners and deserted streets may simply seem like nobler subjects, more modern, more ironic.

Closer viewing shows that Wyeth's work is full of ironies, dark commentaries on country life. Especially in his new paintings, the pretty landscapes are always interrupted by something unexpected, maybe unwelcome. In *Ring Road*, a snowy scene is no winter wonderland — because a yellow traffic sign disturbs the view. Majestic trees are lit by car headlights; country lanes offer views of dead animals with their "strange, luminous light." Trash blows across the landscape; as Wyeth once commented, "I mean, you can't be in the country anymore without beer cans and newspapers."

Visitors to the Brandywine Valley may assume the place is frozen in time, with its Revolutionary War reenactments and carriage rides. But Wyeth knows better. Progress reaches here the same as everywhere. And as everywhere, always, progress is never pure or simple, just as the past was not simply a happier, better time.

What Andrew Wyeth chronicles, finally, is the passage of time. As he pushes 80, the artist is still changing. And the region he has been so loyal to has bestowed its loyalty in return. If this valley is not exactly as it was, neither does it change in a flash, move on to the next hot thing. This place will not bulldoze its historic limestone buildings and erect strip shopping malls.

For that — and for Wyeth — we can all be grateful.

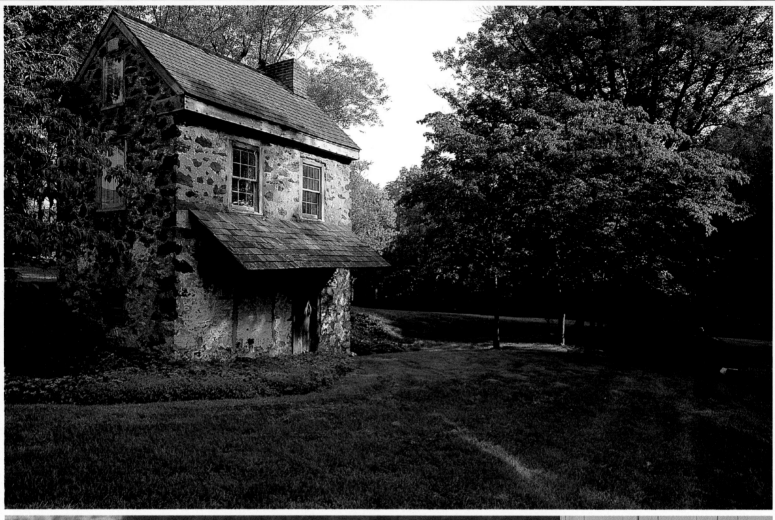

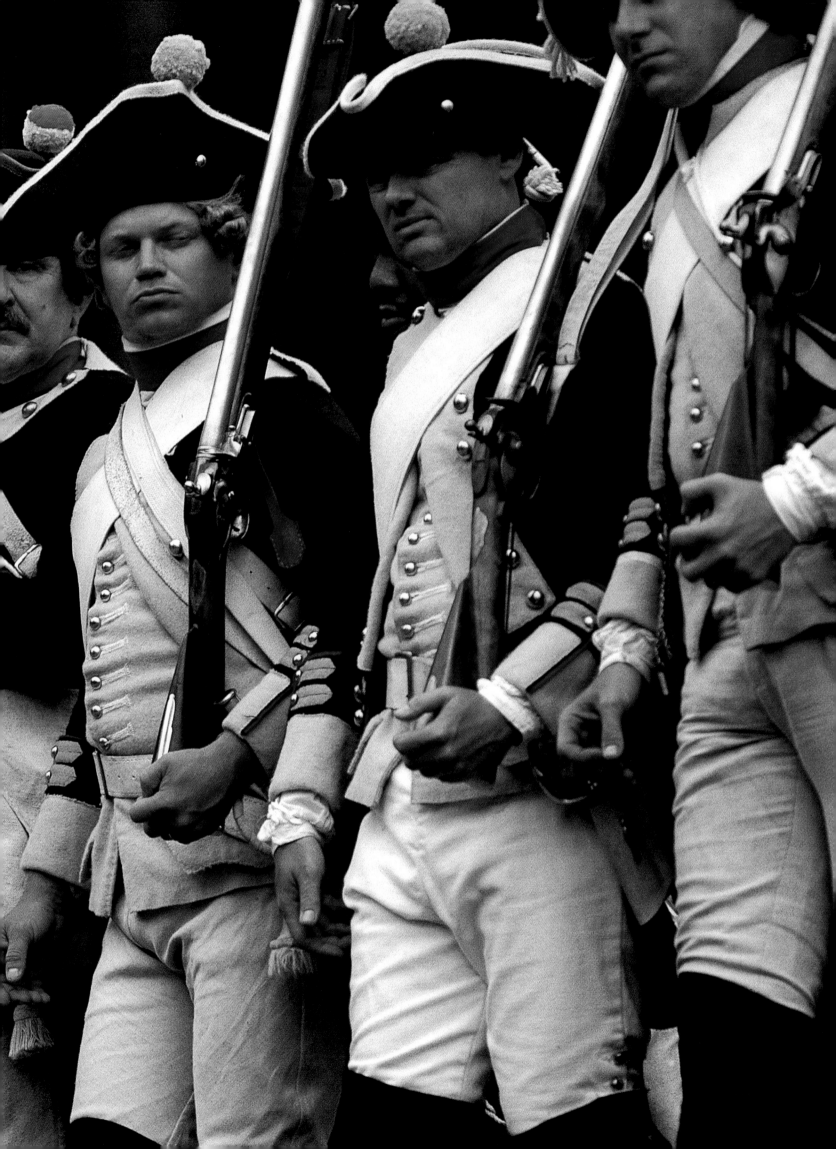

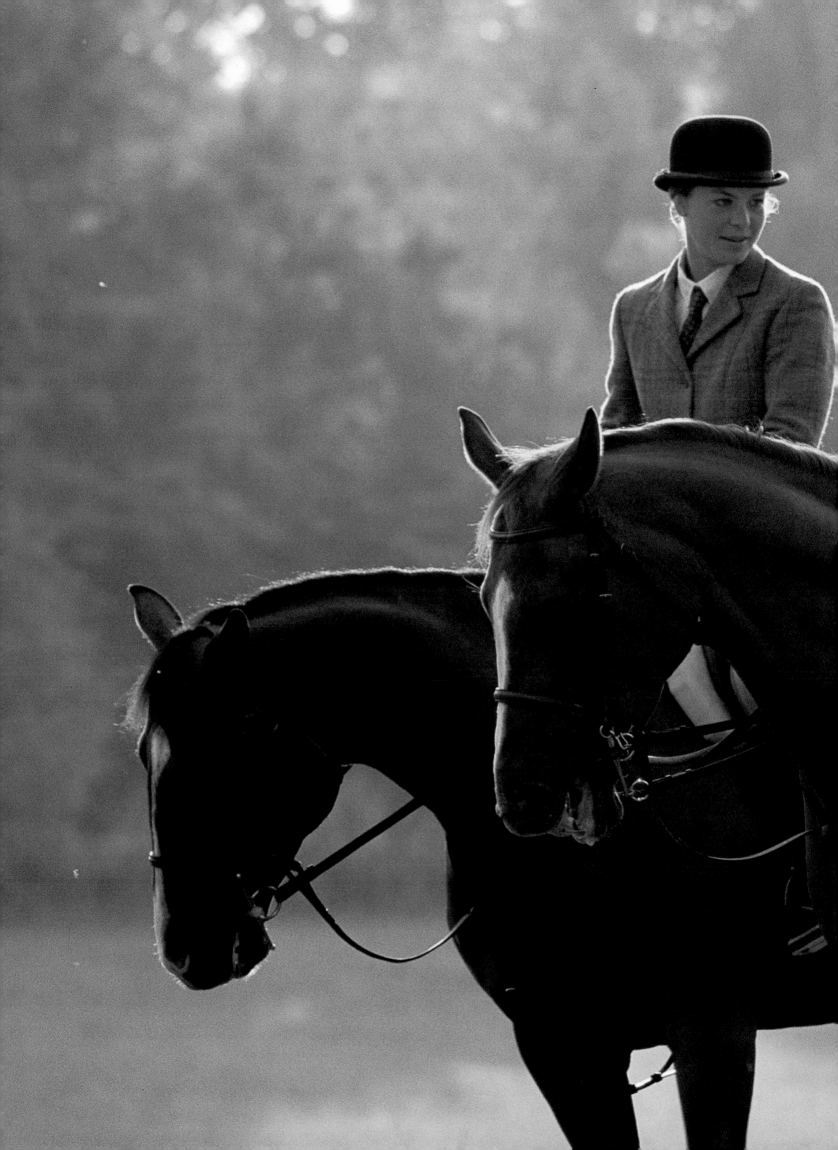

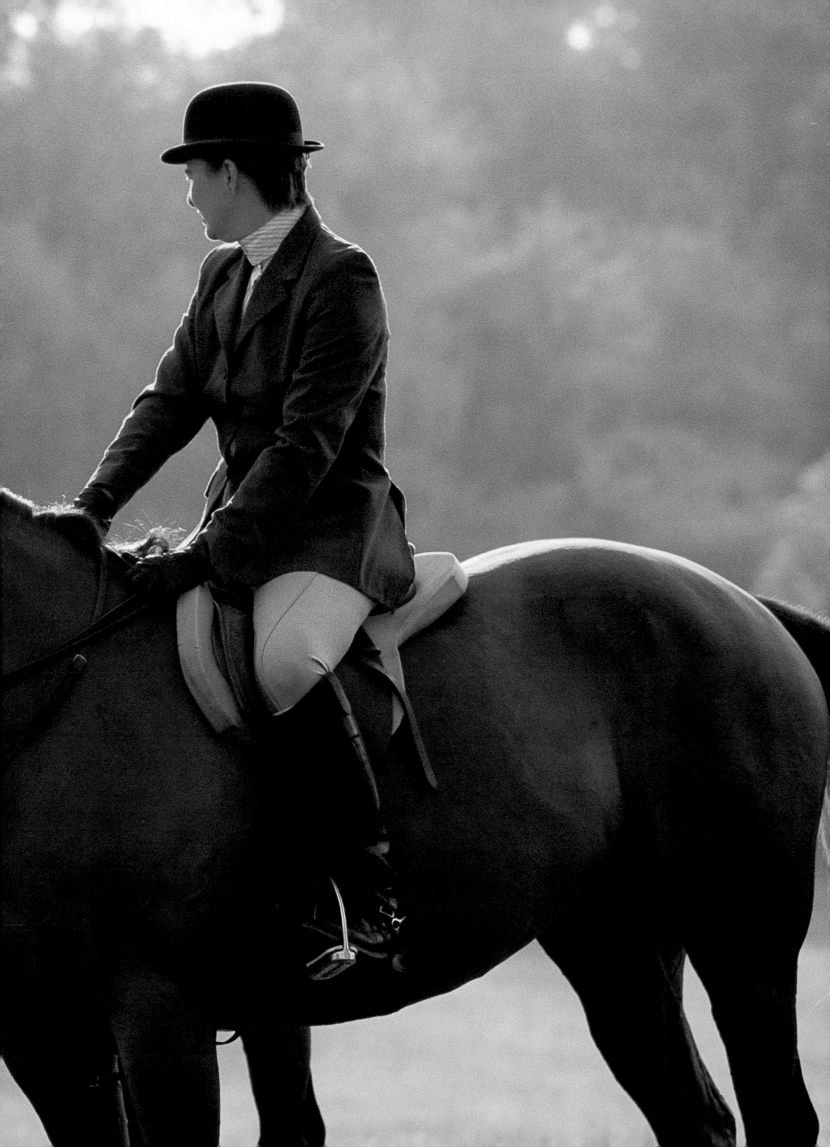

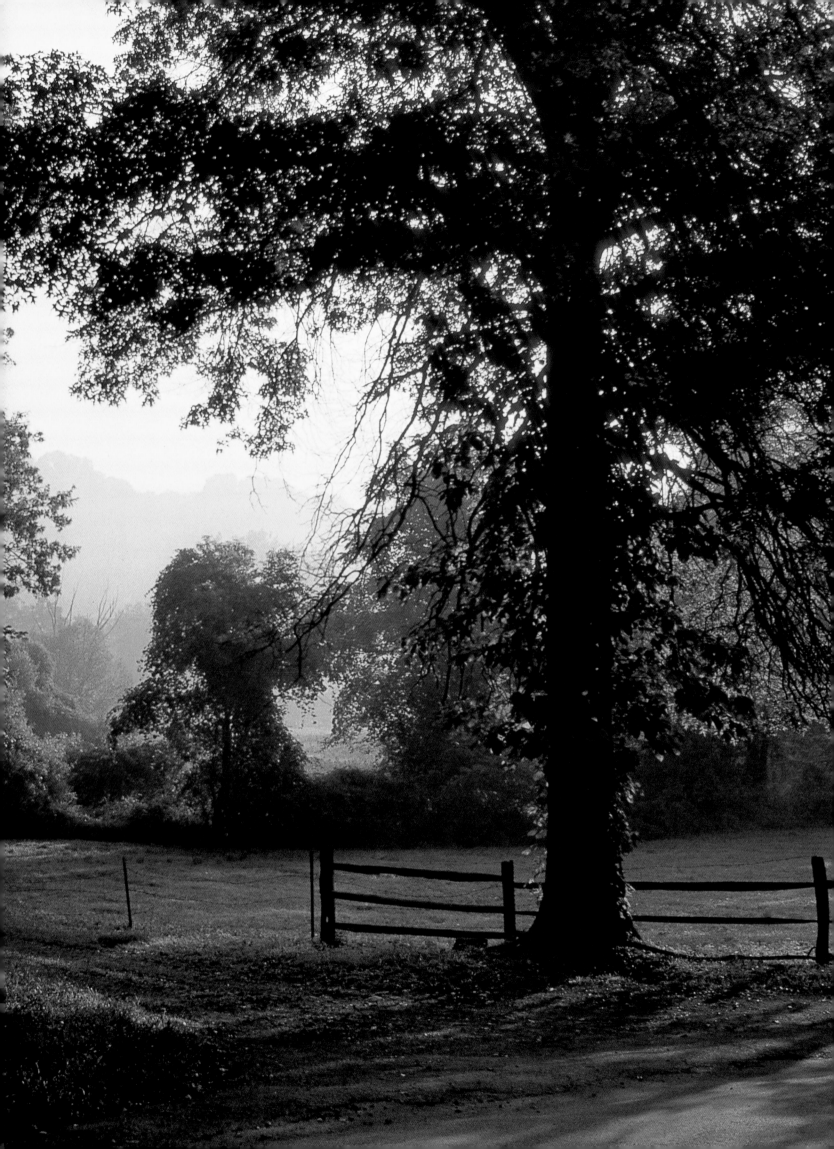

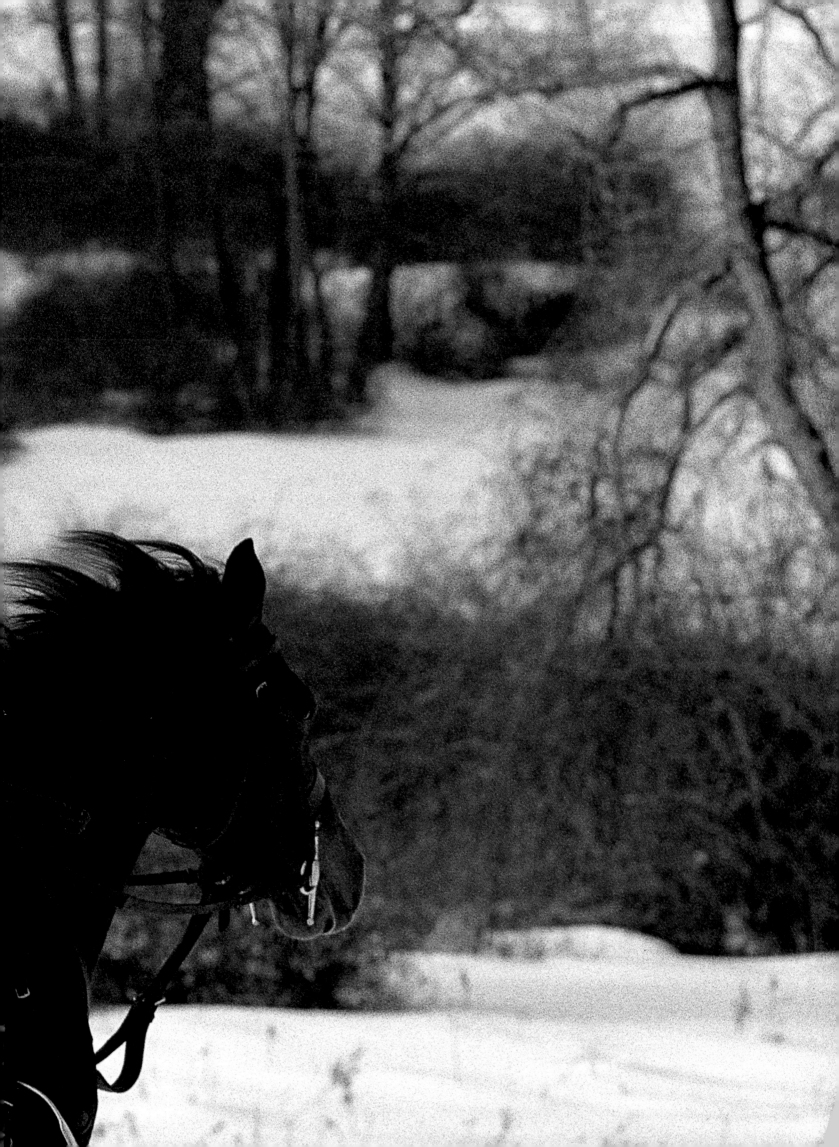

ACKNOWLEDGEMENTS

Photographer's Note

Born in Dover, Delaware, I had been living and working for the last twenty years in Manhattan and was in the process of moving to Palm Beach when the *National Geographic Traveler* magazine offered me an assignment to photograph the Brandywine Valley in the spring and fall of 1991. Ideal timing for me, it was an opportunity to see friends and make familiar a part of Delaware and Pennsylvania that would have been lost to me otherwise.

That cover piece came out in May 1993. Halsey Spruance, a Wilmingtonian working at the *Geographic*, called to say how much he liked the pictures and to ask if I would consider doing an exhibit in Delaware. Later in Palm Beach, talking with old friends Bill and Renee Lickle, I mentioned my talk with Halsey, and they immediately proposed that we do a book on the Brandywine.

Without those conversations and the Lickles' support, generosity and bounteous enthusiasm, this project would never have seen the printer. I'd like to take this moment to thank them both for their interest and their amazing and fearless leap into the world of book publishing.

Likewise, Frank Shields introduced me to Jamie Wyeth; Sam Antupit, the designer, fell upon the talents of Lisa Zeidner, a marvelous young writer, who has etched a lively and incisive text for this book. Dick and Vi Sutton, very old friends, generously gave of their wine cellar, and on numerous occasions put me up for the night. I'm indebted to them all. And I would mention my brother Arthur Edgeworth and his wife, Betsy, and my mother, Salome Edgeworth, all of whom let me stop off from time to time between Palm Beach and Chadds Ford and rest my weary Nikons in Washington and Dover respectively.

Pamela Fiori of *Town & Country* graciously decided to feature portions of this book in a 1995 edition of her magazine, and for this I'm exceedingly grateful. The magazine and I are old friends. In fact, my wife, Kirsten, was a cover subject for me fourteen years ago. We met during the cover shoot on Sutton Place in New York, and I'm constantly thankful for that piece of luck. My daughters, Salome and Alexandra, feel the same.

And lastly, a special indebtedness I reserve for the extraordinary people and scenes of the Brandywine; they were *both* quite special subjects. And they were both there when the light was right — it really made the difference!

Author's Note

The many facts and figures reported here are accurate as of 1994. Timebound though the numbers are, we felt that the specifics on dates and dollars were necessary to give an impression of the region's achievements, and to complement the photographs.

Many thanks to all of the people who shared their memories, insights and expertise with us, most notably William and Renee Lickle. Thanks, too, to designer Samuel N. Antupit, and text editors Emily Heckman and Spencer Beck.

A Note of Special Thanks

Bill and Renee Lickle's house in Montchanin, Delaware, is situated one hundred feet above the Brandywine and looks downriver to the Hagley Museum. For three generations, their families have lived and worked along its banks. Their intimate familiarity with the area helped foster the vision for this book.

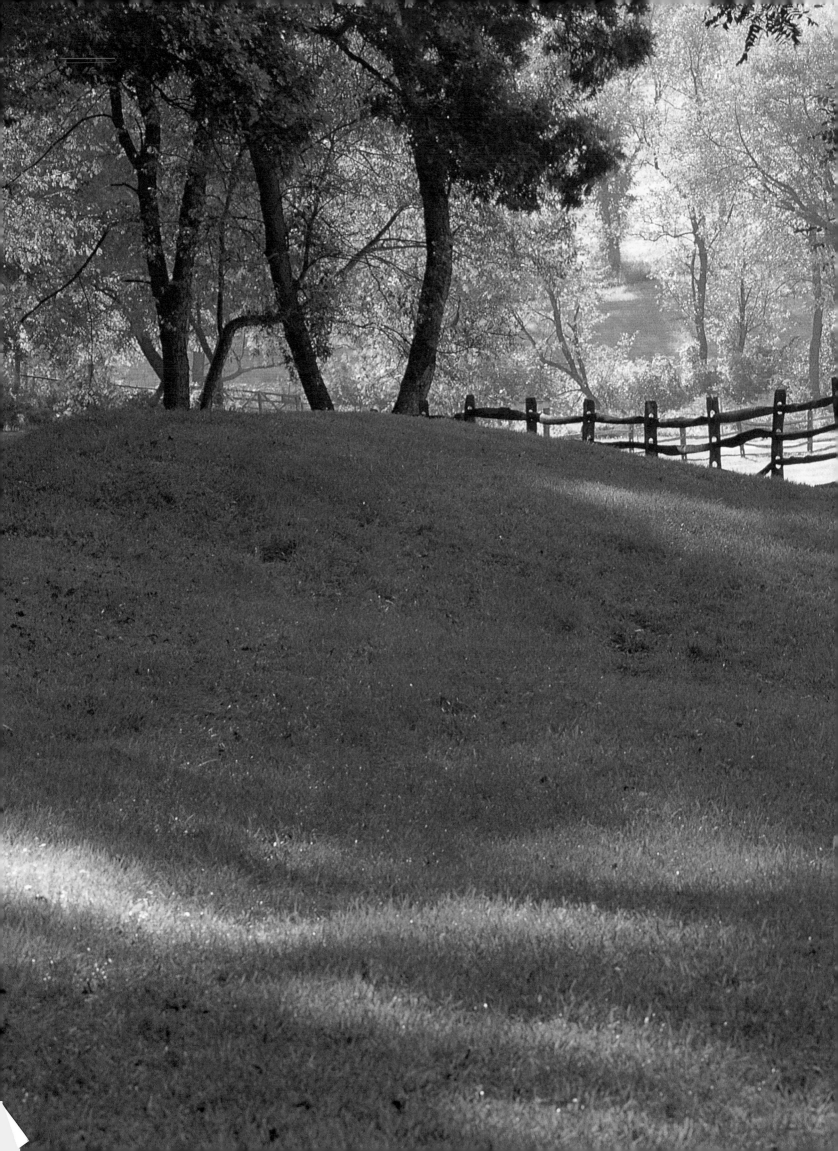